Invisible Dreamer

Invisible Dreamer

Memory, Judaism, and Human Rights

Marjorie Agosín

SHERMAN ASHER Publishing

Book Design: Judith Rafaela
Cover Design: Janice St. Marie
Cover Image: Liliana Wilson "Memorias de Chile"
We gratefully acknowledge Wellesley College for its generous grant supporting the translation process.

Library of Congress Cataloging-in-Publication Data

Agosín., Marjorie.
 [Essays. English. Selections.]
 Invisible Dreamer : memory, Judaism, and human rights / Marjorie Agosín.
 p. cm.
 Includes bibliographic references.
 ISBN 1-890932-19-1
 1. Latin American literature--Women authors--History and criticism.
 2. Jewish literature--Jewish authors--History and criticism. 3. Jewish
 literature--Latin America--History and criticism. 4. Agosín, Marjorie.
 5. Jewish authors--Chile--Genealogy. 6. Chile--Genealogy. 7. Human
 rights--Latin America. 8. Agosín, Marjorie--Translations into English. I. Title

 PQ7081.5 .A35 2001
 860.9'9287'08992408--dc21 2001046339

Sherman Asher Publishing
PO Box 2853
Santa Fe, NM 87504
Changing the World One Book at a Time™

To the memory of Helena Broder
and her lost sisters—
and to the memory of the Disappeared
wherever they might be.

ACKNOWLEDGMENTS

I am deeply grateful to editor and publisher Judith Asher, whose continuing passion and belief in my work has allowed me to dream. I also thank all her staff at Sherman Asher Publishing, especially Nancy Fay for her vision, wisdom and spirit and Julia M. Deisler for her careful attention to details.

I gratefully acknowledge Elizabeth Horan for her inspiration and careful reading of these works in progress.

I offer my gratitude to all the translators involved in this project whose dedication attests to the power of language and the bridges one must always cross.

To my family, who has so patiently understood my vocation as a maker of words, I thank you.

This collection of essays is the fruit of many years reflecting on the ways in which Judaism, Human Rights, and the search for Memory are interwoven threads in the experience of what it means to be human.

Contents

MENDING THE WORLD

THE PERSISTENCE OF MEMORY: HUMAN RIGHTS IN THE AMERICAS

Prologue
for Jane Stapleton

My great-grandmother Sofia used to welcome the season with a suitcase in her hand. She would pause, while sitting on the side of the street, and meditate, feeling the uncertainties of the impending season. Next to her suitcase would be a bag filled with rich earth and bulbs, and beside it would lie a bag of garlic. Uncertainty, frailty, and vulnerability were the parts that composed not only her stories but those of the generations to follow.

Grandmother Sofia survived the pogroms—when the Cossacks set fire to her home and her scarce belongings. She was left with only her courage, her tenacity, and a seven-branched silver candelabra to protect her from the darkness and to illuminate the path for her new life. My great-grandmother Helena, whom I always call The Angel of Memory, trusted the Gestapo with the keys to her home in Vienna. She believed she was going to return to her garden. She believed she would return to her street and neighborhood. She trusted, and she was betrayed. Neither Sofia nor Helena ever returned to Russia or Austria. They joined the frail family of refugees that defined so much of the twentieth century. Their story is an epic that will continue to define the present century.

All of these family histories serve to frame this conversation about immigration to America and the meaning of home. One interpretation of "home" can be extricated from the complex layers of History. Home, for many Jews, was their existence in the Diaspora, their perpetual state of homelessness. Home was that place where they sought refuge from persecution and discrimination. However, the Jews are not and have not been alone in their search for refuge. The Diaspora of the Jews join the ranks of other diasporic groups, such as the African diaspora whose members spent centuries as slaves, and later on forced the coloniza-

tion and apartheid in the Americas, as well as South Africa. Home for many Palestinians has been the refugee camps in the West Bank; for the Bosnians it has been in the Balkans; for many Japanese-Americans it was the internment camps in the United States.

Home is too often a result of politics and privilege. Thus we ask: Who has a home? Who are those people who live at peace, rooted in a single place, and surrounded by the comforts conjured by this exquisite word?

The right to food and shelter, one of the essential decrees of the Human Rights Declaration, remains a privilege for a few, mostly for the inhabitants of the Western World. For many others, home is embedded amongst silence and debris. It is defined by that which has been lost and that which once was the world that they knew.

I shall tell you about my many homes, including my home in America. While I have strong ties to the United States—I was born in Bethesda, Maryland, in 1955—I come from somewhere else. I am the granddaughter of two remarkable women who survived the Russian pogroms and the Holocaust. My grandfather was trying to escape a passionate love affair with a dancer of ill reputation. He found a map and saw a tiny port in the Pacific, which seemed to him to be the last port on Earth. He arrived in Valparaiso, Chile, aboard a cargo ship. He found Chile because of love, and we remained there because of love. My grandfather married while in Chile and thus an entire generation of Halperns-Agosíns became part of an invisible minority of Jewish refugees. In Chile, we had a sense of permanence. We built a home, planted gardens, painted our house with the colors of Chile—blue and red. We were defined by the languages we spoke— Spanish, Yiddish, German, Russian, and French. Thus, when asked about home my first inclination is to say that home is where you and your respective language or languages are at peace with one another. One belongs in the world of affection. May we understand each other's joys and despairs through the texture of words.

Home is belonging to a community and being a participant in the daily go-abouts. Home is strolling through the market, relishing the smells of fresh food and cilantro, walking under an

open window with a loud transmitter playing folk music and the news. Home is where the women are gossiping and the children are dreaming.

I often wondered if belonging was really as easy as it seemed—seeing without questioning. Yet, as I matured I began to understand that the relationship between home and belonging was much more intimate and complex. I do not doubt that we belong to the landscape of our childhood that nurtured us. I know that we belonged to the seasons that were harbors of refuge and continuity. Only while in nature's perfection—where there is no difference between the outside world and myself and, at the same time, my own indifference—have I truly felt that I belonged. Thus we have the second definition of home: landscape and earth / seasons and beginnings.

Often we associate home with roots. Permanence is more often than not associated with grand pianos that defy impermanence rather than suitcases and bulky luggage. At an early age I came to understand that home was not necessarily permanence. Home can represent loss and displacement. Therefore, I went looking for permanence in the traces of the fugitive histories that formed the texture of who we were, and are, and will become. I went looking for home in the sacred language of poetry. I believed that home was more than belonging. Home is understanding and being understood.

Perhaps exile was too familiar of a condition. To be in exile is to join the millions of un-housed who are forced to wander across languages and borders. For me, exile became a home and it thrived in the world of books and poems while mapping borderless territories. Through imagery dreams of the world, spanned by the familiar, were mapped.

The third definition of home is impermanence and the inability to rescue that which is left behind. My great-grandmother Helena never recovered the keys to her home. Her world was a lost world, a world of the dead, a world of memory, a space where ghosts reside—forever adrift.

Home and uncertainty are intricately threaded with the permanence of memory. We are what we remember and we under-

stand heritage and belonging through our own passion to re-member. Home is a living scrap-book of memory that we carry as we move about, as we remember the vanquished and their re-spective passions and sorrows. Memory can never reside in ab-straction. Memory must be cemented into concrete, must be worn like a dress, must be lived in like a home of differing levels, tex-tures, and colors.

On Tuesday, September 11, 1973, I lost what I considered to be my home. The Chilean military, with the full support of the CIA, overthrew Salvador Allende and his freely elected socialist government. In shock and amazement, we witnessed our safe home and country crumble, the presidential palace in flames, and thousands upon thousands killed or missing. These stories, that come from the darkest of Chilean history, continue to haunt us in the similar fashion that the events of September 11, 2001 will haunt the world. That evil Tuesday we lost what we believed was home and we lost what we imagined the world to be— inno-cent, and full of wonder. Sadly, few remember Chile, but the world will long remember New York.

During these moments of reflection I remember my great-grandmother with her ritual of the suitcases. We realized it was time to leave. What to pack and where to go are the dilemmas faced by all emigrants, all displaced people. Some people take spices, others take photographs, or small jewels, or earth from a soothing garden. We take the material objects that surround our world and we choose the symbolic objects that define us. Home is perhaps a few photographs, books, a bag of earth, candles to light the way, or a shawl to embrace us.

We left Chile for the other America. From the America that had sheltered my family, we traveled to the America of the north. As an adolescent I was ambivalent and conflicted. I did not want to lose my home, or walls, or school. But more than that, I des-perately did not want to lose my language.

In 1974 we arrived in Georgia, the other south. I was envel-oped in the experience of loss and homecoming. To this day I continue to struggle with the idea of home and the meaning of belonging. It seems that I have always worn misfit shoes and had to explain who I am and why I have not lost my focus.

In America I tried to preserve my home by not losing my language. I resisted the urge to assimilate into an alien way of life. I began to write poetry about my ephemeral world that had collapsed and about a people shattered to silence and complicity. While I was trying to recover the meaning of home I began to understand what it meant to be a foreigner— always relegated to the back room, always questioned, always put into questions, always asked, "where are you from?" I experienced my solitude like a wound.

If America is a grandiose melting pot and multicultural society, then it is also a place that has not fully welcomed its immigrants, especially those of color. It is a place that used to prohibit the speaking of native tongues, and it is a place that racially profiles those whose origin is from elsewhere. A friend recently asked me why I seem so critical of this society that has given me so much. I think that to be critical is to be American. Freedom, complete freedom, includes the right to a dissenting opinion, the right to question an election. However, considering that only 30% of the citizens of the United States vote, it is fair to call the political culture dormant.

In Georgia and Indiana home was the reconstruction of a world that was lost. My days were perpetually suspended in a daze of remembrance for the family and friends, for my home, my language, and my landscape, which were left behind. Thus, my fourth definition of home is longing.

In America there is a general longing for home, that place of our childhood or our imagination. In my longing and my search, I found home in America, a society that was greatly wanting in comprehension and compassion. Home, for me, became a space of reflection and a space where I could conjure who we were and what we were to become.

America is constantly evolving into a more inclusive society. The achievements of the civil rights movement and feminism changed us forever. Home in America has become not only a place of inclusiveness, but also a place of possibility. In this country, a multitude of languages are spoken. I think that to be a foreigner is to be American. Over the years I have gradually learned to forgive America and to understand its great virtues and terrible

mistakes. I learned that home is also a place of possible change and vulnerability. From my early years in Georgia until the beginning of the twenty-first century, home was not only America but was also the world that was, paradoxically, becoming a land without borders. We were becoming insular and building walls instead of bridges. We may strive for isolation, we may separate ourselves from our Mexican neighbors; however, we cannot help but be global.

I learned that home was found in human compassion and not adobe walls. I learned that the world was losing its borders but simultaneously losing its soul.

As a writer, I found home amongst other writers. I found peace among voices who were new or even unknown in this country. Home was no longer a physical place but, instead, a state of being. My heart found solace amongst my books, other friends in exile, and the condition of impermanence that later defined us all.

And yet, this home was the home of the privileged few in contrast to the staggering numbers of the homeless, the abused, the hungry. These numbers become part of an increasing abyss of despair not only to those who long for home but also to those who have homes. In a space of privilege, home can be music, candles, a verse in a world of dispossession, or a loaf of bread.

The tensions of home and homelessness, of being excluded due to race, class, or gender, and the privilege of wealth gave our power of home to someone else to control and determine.

The events of September 11, 2001 shattered my world twice. Santiago and New York City — it is an eerie coincidence. Santiago is the city of my dreams and adolescence. New York City is the city of immigrants. We may witness the material world crumble, but what remains is not just rock and rubble. What remains is courage amid despair and home amid terror. More so, America became my home—a more real home than my beloved Chile. America was like the rest of the world: grief stricken, vulnerable, but not complacent, and not alone or without unity.

As we rethink this event and plan the future we must reevaluate the meaning of home in America. Shall we protect ourselves simply by excluding those who are not "white"? Shall we

continue to be a nation of dignity and tolerance or a nation that fears foreigners? Shall we be a nation with a death penalty and one that has not yet ratified a human rights amendment? Shall we be a nation against land mines, but not one that makes a serious effort to stop child labor?

These are the issues we will face in this new America that is frail and vulnerable and ambivalent. Perhaps this country will be less arrogant and perhaps it will understand what it is to lose a home and to be dispossessed. I saw photographs of people in New York desperately searching for their relatives amid the rubble. It had an eerie resemblance to that which I witnessed in Santiago. I have found myself, again, among the dispossessed and among the suffering. Thus, home is a place that dwells in the heart.

I have lived here almost three decades. In Chile, I still remember my great-grandmother with her suitcase. Fortunately for her, she never had to leave Santiago. She died in Chilean soil, and I carried her seven-branched candelabra with me as my own sacred possession. We are still here. We have planted gardens with our own hands because to garden is to have faith in the future. Home is to live in a culture that is not homogenous, one that will grow in diversity and will find meaning, and enlightenment, in the differences.

As I end this meditation, I would like to add a few recipes for understanding home in America and the world. Home is to mend the world. Home is to remember to preserve the memory of the dead and the living. Home is to understand what our convoluted history has done. Home is to remember the tragedies and to strive for a deeper understanding of them. Home is a society that remembers and does not deny facts in order to hide prejudice.

Home is an encounter with our deepest self, as well as an encounter with others. All else is irrelevant. Homes may crumble and fall in our desperate struggle to remain human. But they will still be home. Jean Ryhs said "only magic and dreams are true. All the rest is a lie." Home must take root in us as an internal metaphor for refuge, for hope, for possibilities, for illusion. Only then can we be free and restored. Only then can we live safely at home.

November 7, 2001

Introduction

I have always loved words. I like to listen to them, repeat them out loud, and imagine their texture. Sometimes, I dream that they are dragonflies that alight on my hand, quick, daring, and full of hope. I was and continue to be an old child in awe before the vastness of language. I grew up in a country located almost at the end of the world. I believed it was a magical place, and, in reality, it was a mythical place, filled with poets and storytellers.

Chile is a narrow strip of land invented by voyagers like Charles Darwin and fantastic yet real characters like Robinson Crusoe. Here was the pulse of my imagination and the source of my writing. As a child I preferred to be alone while I listened quietly to the pulse of the land, the voices on the wind and, at night, the rain falling gently. I felt that Chile and I were one.

Solitude was my ally, and through it I learned to investigate my surroundings. I found the magnificence of the landscapes, the endless horizon, and the brilliant sun. The voices that surrounded me were simply an extension of characters that told me stories. Among them I remember my nannies, grandmothers, mother, and aunts. I belong to an ancient people, the Jews. I have often doubted whether we are God's chosen people, but I do not doubt the miraculous nature of our survival throughout history and the many persecutions we have suffered. Although always persecuted, the Jewish people created many histories from the Torah to the ideas of Freud, Marx, and Einstein.

I am the daughter of a tribe of nomadic origin whose survival was due to the unity we found in God's word and the Torah. Writing is part of the Jewish tradition and it implies sanctifying deeds, heralding prophecies, and recording the mundane.

When I first approached this collection of essays, a title insinuated itself: "Memory, Judaism, and Human Rights." As I studied the writers I celebrate and discuss in this collection and their texts, I realized that my work during the past decade had often contained these three elements. Jews exist in the collective memory of Western Civilization. Many times these memories are complex, ambiguous, and mysterious yet they represent a powerful historical memory that has allowed the cultural continuation of the Jewish people.

From an early age, my grandfather was a passionate reader of anything related to the Jewish people and he was truly a man of faith. His faith was community-oriented, altruistic and commonsensical. He always quoted the Talmud, "To save one life is to save the world." and Tikkun Olam, "Mend the world." These two constant ideas formed an important part of my social conscience.

I am grateful for the opportunity to have grown up in Chile, in that remote land beset by earthquakes, hurricanes, and a dictatorship. In that small country I learned to love words and the Spanish language as well as the Hebrew language. I grew up surrounded by my siblings and my extended family, filled with eccentric characters: some outlaws, and others founding members of the Jewish community in Valparaíso. My great-grandfather Marcos was the honorary Russian consul and my grandmother Raquel sang in three languages: Russian, Spanish, and Turkish. They all had amazing stories to tell about their transatlantic voyages, the horrors of Europe or their trip across the Andes. Not only did they contribute to my identity as a writer, but they also shaped my destiny as a human rights activist.

My country gave me a rich history while at the same time committing one of history's greatest crimes. I still think of Chile as the noble and peaceful land I used to know and Pinochet's arrival as a monstrous accident motivated by the CIA and the not-so-secret puppeteer Henry Kissinger. Following the Agosín family tradition, I also became an uncertain traveler. I arrived in Athens, Georgia, the lion's den located in a marvelously absurd and sinister country whose foreign policies were the direct causes of our exile. Today I am here with my ancestors who are very

much alive in my memory. I have awakened them from the long slumber of death and oblivion. I have written about them and they are now immortal citizens in an everlasting and living history.

This anthology is divided into four sections that reflect my thoughts, illusions, and preoccupations on the above topics. Each section responds to a particular way of capturing the reality that surrounds us.

The first section is dedicated to the process of writing and questions the complex trauma of writing in a language that is not one's own from a country that is not one's own. I find that while writing in exile I have developed a link with others such as Kafka who always wrote in German and who lived in Czechoslovakia; to Nabokov and Brodsky who toyed with the English language during their stays abroad; and to Paul Celan who lived most of his life in France and never stopped writing in German. I meditate on the importance that the Spanish language has had on my writing, the ways I define myself, and how language has given me the possibility of recovering long lost memories and hopes.

The second section is a tribute to my female ancestors, all of whom were there to guide my destiny and that of their families. Through my writing I wish to give back to them a little bit of their unconditional love and their faith in me.

The third section is dedicated to Latin American–Jewish literature, a topic that has been near and dear to my heart these past few years. I think that the invisibility of Jewish writers points out the possibility of a strong anti-Semitic undercurrent in Latin America. I believe this was largely due to ignorance rather than hatred and was supported by the strong influence of the Catholic Church as a tool for channeling prejudice against the Jewish people. Let us remember that it was not until the 1970s, during the Second Vatican Council, that the Catholic Church and the Jewish people were reconciled and the Catholic Church stopped demonizing the Jews and accusing them of murdering Christ.

I think that the Jewish literature of Latin America and the United States is not a fad but rather a way to respond to certain historical moments. We are currently living in a society that stresses the importance of a multicultural education and incor-

porates the literature of various minorities in the curricula of colleges and universities. This is an essential part of educating a nation that is clearly bi-cultural and almost bilingual.

The final section touches upon issues of human rights and my preoccupation with memory and dignity. We are living at the beginning of a new century, a period in which the concept of human rights is firmly ingrained in the political and ethical culture of our nations. Last century saw the emergence of figures such as Rigoberta Menchú, Baltasar Garzón, Mother Theresa and Nelson Mandela. However, we have advanced very little in resolving the issues that lead to atrocities such as the genocides in Rwanda and the Balkans and the kidnappings and assassinations committed by Colombian guerrillas and terrorist groups. The existence of all of these human rights violations points to the precarious nature of history and its protagonists. Innumerable wars were waged in the twentieth century, and their legacy is part of the common culture and history of our nations. This final section is dedicated to the Mothers of Plaza de Mayo, the Chilean *arpilleristas,* and all courageous women who fought for the creation of a more civil, dignified, and egalitarian society stemming from their vision of a civilization based on peace.

While I was at a lecture in Washington, D.C., I read a poem about the death of a million Jewish children in Europe. Afterwards, a young Egyptian man angrily asked if I had also written a poem about Palestinians. I answered that the Jewish children in my poem were representative of all children since children are a universal treasure. I said that their nationality or ethnicity was ultimately unimportant. I went on to explain that I believe that the best way to determine if a country is defending its human rights is to see how the children of that country live.

Let these essays be a reflection on the dialogue between writers and readers and the legacy that motivates us to reflect and meditate on these important issues. In a beautiful text by Gabriela Mistral, the author quotes a conversation she had with an imaginary Teresa de Ávila. In it, Gabriela Mistral perceives Teresa de Ávila as a very wise and happy person. When Mistral asks her if there is a certain degree of vanity in founding so many

convents, Teresa de Ávila responds, "If we founded less of them my daughter, time would blow strongly and leave nothing behind. The vain avoid acting in order be free of mockery. Humility is to build and build." At times I wonder if my desire to have people read my texts is an act of vanity, but I believe that Teresa de Ávila's response applies to my literary work as well. If we only create a few works of literature or art, they will not withstand the test of time. In order to remember and leave a lasting legacy, we must continue to write.

I want literature to be a means for creating humility. All acts of creation are motivated by the powerful intuition that assails the artists' hands and minds. If this intuition is used to fulfill someone's personal ego, it does not authenticate the power behind the creativity. Let the reader experience this anthology as Teresa de Ávila suggests: as a divine puzzle.

As I write this introduction I am living on the coast of southern Maine. Somehow those who live in exile seek the comfort of a familiar landscape and the rhythms of times gone by. Here in Maine time is clear, transparent in its steady flow. The days are all the same and yet very different. The people of Maine remind me of Chileans: austere and generous. Yesterday I went to a nursery to buy plants for our home here. Having grown up in Chile I did not know the English names of the plants I wanted to buy. The people at the nursery gently led me around the gardens and helped me learn the names of the beloved plants and flowers that I sought. I learned from the gardeners and slowly I regained some of the happiness I once knew among familiar flowers, trees, and shrubs.

My memory becomes clearer in Maine. I recognize the scents that surround me. I can sit and imagine that the sea before me is the sea I once knew as a child. I also know that time and tide erases footsteps and what is left on the sand can be lost and later recovered, like memory. The sand here in Maine is my friendly accomplice as I embark upon a journey through my memories. Here, surrounded by ocean, sand, and woods, I feel at the center of my world, a world I know and from which I can remember, create, and invent. I carry within me the histories of many women and the memory of what my mother once told me when she gave

me a rock, some sand, and an agate from Isla Negra: "Do not forget these are your treasures. The whole universe is contained within these objects."

I give you this anthology as a humble gift. See it as a crystal through which you will be able to appreciate a moment of quiet contemplation.

Marjorie Agosin
May 13, 2001
Ogunquit, Maine

Translated by Monica Bruno Galmozzi

Trespassing Language:
Writing and Exile

The Alphabet in My Hand

Beyond
the momentary
light
you were there, word,
mother tongue,
aroma,
dominion of memory.

I dreamed of inventing
your cadences,
rhythms tinged blue,
like the color of certain replete
dreams.
I dreamed of the two of us,
and the alphabet burned with love.
At last I felt sated in my language,
secret, woven signs,
the illuminated manuscript
like the nights of the Jaguar.

Language,
alphabet in my hands,
I delighted in repetition,
blessed by sacred, melodious
discovery,
inhabited by pleasure.
Time and again
I repeated the words
libélula
liturgia
litographía
literas

Mother tongue,
secret caress along the root
of my ear,
I who lack roots,
times, borders.

...

They tore me from you, mother tongue.
I still feel that ferocious wound
unable to hear you
echo in my astonished ears
at dawn.
They took me far from you, mother tongue,
and my voice became a dormant candle.

...

It is brutal to be another
in a different language,
forced into translation
and invented in trajectories
to be unable to say, to be,
to not recognize
and always be asked
where are your parents from?

...

Mother tongue
come back to me,
awaken me.
I do not want to be a dry island,
I want to write along your arteries,
sail in your ship.
Wild and gentle language,
do not forget me.

Translated by Laura Nakazawa

(selected verses from "An Alphabet in My Hand," title poem of *An Alphabet in My Hand*, Rutgers University Press, 1999)

ALWAYS LIVING IN SPANISH:
RECOVERING THE FAMILIAR THROUGH LANGUAGE

In the evenings in the northern hemisphere, I repeat the ancient ritual that I observed as a child in the southern hemisphere: going out while the night is still warm and trying to recognize the stars as it begins to grow dark silently. In the sky of my country, Chile, that long and wide stretch of land that poets have blessed and dictators abused, I could easily name the stars: the three Marias, the Southern Cross, and the three Lilies, names of beloved and courageous women.

But here in the United States, where I have lived since I was a young girl, the solitude of exile makes me feel that so little is mine, that not even the sky has the same constellations, the trees and the fauna the same names or sounds, or the rubbish the same smell. How does one recover the familiar? How does one name the unfamiliar? How can one live in a foreign language? These are the dilemmas of one who writes in Spanish and lives in translation.

Since my earliest childhood in Chile I lived with the tempos and the melodies of a multiplicity of tongues: German, Yiddish, Russian, Turkish, and many Latin songs. Because everyone was from somewhere else, my relatives laughed, sang, and fought in a Babylon of languages. Spanish was reserved for matters of extreme seriousness, for commercial transactions, or for illnesses, but everyone's mother tongue was always associated with the memory of spaces inhabited in the past: the shtetl, the flowering and vast Vienna avenues, the minarets of Turkey, and the Ladino whispers of Toledo. When my paternal grandmother sang old songs in Turkish, her voice and body assumed the passion of one who was there in the city of Istanbul, gazing by turns toward the west and the east.

Destiny and the always ambiguous nature of History continued my family's enforced migration, and because of it I, too, became one who had to live and speak in translation. The disappearances, torture, and clandestine deaths in my country in the early seventies drove us to the United States, that other America that looked with suspicion at those who did not speak English and especially those who came from the supposedly uncivilized regions of Latin America. I had left a dangerous place that was my home, only to arrive in a dangerous place that was not: a high school in the small town of Athens, Georgia, where my poor English and my accent were the cause of ridicule and insult. The only way I could recover my usurped country and my Chilean childhood was by continuing to write in Spanish, the same way my grandparents had sung in their own tongues in diasporic sites.

The newly learned English language did not fit with the visceral emotions and themes that my poetry contained, but by writing in Spanish I could recover fragrances, spoken rhythms, and the passion of my own identity. Daily I felt the need to translate myself for the strangers living all around me, to tell them why we were in Georgia, why we ate differently, why we had fled, why my accent was so thick, and why I did not look Hispanic. Only at night, writing poems in Spanish, could I return to my senses and soothe my own sorrow over what I had left behind.

This is how I became a Chilean poet who wrote in Spanish and lived in the southern United States. And then, one day, a poem of mine was translated and published in the English language. Finally, for the first time since I had left Chile, I felt I didn't have to explain myself. My poem, expressed in another language, spoke for itself ... and for me.

Sometimes the austere sounds of English help me bear the solitude of knowing that I am foreign and so far away from those I write about. I must admit I would like more opportunities to read in Spanish to people whose language and culture are also mine, to join in our common heritage and in the feast of our sounds. I would also like readers of English to understand the beauty of the spoken word in Spanish, that constant flow of oxytonic and paraoxytonic syllables (Verde que te quiero verdo), the joy of writing——of dancing in another language. I believe

that many exiles share the unresolvable torment of not being able to live in the language of their childhood.

I miss that undulating and sensuous language of mine, those baroque descriptions, the sense of being and feeling that Spanish gives me. It is perhaps for this reason that I have chosen and will always choose to write in Spanish. Nothing else from my childhood world remains. My country seems to be frozen in gestures of silence and oblivion. My relatives have died, and I have grown up not knowing a young generation of cousins and nieces and nephews. Many of my friends were the disappeared, others were tortured, and the most fortunate, like me, became guardians of memory. For us, to write in Spanish is to always be in active pursuit of memory. I seek to recapture the world lost to me on that sorrowful afternoon when the blue electric sky and the Andean cordillera bade me farewell. On that, my last Chilean day, I carried under my arm my innocence recorded in a little blue notebook I kept even then. Gradually that diary filled with memoranda, poems written in free verse, descriptions of dreams and of the thresholds of my house surrounded by cherry trees and gardenias. To write in Spanish is for me a gesture of survival. And because of translation, my memory has now become a part of the memory of many others.

Translators are not traitors, as the proverb says, but rather splendid friends in this great human community of language.

I discovered that English
is too skinny, functional,
precise,
too correct,
meaning
only one thing. Too much wrath,
too many lawyers and sinister policemen,
too many deans at schools for small females,
in the Anglo-Saxon language.

II
In contrast Spanish
has so many words to say come with me friend,

make love to me on
the césped, the grama, the pasto.²
Let's go party,³
at dusk, at night, at sunset.
Spanish
loves
the unpredictable, it is
dementia,
all windmills and velvet.

III
Spanish
is simple and baroque,
a palace of nobles and beggars,
it fills itself with silences and the breaths of dragonflies.
Neruda's verses
saying "I could write the saddest verses tonight,"
or Federico swimming underwater through the greenest
 of greens.

IV
Spanish
is Don Quijote maneuvering,
Violeta Parra grateful
spicy, tasty, fragrant
the rumba, the salsa, the cha-cha.
There are so many words
to say
naive dreamers
and impostors.
There are so many languages in our
language: Quechua, Aymará, Rosas chilensis,
Spanglish.

V
I love the imperfections of
Spanish,
the language takes shape in my hand:

the sound of drums and waves,
the Caribbean in the radiant foam of the sun,
are delirious upon my lips.
English has fallen short for me,
it signifies business,
law
and inhibition,
never the crazy, clandestine,
clairvoyance of
love.

Translated by Celeste Kostopulos-Cooperman

[1] First appeared in: *Poets & Writers Magazine* (March/April 1999): 25-27.

[2] All three words mean grass.

[3] The Spanish version of this poem uses two phrases that mean to party: dejuerga and de fiesta.

A Writer's Thoughts on Translation

> Translation is akin to what technology has labeled access. It is through translation that we touch, hear, and understand each other, and it is translation that gives us pause to reflect on what we read and see.

Thank you very much for being here on a beautiful Sunday afternoon. I hope that we will also have a very beautiful and meaningful time. First I will speak to you about this very complex topic of memory and translation. When I spoke with Judith Asher, the publisher of *Lluvia en el desierto,* about my presentation she said to me, "Well, at least you are being brave and not talking about the same things." And I think that's something one really has to be careful about because as poets, as writers, as artists we can copy others, but it is very dangerous to copy one's self. So, I would like to speak to you about what it means to be translated. How does a poet who does not write in English feel when her work is translated? Afterward I will read you a few fragments from an essay that I wrote for *Poets & Writers* describing exactly what it means to be a person who lives in translation. The reason I want to read you some excerpts from this essay is because after I wrote it, I received many letters. Among the wonders of literature, of poetry, is that you are the readers and we write, and sometimes we do not know how we can communicate with each other, but then I receive letters in which people say, "Oh, I always live in translation; I am Polish." Or "I received a beautiful poem from a woman who has lived for 46 years in Mexico, but she's an American; she writes and lives in English in a Spanish land."

I was born in the United States by some fate or destiny, and when I was three months old, I went to Chile. I did not learn English until I arrived in this country a long time ago, when I

was 16 years old. You can imagine that adolescence is not the easiest of times. Perhaps you can imagine what it's like to be thrown into a high school in Athens, Georgia. If you think that in New Mexico you are isolated, sometimes I think Georgia was even more isolated, especially for someone who could not speak a word of English. My mother had to translate Shakespeare's sonnets for me from the English to the Spanish, and, believe me, Shakespeare also works in Spanish. I felt that without a language I had no voice; I had no identity; I was nothing. It took many years until I learned—I don't want to say mastered but was able to communicate in—the English language and became a person in English. Then I acquired a sense of self in a new language. That to me was very important, for without translations we are speechless. Translations are like crossings of borders, crossings of landscapes, crossings of voices.

What I learned about translation was that even though I became someone once I learned English, I did not want to lose who I had been. I did not want to lose my Spanish self, which was really my Spanish language, because you are what you speak. For me, there were two dividing ways, sometimes paths in conflict and sometimes roads that intertwine and embrace.

There is a terrible pain in not understanding the original—about not reading something in Chinese, in Polish, in Italian. But there is a tremendous liberation in reading something that is not in the original and knowing that the original exists, that it is real.

Returning to this near duality of living, of existence, I kept the Spanish because the Spanish language allowed me to retain what I had dramatically lost, which was a home, a country, a family, a language. I also wanted my work to be in English so that what I lost would be known. For loss has to be known so that somehow that loss can be shared.

That brings me to my other point about the act of translation. To quote Phyllis Hotch, a poet from Taos, translators are like unsung heroes and heroines. I would like to go even further to say that translators are the messengers of the spirit. You bring a message to someone who does not understand the original.

Translation occurs in the court system, but that is a very representational translation. The translation of art, the translation of poetry, however, is the translation of the spirit. A good translator translates what is not said. You can have thousands of words, but a translator should not focus on the words. He or she should focus on how to arrange all of these letters and phrases so that these words will have a meaning, so that these words will have an echo, will have a sound.

I think that memory is a form of translation. What motivates the artistic expression of poets and fiction writers, essayists and painters is memory. But memory is also very complicated because it consists of what one chooses to remember. Similarly a translator has to choose the right words, and that again makes translation an act of choice. You must not be faithful to the dictionary; you must be faithful to the spirit of your own language. I also think there's a similarity between memory and translation, and Nancy Fay, Judith Asher, Alvaro Cardona-Hine, and Celeste Costopoulos, all the people who have worked on *Lluvia en el desierto,* have taught me a great deal. In the past, I wrote a poem and then I didn't care. I went on to the next poem, and whoever translated it, that was their problem. But that's a mistake.

I think that old age and maturity make you slow down and be wise, and translations are like memories because memories are full of layers. And when you construct a translation of a poem, you have to go through layers, and you may have five, six, ten translations before you really feel that this is the poem. So in that sense, the retrieval of the act of remembering, the creation of the artistic work, and the process of translating have some inner connections.

I also think that memory is ambiguous. What you tell me today—maybe you will meet with me ten years from now and not remember your story, or tell me a different story. So I think that the translator also understands the ambiguities of his or her task. Sometimes translators revise their work. For example, they may translate the poetry of Cesar Vallejo or Pablo Neruda, and ten years later they realize that their translation was ambiguous,

that it is no longer valid. Like memory, it goes through a process of constant revision.

The other point that I would like to address is the influence by being a woman in this world. Ruth Behar, an anthropologist, writer, and good friend of mine, wrote a controversial book called *A Translated Woman*. It's about the life of a woman who was not good or kind but a very evil woman who lived on the Mexican frontier. Ruth was interested in recording and translating this woman's life. Ruth's work as an ethnographer has made me think about the role of women artists as translated people and the role of women in general as translated beings. I think that sometimes we are forced to be a certain thing, to write a certain way. For instance, when a woman writes political poetry, the critics say, "this is not what a woman poet should do," and in this way I think that being translated can sometimes be a negative force. It could mean that the writer is forced to be someone else. But if we shift this negative meaning, through the work of a very clever and able and passionate translator, the poet will never be forced to be someone else. A good translator will allow the poet to become the very same poet in the language into which the work is translated.

So a translator does not simply translate; the translator also becomes that voice. You also become the words of Federico García Lorca; you become Czeslaw Milosz; you become Italo Calvino; you become Gabriela Mistral; you become Elena Poniatowska. And how to become someone else—that's perhaps the greatest challenge for a translator because to become someone else is to become compassionate. To become someone else, you have to be in love with someone else. And in that sense I strongly believe that translations are acts of love because after so much laboring you have the name of the poet on the cover of the book, maybe the name of the publisher next to it, even the name of the person who did the cover photograph, but the translator is almost an anonymous figure. If it weren't for that act of love by the translator, great literature would not exist in other languages.

I have given you some things to think about, and, because I am a teacher, I will offer a few points of summary and conclusion. My first point has to do with memory as a form of translation and memory as an art of transformation. The act of translation is an

act of transformation, and in that sense translation also becomes political. There are works of wonderful unknown poets all over the Americas and in the countries of Eastern Europe. For instance, there is an incredible poet who survived the siege of Sarajevo, Ferida Durakovich. Christopher Merrill translated her, and because of his work, we know that she exists. So the idea of choosing perhaps to translate what is unfamiliar, what is dangerous, what is not mainstream, that is also an act of love and an act of courage.

The second point has to do with the idea of empathy for the soul of the original language and the way in which this empathy will be carried on in the new language.

Finally, we all talk about the age of global communication, instant communication, and e-mail, but if you look at these huge bookstores the size of malls, you find very few works of translation. It's again the small bookstores, the independent bookstores, and the independent presses that are trying to make available unknown voices. For instance, we see the works of Pablo Neruda. A great majority of Neruda's work has been translated into English and published by Copper Canyon Press, a small press in Seattle, Washington. That tells us a lot about the economics of translation and the importance of looking beyond the economically powerful publishers and bookstores to those presses and stores, who, like the writers themselves, struggle against obscurity.

Before I go, I will read to you briefly what I wrote for *Poets and Writers* about how I became interested in language and in different languages, from an essay entitled "Always Living in Spanish," published in the spring 1999 issue of *Poets and Writers*:

> Here in the United States where I have lived since I was a young girl, the solitude of exile makes me feel that so little is mine; that not even the sky has the same constellations. The trees and the faunas do not have the same names or sounds, or the rubbish the same smell. How does one recover the familiar? How does one name the unfamiliar? How can one be an-

other or live in a foreign language? These are the dilemmas of one who writes in Spanish and lives in translation. Since my earliest childhood in Chile I lived with the tempos and the melodies of the multiplicity of tongues—German, Yiddish, Russian, Hebrew, Turkish, and many Latin songs because ... everyone was from somewhere else. My relatives loved, sang, and fought in a babel of languages. Spanish was reserved for matters of extreme seriousness—for commercial transactions or for illnesses but everyone's mother tongue was always associated with the memory of spaces inhabited in the past. The shtel, the flowering and vast Viennese avenues, the minarets of Turkey and the Ladino whispers of Toledo. When my paternal grandmother sang old songs in Turkish, her voice and body assumed the passion of one who was there in the city of Istanbul gazing by turns towards the west and the east.

This other paragraph has to do with what happens when you write in Spanish and you find that the sounds of English are not quite the sounds with which you are familiar:

I miss that undulating and sensuous language of mine: those baroque descriptions; the sense of being and feeling that Spanish gives me. It is perhaps for this reason that I have chosen and will always choose to write in Spanish. Nothing else from my childhood world remains. My country seems to be frozen in gestures of silence and oblivion. My relatives have died, and I have grown up not knowing a young generation of cousins, nieces, and nephews. Many of my friends were disappeared, others were tortured, and the most fortunate like me became guardians of memory. For us to write in Spanish is to always be in an active pursuit of memory. I seek to recapture a world lost to me on that sorrowful afternoon when the blue electric sky and the

Andean cordilleras bade me farewell. On that, my last Chilean day, I carried under my arm my innocence recorded in a little blue notebook I kept even then. Gradually that diary filled with memoranda, poems written in free verse, descriptions of dreams and of the treasure of my house surrounded by cherry trees and gardenias.

To write in Spanish is for me a gesture of survival, and because of translation my memory has now become a part of the memory of others. Translators are not traitors, as the proverb says, traductores, traidores—but rather splendid friends in this great human community of language.

Edited version of a speech delivered at St. John's College, Santa Fe, New Mexico, August 28, 1999. First appeared in *Multicultural Review*, 9 (November 2000) : 56-59 in a slightly different version.

Works Cited

Agosin, Marjorie. "Always Living in Spanish." *Poets and Writers* (March/April 1999): 29-31.

In Search of a Nomad:
Gabriela Mistral and Her World

Anomalous, eccentric, prolific, patient, always revising her poems, eternally wandering and, above all, permanently a foreigner, the presence of Gabriela Mistral, almost one hundred years after her birth, continues to awaken passions, rancor, and a deep ambiguity that is oftentimes its most exquisite privilege.

Who is Gabriela Mistral really? Is she the teacher in Elquí, in the remote areas of the Little North of Chile, as the locals refer to it? Or is she the educational reformer who traveled, invited by the government of José Vasconcelos, to reform the Mexican schools? Is Gabriela Mistral just the winner of the Nobel Prize in Literature in 1945 when, after the pain of World War II, the world's vision focused on America, the continent that was less barbaric than the Europe that grants these prizes? As time went by, Gabriela became all of these things: humble teacher, political figure, women's rights activist, delegate for her country to ratify the Human Right's Declaration, and an icon of her people whose face appeared first on national postage stamps during the tumultuous years of the military dictatorship and then on paper currency.

She is a figure that perpetuates unconnected images of benevolence and arrogance, of love to the indigenous people and paternalism. She continues to be Gabriela, the ever-present voice in a Latin America struggling with the same problems that she showed to the world through her poetry, her words, and her political activism.

In these pages I want to trace a poetic-historical itinerary of Gabriela Mistral's life, focusing on her unique works, in order to later introduce you to texts that were not well known: the *recados,*[1] short messages, literary jewels dedicated to praising, announcing or denouncing events and historical characters of her era.

Although Gabriela Mistral's life was characterized by a constant wandering through the American continent, in North America as well as in Central and South America, her anchor and her poetic presence never left her birthplace, the Elquí Valley, an area of impressive beauty and biblical landscape, delicate hills, intense sun, little streams, fig and olive trees. Elquí surprises all travelers due to its beauty the like of which is not to be found anywhere else in Chile. It is also surprising to discover its mystical and biblical character. It is a region surrounded by silence and at the same time filled with the melodious sounds of the rivers and winds that encircle it. Elquí could well be a landscape from Jerusalem or Toledo. Gabriela Mistral was raised in an agricultural area with a strong pastoral presence, filled with mountains and trees. She herself states that she never could abandon such a landscape. At the same time, that landscape became richer and more complex as it encompassed the entire American continent. Notwithstanding her almost obsessive love for Chile, Gabriela wanted to experience other cultures, to be a post-modern woman, to be transcultural, and, above all, hybrid. She was among the first writers to incorporate the Caribbean and Puerto Rican presence in her vision of the Americas.[2]

Gabriela Mistral studied to become a teacher in what was called, at the time, the Normal School, where, almost exclusively, all the teachers in Chile were taught. The teacher was, par excellence, a woman dedicated to fomenting the wellbeing of others, as Gabriela so powerfully exemplifies in her poem "The Rural Teacher":

> The teacher was poor. Her realm is not human.
> (Thus is the sorrowful sowing of Israel)
> She wore tan skirts and wore no jewels on her hands
> and her spirit was a gigantic jewelry box!
>
> Like a swollen glass was her soul
> ready to empty itself on humanity
> and her human life was the dilated breach
> which usually opens up for the father to throw forth
> light. (14-15)

The tone of "La maestra rural" is similar to that of the first collection of poems published by Gabriela Mistral. It has an elegiac and religious tone, but at the same time it questions things, as we can see in the poem "Nocturno místico": "Our Father who art in Heaven/why have you forgotten me?"

The critics of her time and the reviews in the provincial newspapers praised this first book, which, ironically, was published in 1922 in New York City, where she would later die. The book was published under the auspices of the scholar Federico de Onios who was struck by her poetry, so uncluttered by adjectives. It was a poetry capable of forging alliances between the mystical and the telluric through a voice that questioned or doubted, yet also represented the forgotten beings, especially women.

Around 1914, Gabriela Mistral was known not only as the rural teacher but as the winner of the Floral Games and author of the famous "Sonnets of Death,"[5] whose origins were attributed to the suicide of her true love, the young Romerio Urretia. For many years, as Jaime Quezada says, these "Sonnets of Death," along with the poet's shyness, her solitude, and the absence of any children, defined Gabriela, both the person and her work. More than fifty years went by before Gabriela Mistral could achieve a face: that of a passionate woman ready to fight for the American identity.

Desolación is the poetry book that gave Gabriela Mistral a place in the world. Her book was read both in universities and by the general public who became aware of Gabriela as a wanderer and traveler. After she won the Floral Games, she traveled throughout the schools of Chile teaching the alphabet in the most remote areas: the Andes, Traiguen, Punta Arenas, Temuco, and Santiago. These rural Andean towns and others, such as Punta Arenas, the southernmost city in the world, informed a continuous and extensive geography that was key to Gabriela's work, especially her poems, which always included the powerful elements of absence and melancholy. In spite of being in such a remote area, Gabriela Mistral did not cease in her effort to write notes and book reviews for the provincial newspapers, thus uniting her interior poetic world to the exterior world which updated her and gave her a place in the literary world.

It was the same topics, worked with great constancy—the rural teacher, Christ's life, questions about faith, the Chilean landscape, solitary and remote—which she carried within her almost as a brand. In *Paisajes de la Patagonia,* Gabriela writes:

The thick fog eternal, so I will not forget where
I have thrown myself into the sea with its salty waves.
The soil to which I arrived has no spring:
it has a long night in which my mother hides me.
(37 Part I, Desolacion)

That long austral night was the emblem, the metaphor of the internalized territory, the nation, and the feeling of being a stranger within her own history and her own country. It is important to question why, although Gabriela participated constantly in the national history of Chile as a teacher and as a writer in the newspapers, did she, in her conversations with and declarations to the press, consider herself an outsider? That is to say that Gabriela was and was not from Chile. She spent her whole life reconciling her place within the country that gave her speech yet at the same time relegated her to invisibility and very belatedly granted her the honors she deserved. Let us remember that Gabriela won the Nobel Prize before she was awarded Chile's National Literature Prize, a somewhat rare phenomenon.

Many times I wonder, what does Gabriela's poetic voice have that dazzles some and provokes rejection from others? The answer lies in the fact that her voice is an authentic expression, different from all the other poets of her time, especially the group of women who dominated the Latin American literature of the 1920s. By this I mean writers such as Alfonsina Storni, Juana Ibarburu, and Delmira Agustini, women whose literature is intimate, personal and courageous when researching gender issues and altering the Latin American landscape. Gabriela's poetry is tinted by the symbolic cultural space. She introduces Latin American topics as a continuation of the dialogue on what it means to be from the south. She praises the traditions of women's occupations, such as being a teacher, believing that in teaching lies the liberation of women when they are educated. Gabriela under-

stands, very early on, that the secularization of education will be her most essential legacy as well as that which will offer the possibility for women to acquire a public space of power and a woman's political voice.

Gabriela Mistral is capable within a single poem of talking about faith and landscape, about women and history. She understands both the person who prays and the person who breaks into song. Between the word that implies and the spoken word we see the emergence of a unique and vibrant Gabriela whose poetry grounds us in the earth as well as the political gestures that speak of freedom. Gabriela embarks on a journey that oscillates between the personal and intimate and the public and collective, raising the flag of women's plight with faith and vision.

ELQUÍ: POETIC IMAGERY

If Gabriela defines herself as the woman who travels, who has no residence that lasts beyond her consular term, or who often changes addresses, this image of the wanderer merges with the image of the figure who never abandons the childhood landscape. No matter how often Gabriela appears to the critics as the cosmopolitan figure, we must not forget that first and foremost she came from a rural family with few means, a poor agricultural area at a time when power was still measured by the richness of the land.

The Elquí Valley is a peasant region of Mediterranean climate with cattle that wander around on the hills and the Aconcagua River Pass, which leads to the valley and the whole Andean area. The Elquí Valley, like the surrounding regions, suffered from the arrival of the Spaniards as well as the conquest and agrarian reforms to the area. From the end of the eighteenth century to the mid-nineteenth century, it was a fragmented valley, divided by the landlords who split the valley up into various small neglected tracts of landed real estate. Gabriela's family was one of the small land owners of the area, but Gabriela's education was purely rural.

It is important to note how Gabriela was brought up and how this tinges her vision of the world, molded by nature and

the people who surrounded her. In her literature the presence of nature, of valleys, mountains, and rivers, is very obvious. She does not choose for her poetry the vision of the world that has to do with witches and magic or the region's folklore. Her cosmovision is rooted in the oral history, so typical of the Old Testament, that later dominated her life and made her one of the very few Latin American writers who dedicated her poems to the Jewish people and to certain women of the Bible, such as Ruth.

During the time that Gabriela was growing up, the only readings from the Bible that were known were those from the New Testament. The scholars believe that her family must have found phrases and writings that dated back to a Bible of the Old Testament, possibly brought to Chile by Protestant shepherds at the turn of the century. The readings that Gabriela quotes come from the Bible of creation and origin. Her poetry, and her other literary work, as far as one can tell, does not contain the enchanted and mystical creatures that are common to the Elquí region nor does she seem to refer to an *ánima* cult. However, almost twenty years later and in a posthumous text, Gabriela Mistral revealed the secrets of death and the nocturnal journeys of the dead through her very extensive and perplexing *Poema de Chile*, where a dead woman returns to visit her America.

Tala

After various posts as a rural teacher in Chile, Gabriela began her life as a wanderer in Mexico. If Mexico represented for Gabriela the great journeys through the Americas, it also reinforced her feelings of being a foreigner both outside and within her country. Accused of being an "outsider" who was going to resolve the educational reform issues, Gabriela decided abruptly to end her stay in Mexico and published those writings for women that she had been working on for years. These writings, which to a modern-day reader may appear superfluous, gained great importance for many generations because they created a catalogue of voices with the sole purpose of educating women.

Gabriela wrote an apologetic introduction which at times reminds us of a treatise on the weak, as Josefina Ludmer would say in "Las tretas del debel." When referring to the Mexican nun, Sor Juana Inés de la Cruz, Gabriela says that they both wrote letters from a foreigner's perspective and for a foreigner's perspective. Little has been said about the tone of those letters, but I gather that this Mexican experience made her feel forever like an outsider and filled her subsequent work with stories of hiding and masks that would become part of her poetic legacy and her contradictory personality, tinged with some rancor.

The critics of Mistral's work, who until a decade ago were predominantly men who emphasized those aspects of Mistral's work that defined her as the mother/teacher archetype, describe *Tala* as the most serene book she wrote due to the Americanist outline of the poems. I think that all of Mistrals' texts maintained a feeling of Americanism, including the section of *Desolación* where she presents the idea of a Patagonian landscape and the area around Magellan which almost fifty years later gains extraordinary importance. *Tala* proposes a transcultural vision of America and its people. It is a text where the voices of silence become part of the landscape, where the legacy of Americanism joins the legacy of an American vision. The clay pots, the rivers and nature are personified and join voices with Gabriela and the poetry that delineates them.

The hymns dedicated to the "Tropical Sun" or the "Praises for the Island of Puerto Rico" represent one of the peak achievements of her poetic genius, but they are also the beginnings of a lyric that is not epic nor grandiloquent but rather analytical of the materials, the bread, the wheat and the ashes. In *Tala* geography describes an overwhelming nature that is profoundly human and earthly. If in *Desolación* and other poems there is a saintly and religious Gabriela, here we see a wandering Gabriela who dares to look up at the sky, but this time it is not God who assumes the role of the protagonist nor is he the object of her questions. Gabriela Mistral portrays herself; and the images she sees reflected are those of a stranger, a wanderer, and a woman without a face. *Tala* is significant as a book not only because of its

unifying vision of America, but also because it questions issues before God through a courageous and inquisitive voice that does not hide.

One of the most powerful and enlightening articles about *Tala*, written by Adriana Valdés,[3] proposes a new vision of Gabriela and her poetry. She does not deny the importance of the American, but her point is that in *Tala* Gabriela assumes another voice that lives within her: the voice of the foreigner, the old voice—Sibyl's voice. It is evident in the section entitled "Las locas mujeres" that Gabriela outlines a new way of being a woman that goes hand in hand with the occult, the secret and maybe the magical aspect of things. Much has been said about Gabriela the teacher, the educational reformer, and the consul, but very little has been said of Gabriela the Sybil or the Cassandra. Adriana Valdés tells us that, in *Tala*, Mistral offers us the possibility of speaking out as a transgressor. She is not the woman looking for God, but she is the mother, and in her search she is looking for herself.

Tala is a book where women's identity takes on varying proportions. *Tala* is also a book of great transgressions, and this sense of not belonging to the established canons of the world marks a great portion of Gabriela's poetry. For example, in "Nocturno de la Consumación" (115-116) we see the presence of the dead Christ and this image occupies the "place of the mother," thus granting itself the luxury and possibility of speaking out. Here Mistral approaches a crucial territory: that of language, both in its poetic functions as well as its historical function for women never underplaying women's traditional roles.

We see this in the invocation to a dead mother:

> *Mother of mine in a dream*
> *I wander the thistle-filled landscapes:*
> *a black mountain which we must circle*
> *always, to reach the other mountain;*
> *and you are on top of the next one, vaguely*
> *but always there is another rounded mountain*
> *which must be circled to give way*
> *to the mountain of your joy and mine.* ("La fuga," 113)

The subject of this poem is the mother, and it is she, Gabriela, who calls her in the persona of the one who searches. In *Tala* there are other poems filled with polished lyricism and the unencumbered rhythm of words, but even more, they are filled by a sense of desolation that accompanies the rhythm of the lives of so many women alienated from their own histories:

> She speaks with a local accent
> of her barbarian seas
> I don't know with what algae or what sands.
> She prays to God without a load or weight
> aging as if she were dying
> in our orchard which made us strangers.
> ("La Extraanjera," 153)

Gabriela continues to address women's identity in old age:

> You forgot the unforgettable death
> like a landscape, like a job,
> a tongue
> and death also forgot its face
> because it forgets faces with eyebrows.

If there is an obsession for America, there is also a desire to name herself in the intimacy and the faces without a name, the moments in which women assume silence as the power of old age.

LAGAR: WOMEN'S TERRITORY

Gabriela explores a great portion of the themes of her literary work published while alive in *Lagar* and in the posthumously published poem *Poema de Chile,* which is a meditation and exploration of the American continent from an ecological point of view. *Tala* is the germ that liberates Gabriela in order to be able to speak about women, her powers and hidden strengths, like the mystery of creativity. All of Gabriela's approaches to women's spaces are based on a perspective of education or human rights and children's rights. In *Tala,* Gabriela speaks of the privilege of insanity as a possibility for achieving freedom, and she dedicates

a series of poems to insane women where she insinuates that insanity is the power of the marginal and, obviously, of women.

Tala, as Adriana Valdés points out, is a book of encounters and intersections. It is a literary vision that mobilizes from the small, almost claustrophobic, space of the valley, to place Gabriela as a woman with her lyric and her self. Tala is an essential book that marks the path of Latin American lyricism, published at the same time as Vicente Huidobro's "Altazor," a surreal epic poem, and Pablo Neruda's "Residencias" 1 and 2. Tala is different from these other texts in that the spaces created by Huidobro and Neruda are spaces where one discovers the vertiginous experiences of the First and Second World Wars, the tenebrous fall of surrealism, and the ambiguity of identity. Tala is a book that speaks about women's hidden powers, the divine and often lacerated power. In contrast, Lagar has images of priestesses, of the power within the self, of strangers assuming power within a land that belongs to no one and possibly within their own lands.

Up to a certain point, Lagar is an elaboration of the themes found in Tala, but it is a book that inserts itself more solidly in world politics and European history, as we will see in the poems dedicated to war and prisoners. Here, Gabriela is perhaps less hermetic and less of a transgressor, but still she assumes the voice of the clairvoyant poet and the role that she must take to denounce history. Lagar is then the sum of all the worries and preoccupations in her literary work, her profound humanism and compassion, her conscience and peace. It is in this field that Gabriela was of vital importance and we must rescue the importance of her role in the various manifestations in favor of peace, as well as her vital participation in the signing of the Declaration of Human Rights as Chile's delegate.

Lagar, written almost at the end of her life, is dedicated to assuming the voice of the clairvoyant woman who retells the horrors she has seen and at the same time tries to rebuild a more just society. We should remember that, historically, Mistral assumed a very clear position when she spoke out against fascism

in Spain during the time when she was Chile's consul and also during her time in Brazil, of which little is known.

Gabriela wrote *Lagar* during her last consular stay in Brazil and in a time close to her own death and the death of her beloved nephew. It was a time of personal and historical pain, and it is this book that would be the only one of the four she wrote to be originally published in Chile. It would have been possible, for example, to publish a second edition of her earlier works in Chile, but lack of interest indicated an absolute indifference to her work while she was alive. Before her death, Gabriela returned for a very brief period to Chile and traveled throughout the country. She was the foreign poet, the visitor who always felt part of the country of absence.

Lagar, as Jaime Quezada points out in his introduction to *La prosa y poesía de Gabriela Mistral*, an important Venezuelan edition, is the end of a poetic cycle begun with *Desolación*. I would say that *Lagar* is a more universal book. It is a book in which empathy and human suffering are fully shared in a text that shows solidarity and fraternity, as we see in the poem entitled "Guerra" ("The War"). The poet also inserts herself as part of the interior war that she had to live:

> Come brother tonight
> to pray with your sister who has
> neither children, nor mother, nor a present caste. (181)

Lagar assumes Gabriela's and the planet's orphanage and loneliness, but it also evokes the solitude of man when faced with destruction. If *Tala* represents a fertile, beautiful, and daring book, *Lagar* is the conscience of the realm, of the earth surrounded by fog and ashes, of that which disappears and only remains through the power to evoke.

> Traces of what is not
> the fugitive man
> I only have the traces
> and the weight of his body
> and the wind which carries him
> neither signals nor a name
> neither the country nor the town. (183)

Devoid of both a human and a national geography to re-
cover and rename, Gabriela silently, during her residence in the
United States, almost at the end of her life, began Poema de Chile,
a new poetic experience, using the voice of a woman, shrouded
but vibrant, who possesses an ease of naming and telling. She is
a dead woman who travels the vast Chilean and Latin American
territory naming what she sees: fauna, forests, the color of the
sky. It is a book that flies and one flies with it through its pages
and accompanying a ghostly woman often called insane by the
other characters in the poem as a gesture of power and tender-
ness. It is precisely this insanity which allows her to learn about
the geography that she so loved from an ecological point of view
where the earthly is not a political or historical space. All borders
are erased as well as the spaces between life and death.

The insanity described in *Poema de Chile* is a wise insanity
that plays with the image of the dead woman who frees herself
and lives after death. In contrast, the insane women in *Tala* ap-
pear mainly to be disturbed, delirious, and desperate women made
insane by their loneliness. It is also interesting to note, rescue,
and recount the way in which *Poema de Chile* is constructed.
Through this poem, Gabriela continues to ally herself with a sense
of permanence in the arts, the memories and the denial of oblivion.

I feel there are various similarities between *Poema de Chile*
and the poems in *Ternura*. The latter anthology is seldom dis-
cussed by the critics and, considered by many as a minor work, it
attempts to interweave the life experiences and the childhood
games of the children in the Americas, to celebrate the animated
objects and to introduce a woman who narrates stories, a
globetrotter, a woman who represents the face of Gabriela and
also participates in a fabulous and creative childhood. *Poema de
Chile* recovers the astonishment and the enthusiasm we once felt
for nature, for the leaves of certain trees, the names of certain
birds; and more than a praise for Chile's nature, it is an offering of
love to those small and invisible things in a vast and mysterious
geography. *Poema de Chile* is a glance from the perspective of a
dead woman at the paths of life and nature that explores alter-

nate worlds. Gabriela, already letting go of her earthly surroundings, is capable of sharpening the senses and creating again what she had begun in *Lagar* and *Tala*: a transnational and transcultural vision of history and of the American culture. Gabriela also continues to be well ahead of her time, not only in terms of the ecological recovery of certain elements in our living nature but in her descriptive verses. In *Poema de Chile* Gabriela begins to forge a strong relationship with history—not the history of facts and wars but the history that Miguel de Unamuno would call "the intrahistory of history," which is the daily life and has the face and the presence of a woman. Then, in this poem, Gabriela continues with this clear portrait of the peasants' and indigenous children's lives in Atacama. Gabriela is one more voice, a narrator of innumerable deeds and histories and tiny things, which reminds us of Neruda who later wrote about the greatness of the human realm through the presence of tiny and majestic things, like tomatoes, fried conch, books and socks.

Unlike her other books, with the exception of *Ternura* where there is love for all small things and a sensual dedication to the history of animals, *Poema de Chile* and the shrouded poet, devoid of baggage, create a vibrant and profoundly human dialogue with her guide, an indigenous child from Atacama who travels and discovers with her the human and natural geography. These discoveries turn geography into a lyrical history of the spoken word and the people's customs, dating back to many of Gabriela's writings that were only *recados*, brief messages that took on the presence of an oral tradition in her poetry as a new way to create a personal and collective memory. Maybe this is the reason why the mystery found in storytelling, whether by children or adults, is what best describes the years that Gabriela Mistral spent as the narrator of short stories, brief anecdotes, prose poems, and, most particularly, her *recados*.

THE RECADOS

The *recados*, short messages, letters , and literary essays, were part of Gabriela's literary work for more than thirty-five years.

She would obstinately send them to newspapers in the Americas, and especially to the well-known Costa Rican literary magazine *Repertorio Americano*. Dispersed over so many years they were relegated to oblivion. The collection of *recados* about women will allow us to know and analyze Gabriela Mistral, her relationship with her culture, her identity, and the power of her cultural imagery.

It is interesting to ask ourselves, what do these *recados* imply and what part do they occupy within Gabriela's creative repertoire? The *recados* reveal a tenacity and constancy to be a force in the world, to reveal events that surrounded Gabriela Mistral and her history. An analysis of these *recados* will allow us to get closer to the preoccupations of the historical time in which Gabriela lived. Very little has been said about Gabriela's vast library (despite the fact that she moved often, Gabriela had a very large library) and her curiosity for the most varied themes ranging from botany to zoology through pre-Columbian and contemporary history.

Gabriela's *recados* were published in the Costa Rican *Repertorio Americano* and were compiled for the first time by distinguished professor Mario Céspedes and published in 1971 with a brief second edition in 1978 in Chile. It must be noted that the *recados* have not been studied in detail. They are almost unknown and they reveal great clues about Gabriela's personality. For example, they show us her thoughts about what the literary critics had said about her works ("Letter to my Biographer"); her love for Chile, science, and women of science ("Recado to Madame Curie"); and the *recados* we are most concerned with here, those that evoke a great passion for women. Jaime Quezada states that few writers have rendered women's presence and wisdom so important as well as shown such an appreciation for women, both Chilean and foreigners since then:

> Mistral cared very little for the limitations imposed by nationality and race. To define women, Mistral uses a word that is very much her own and which will accompany her throughout history. She calls it *mujerío*.[4] This unique word was always very close to her preoccupations... in the prologue to the book or the public conference,

in her letters or at the table where she shared maize and milk.

The woman of the Mistralian era, whether a teacher, artist, writer, or simply a housewife, would be an enthusiastic and revitalizing motivation for the writer in her daily routine.

Gabriela's presence is part of that effervescent period when women were demanding the right to vote as well as demanding a strong female presence in the assemblies. Gabriela states that "women only gather to rub elbows with the politicians and achieve suffrage or to organize charitable activities." This feminism points to a struggle for social action, educational reforms and peace. It was a struggle in which she participated until the end of her days and she did it not only as an effort to vindicate human rights but to make women's rights part of human rights. In this area, she was a pioneer and a visionary.

The *recados*, by definition, are brief essays, two to three pages long. Sometimes they are written as letters and Gabriela calls them elegies. Each one of them has the presence of the oral element, that is to say, the possibility of being read to an accessible audience, and they belong to that hybrid and complex zone between literary criticism and subjective impressions. What is most fascinating about these *recados* is the fact that they reveal the quality of what is immediate, like a history that tells something that must be shared. The *recados* do not have as their ultimate goal presenting the objective reality of these facts, but, rather, they wish to show us and allow us to feel how that reality had an impact on Gabriela Mistral's life. That is to say, they are brief meditations, glimpses in which the personal is the historical, where the writer's place finds its way into the social configuration of its time.

María Ester Martínez is one of the few writers who has dedicated an essay to Mistral's work as a creator of *recados* linking this experience with that of a literary critic or of the common reader's experience as described by Virginia Woolf. Martínez believes that these *recados* are valuable not only as historical documents but

also as a key part of literary criticism. She states in her unpublished essay:

> The texts in which Gabriela expresses her critical review of various authors and works are called recados. We could add the literary adjective since these texts, aside from fulfilling the goal in spirit that Mistral gave to the *recado*, to be a text whose purpose it is to inform, value and express an opinion, she gives an opinion that allows us to know and value the knowledge and reception that foreign and national literary works had.

Martínez uses the definition of the Spanish Royal Academy of *recado* (a message or response) and shows that Mistral stays within this definition. *Recados* also means a message that reveals a memory, and the last definition given in the dictionary is "to give a gift." With this in mind, we might say that Mistral exerts a novel and important action, that of giving praise, through words, to certain beloved books, such as her *recados* dedicated to Rilke's works and in one filled with love and fervor entitled "San Francisco's motives." Gabriela's *recados* are gifts, gifts of memory and of the experience that is implied in writing from one's memories. This can explain the deep devotion and loyalty with which Gabriela nurtures her personal correspondence in America and Europe. Among her most avid correspondents we have Victoria Ocampo and Alfonso Reyes, who also figure prominently in her *recados*.

There were approximately one hundred and fifty *recados* published between 1919 and 1951, and the ones that we are concerned with here are dedicated to women like Sor Juana who had a strong historical presence. Gabriela's *recados* are visions of shared readings, such as her *recados* dedicated to Teresa de la Parra and the ones written to women she admired, such as Sor Juana, Victoria Kent, and Victoria Ocampo. It is obvious that these *recados* allow us to appreciate, see, and feel the greatest degree of internationalism and transculturation through Gabriela's clear and pristine prose. Her attitude about women's contributions reveals a vision of empathy around the works of women and also a strong

passion for the vindication of those texts written by women. I believe that if it were not for Gabriela or the connections she established with women in America and Spain, there would be no information about the books that they published. She herself, who only published one book in Chile, becomes the vehicle to create alliances and readings for women. That is to say, both the written *recados* and her other texts work to create a women's audience and to awaken an interest in reading. This is one of the most crucial aspects of the *recados*: the incorporation of this voice into her texts in order to give a presence to the literary works of other women.

Mistral's *recados*, as María Ester Martínez points out, are filled with intuition; their prose is filled with sensitivity; and, above all, her writing is authentic, without false adjectives. When Gabriela wrote the *recados*, she broke all the norms, for at that time, one was supposed to write only about classical authors, important men, especially the French. Gabriela writes about the new women's voices that had begun to be heard, as we see in a in a *recado* dedicated to a key literary text, *Ifigenia* by Teresa de la Parra. Mistral is also a step ahead of her critics, who limit themselves to exposing, without revealing, the real "me" that arose from their readings—a laudable aspect of the type of discourse that Gabriela forged. Her discourse narrates her own history and feelings. In the artist's decalogue, Mistral says, "You will give your work like you give a child, decreasing the blood to your heart." The *recados* acquire a new reading, one that feels like a dialogue and is always clear. Mistral elaborates a new way to make literary criticism, similar to the style of analysis used by Virginia Woolf in *The Common Reader.*

During all of those years in which Gabriela Mistral dedicated her time to writing *recados*, she was always clear, personal, and authentic without allowing herself to be influenced by the other critics who wrote at the same time and who judged and criticized her either for personalizing her writings or being too archaic. Mistral continued to evolve, vibrate, and be a part of the world and history, exercising a unifying role for women and their histories. She rejected the critics' comments and cultivated the

recados as an intimate and deep relationship with what is written. Thus she created new disruptions and new ways to exercise her gift, her vocation.

For both admirers and repudiators of Gabriela Mistral, the fact that she was given the Nobel Prize in Literature is still cause for commotion in the literary circles of Latin America and Spain. As Elena Gascón Vera comments in her article about Gabriela Mistral and Spain, regardless of Gabriela's ambivalent feelings toward Spain, one must note that the Nobel Prize that she won was endorsed by the Spanish Language Academy and all Latin American academies. Gabriela was supported and backed by the presence of more than twenty-one counties that supported her candidacy for the Nobel Prize. Ironically, she received this international prize long before her own country recognized her achievements. She never forgave Chile for this, and she continued feeling that it was the country of absence for her.

> *Country of absence,*
> *strange country,*
> *lighter than an angel*
> *and subtle sign*
> *the color of dead algae*
> *the color of fog,*
> *with the eternal age*
> *without a happy age. (Tala, 152)*

Another prophetic line from the same poem is "And in a country without a name I shall die." Gabriela died in New York City and her remains were taken to Santiago de Chile. Her burial, like Neruda's years later, became a historical event at a national level and defined the literary history of the country. The day Gabriela died was declared a national holiday in Chile, and her wake lasted three days. This managed to define her importance in Latin American culture and froze her in time, as Elizabeth Horan suggests.

However, Gabriela continued to be the poet of absence. Chile, when it comes to its writers, has been a male-dominated and exclusive country. To that effect, we have only to note the many out-of-print books by women writers, the fact that few literary

prizes are given to women, and the existence of malicious and prejudiced literary criticism printed in newspapers dedicated to women's works.

Gabriela's image was comfortable or complex, depending on the different governments that claimed her life as their own. The right-wing governments, including that of Pinochet, desperate for a cultural image to show to the world, took Gabriela's image and made it into that of an abnegate teacher and a religious figure. In their paintings depicting Gabriela, she looks like a nun, covered from head to toe. As Horan describes it

> to honor Mistral became a ceremony of false tenderness which apparently recognized but falsely rejected poor children, agonizing mothers, abandoned indigenous peoples, the refugees and field workers. Her death told us clearly why this woman, one of the twentieth century's greatest poets, preferred the anonymity of exile rather than living in a trap, constantly accepting the affronts of the daily bread of her "nation."[5]

During Salvador Allende's regime, the years of the Unidad Popular, Gabriela was vindicated. New, popular editions of her works were published. Her portraits showed her as a more beautiful and sensual woman, with more revealing cleavage, in contrast to Pinochet's government dressing her up as an austere woman with high-necked blouses. Once revived, Gabriela continues to be subversive. Even after her death she refuses to remain silent, refuses to become part of Chile's hagiography, and has become a figure that the critics, especially the feminists, have managed to interpret differently.

Hence, there has always been a symbiosis between the figure of Gabriela and the national culture. Mistral is part of our history. She occupied consular posts throughout the Americas and Europe, but as many have said, she has not been read widely. Gabriela did not belong to an elite group or to the landowners, but she managed to rub elbows with the most aristocratic families, with presidents such as Pedro Aguirre Cerda, and with important senators, such as the Tomic brothers, in order to ascend

to her position of power and maintain it. In this we see her greatest merit: the possibility of being part of power but at the same time remaining committed to her causes, especially those involving women.

One cannot see Gabriela only as a poet, although her poetry is the most essential part of her literary work and her vision of the world. Gabriela is, above all, a wanderer, filled with unbridled curiosity. She says that she would write on her knees, and in that position she wrote texts about Castille in which she imagined Mother Theresa wandering through the fields. She writes *recados* about her, forging alliances between the present time, her view of Spain, and the past, framed by great figures who influenced her work. She writes about materials, about bread, maize, sand, and ashes. For her poems, which are extraordinary hymns of lyrical ability, she chooses the fauna of her beloved Americas or the tropical sun. Thus, Gabriela unites with and gives voice to history and her own memory through poetry, prose, and lyricism. Moreover, Gabriela Mistral exerts with tenacity the passion to tell a story through her tender children's poems where, for instance, she writes a section called "La cuenta-Mundo" and dedicates a poem to air:

> *This which passes by and remains*
> *this is air, this is air,*
> *and without a mouth you see it*
> *it touches and kisses you, loving father.*
> *Oh, we break it without breaking it;*
> *wounded it flies away without complaining. (87)*

She also writes about tables:

> *The table, son, is ready,*
> *in its white, still cream,*
> *and with four blue walls,*
> *the tiles reflect the light.*
> *This is the salt, this is the oil*
> *and at the center is the bread which almost speaks.*
> *(Tenura, 90-91)*

Here we see the elements almost as if we were witnessing miniature versions of them. The air, as described to a child; the table, described almost as if it were part of an interior landscape. This is Mistral's lyricism, one that contains the possibility of stopping before both the small and the great objects. The personal histories and the great history interweave and forge personalities, like the world vision of this one woman, grand, loved, and misunderstood.

THE MILLENNIUM AND GABRIELA

At the end of this millennium it becomes more essential to incorporate Gabriela Mistral into the great postmodern currents of thought, not only as an artist but also as an activist involved in the great transformation processes of this century. She represents the search for an identity—not through the patriarchal power but rather through the minorities, like the indigenous peoples and women, the presence and search for an American without lands, an American continent which could reinvent and define itself. Among countries and cultures where the intellectual level is not homogeneous, Gabriela assumes with clarity and honesty her artistic vision exploring the great questions confronting humanity— justice and the right to peace. Thus, she inserts herself early into the new millennium, renovating the Latin American cultural construct: the oral traditions of indigenous languages which become part of her poetry, the childhood traditions which become part of her work; the vast Latin America territory which is forever part of her work. And she does not forget the position of women but rather makes them ever present in the private and public spheres. In addition, she validates and gives plenitude to that other power that women possess, a power that may be hidden and intuitive and irrational, but a power that is key in the organization of all social conscience.

The preoccupations of this wandering woman placed her at the center of an illuminating and far-reaching vision within the perspective of great projects to vindicate women and children. Her preoccupation with women's and children's rights is not a cliché but rather a progressive and defiant look at the status quo.

One must then look at Gabriela not simply as the mother and educator but as the transgressor who regardless of her humble social class and mixed blood managed to impose herself on a chauvinistic, homogenous, and conservative society. Gabriela Mistral, who was self-taught and learned from foreign books by herself, is above all things a woman who participated in the great movements of the turn of the twentieth century. She fought for women's vote and created, through her role as a teacher, an important pulpit for educational reform.

Let us remember that in Gabriela Mistral's time women's public voices were censured and relegated to a secondary plane, unless those voices fit into the status quo. Gabriela, carefully, managed to play with this status quo and created for herself a significant and ever-vigilant voice. For example, at the beginning of her career, she received the support of great male figures such as Pedro Aguirre Cerda and José Vasconcelos. They were the ones who granted her a voice and gave her a pulpit, always as a teacher. However, from that platform she defiantly created a forum for women. She wrote for them. She prepared an anthology dedicated to them where the domestic is honored but intermingled with the importance of not allowing anyone to silence you. Mistral, from her early days in the Elquí Valley, was a great transgressor. Let us also keep in mind that Gabriela's humble origin and mixed heritage were ever-present in her mind. Using that public forum, from the margins, she was allowed a great number of disturbances and games that won her fame as an anomalous yet enlightened and visionary figure.

One of the most bizarre images of Gabriela Mistral's iconography is that of a dead woman who floats through a landscape, a mythical and religious space. It would seem that the Chilean culture is most comfortable with the image of the dead Gabriela, a woman with divine character. Curiously, while alive Gabriela was working on the image of her own death, but she had done it in a subversive way through the dead woman in *Poema de Chile*, a dead woman who has fun and is happy because, somehow, during her long trip through Chile, she finds her place. She speaks of flowers and animals and intones an international discourse,

without borders. After her death, Gabriela becomes a subversive magician who speaks for the dead and the living.

The *recados* defy all the clichés surrounding Gabriela Mistral, who managed to understand the fact that the search for popular folklore and her roots were just ways to hold a dialogue with one's nation.

I hope that with this introduction I have created a new forum for the reading of Mistral's works. These *recados* and political essays allow us to see an intimate Gabriela and they also permit us to observe a colloquial language, full of life; a language that is freed from her first poetry anthologies and allows us not to peg her in her role as a poor and oppressed teacher. Let these pages illuminate a traveling and sedentary Gabriela, a diplomat and a peasant, a somber and very clear woman—a Gabriela who drank scotch, smoked cigars, and wrote poetry while on her knees. The *recados* are a universal and key aspect of Mistral's literary work. They show us whose books she read, how she viewed her contemporaries, and, above all, how she viewed herself and how her writing was inseparable from her being and her life.

Translated by Monica Bruno Galmozzi

[1] For the *recados* we have used the following editions: *Recados para América. Textos de Gabriela Mistral* (Editorial Espesa, Santiago, Chile 1978). Other *recados* were obtained from the book by Roque Esteban Scarpa, *Gabriela piensa e….* (Editorial Andrés Bello, Santiago, Chile, 1978).

[2] For a detailed biographic analysis of Gabriela Mistral, I suggest Elizabeth Horan, *Gabriela Mistral, An Artist and Her People,* Inter-American Cultural Series, published under the auspices of the Organization of American States. Also, I recommend the book by Jaime Concha, *Gabriela Mistral* (Madrid, Tauro, 1983) and the book by Marielise Gazarian Gautier, *Gabriela Mistral, the Teacher from the Valley of Elquí* (Chicago:Franciscan Herald Press, 1975).

[3] One of the most illuminating essays about Gabriela Mistral is the one by Adriana Valdés in *Composición de lugar: escritos sobre cultura* (Editorial Universo, Santiago, Chile, 1995). The article is called "Gabriela Mistral: identidades tras la fuga. Lectura de *Tala,*" 196-214.

[4] Could be roughly translated to "womanness."

[5] Many of these ideas about Mistral and her relation to Chilean politics and history come from statements made by Elizabeth Horan, especially in "Gabriela Mistral: Language is the Only Homeland" in *A Dream of Light and*

Shadow, University of New Mexico Press, 1995 as well as an article entitled "Santa maestra muerta: Body and Nation in Portraits of Gabriela Mistral," *Taller de Letras* (Universidad Católica de Chile).

Works Cited

Ludmer, Josephina."Las tretas del debel" in La sartén por el mango. Puerto Rico: Ediciones Huracán, 1987.
Mistral, Gabriela. Edición de Jaime Quezada in *Gabriela Mistral, poesía y prosa.* Caracas, Venezuela: Edición de la Biblioteca Ayacucho, 1993. Unless otherwise noted all reference to her poetry are from this collection.

GABRIELA MISTRAL:
WRITING ON MY KNEES

Her presence is always like a fragrance, like the footsteps that we can hear in the sleepless night and, through them, we reconcile the sleep that was lost in the depth of sleep itself. Are the poems I hear hers? Is it her peasant voice filled with the taste of warm soil?

> At night, the vagabond wind sways the wheat.
> Listening to the loving winds, I rock my child.
> (from "Rocking")

This is Gabriela Mistral's voice, to date the only Latin American woman writer to receive the Nobel Prize in Literature. And yet she is still the least read and least translated Latin American poet. However, her voice and her writing occupy a "safe place" in women's literature of Chile as well as in Latin America. How do I speak of her, my Gabriela? I say mine because in those moments of deep sadness, in my darkest hours, she has always been beside me. She remains immutable and loyal.

I like to think about Gabriela Mistral, feel her as if her footsteps and her fragrance that resembles the soil of the Elquí Valley were next to me and my words, because through her I learned what it means to separate the private from the public words. In my life, everything is inextricably linked to her, and I believe that Gabriela is eternal in the lives and inspiration of those women who write. For the women of Latin America, including my generation, the gift of speech has been oftentimes prohibited and censured. The right to speech has been the privilege of the patriarchal culture that referred to women using gender-biased terms such as "poetess" or poet apprentice. The literary critics commented on Gabriela's beauty or ugliness, but they did not com-

ment on her deep and heart-wrenching words. That is why the powerful presence of Gabriela Mistral, a rural teacher who appeared in the Chilean cultural horizon, is a great anomaly within a culture that wanted to deny her access to these public spaces. However, her voice bursts into the private and public arenas with a strong and calm presence. If she achieved it, it would seem possible for all of us to achieve it as well. Those were our topics of conversations in high school. Those were our hushed wishes when the administration would tell us that it was important to be more like Gabriela Mistral. But who was Gabriela Mistral? Was she the wanderer who traveled throughout the world without direction? Was she the ambassador of a country that did not publish any of her books while she was alive and did not grant her the national literature prize until after she had obtained the Nobel Prize? Or was Gabriela a tall and large woman who often dressed herself, as she said, in "drab skirts," who was humble and loved Saint Francis of Assisi?

Gabriela's presence represented the complexity and permanent conflict of women who write and those who dedicate their writing to the vast social and political compromise. That is to say, those women who build a literature of conscience. I say complex because we must not forget that Gabriela's life was dedicated to searching for truth and justice and that she traveled throughout the world speaking out on topics that few wanted to address: the rights of indigenous people and women. This is one of the reasons why Gabriela has great importance in my life and why at night I sleep next to her words, which help me to rest and alleviate the weight of the night. I caress the back of her books, and her verses rock me gently.

I like to approach her books, only four books of poems, published outside of Chile, and thousands upon thousands of texts in prose disseminated throughout the world. In her poetry she bares her soul, and the language combines the oral with the written word, the sung with the prayed. I wonder if this is the reason why every time I go to sleep, I hear her poems as if they were songs. More than music and the cadence of her verse, Gabriela shows me poetry as a possibility for creating a conscience

and establishing bridges between men and women in order to traverse borders. A vision that appeared early on in her work alludes to a Pan-American concept of the continent and of literature, as well as the possibility of creating voices and making those often-invisible characters regain their voices and strength, as we see in her poem "Those Who Do Not Dance":

> *An invalid girl asked,*
> *"How do I dance?"*
> *We told her:*
> *let your heart dance.*

Nature always seems to be alive for this invalid girl who can dance through the possibilities created by affection and poetry. Many times, late at night, I have read the artist's decalogue where Gabriela says, "Beauty will not be your excuse for luxury or vanity, but rather you will create the soul's natural nourishment.... Your beauty will also be called compassion and you will console the human heart."

Gabriela, over a hundred years after your birth, you are present for me in dreams and in your four books, so familiar to many, but still unknown for many others. Your presence is warm and clear. Although I have never seen you in person, I confuse myself when I invoke you and I become the protagonist of my mother's story when in that far-away town of Osorno, in the south of Chile, she handed you a bunch of flowers. That story always occupied an altar in my memory.

Gabriela, you are a traveler and a wanderer like many women who move from room to room thinking that when night falls, they will be in those imagined cities while they sleep. Maybe it's my own exile that has made me reread your poems every day and discover what is behind every word. When I read your work, poetry takes on a divine presence for me. I remove myself from the daily routine, and I turn the everyday, like rocking a child or walking on the sand, into divine acts of language, the sacred presence of poetry.

You won the Nobel Prize in Literature and then you were rewarded by your country, which did not recognize you until

after your death. At that point, the streets were filled with rose petals and the children recited your poems often. You became a comfortable symbol of our nation. Your profile appeared on stamps to commemorate anniversaries such as our independence, and you also appeared on coins and bills. But what we really wanted was to read your words because words that are not read end up in the coffers of oblivion. The poets of Chile read you out loud, they write about you, and when they write about the invisible, you appear.

> We women do not write only like buffoons, who for the critical moment would arm themselves with lace-sleeved jackets and sit so very solemnly at her mahogany desk. I write on my knees, the desk table has never been of any use to me... not in Chile, Paris or Lisbon. I write during the morning or night. The afternoon has never given me an inspiration. I do not understand the reason for its sterility or lack of desire for me, I believe that I have never written a verse in a closed room or in a room facing a drab wall of a house. I always seize a piece of sky that Chile gave to me with its blueness. Europe gives me white scrubbed clouds. My mood improves if I positively direct my old eyes and gaze at a mass of trees.

Regardless of the fact that I also write on my knees and it always seems that the sky is very close to my hands, I think I write next to you, Gabriela, because just like you, I am a wanderer, inhabited by the ghosts of memory. You are one of those ghosts who walks in the world through their poetry: "American lands and my people alive or dead return to me in a melancholic and faithful procession."

Translated by Monica Bruno Galmozzi

First appeared in *The Bitter Oleander: A Magazine of Contemporary International Poetry and Letters*, 6 (June 1999).

GABRIELA MISTRAL'S LIBRARIES
dedicated to Elizabeth Boylan

More than a courageous and intrepid adventurer, Gabriela Mistral was an avid reader for her era. She loved the search for the truth through the books she discovered that became participants in her poetic adventure as well as her political and social thinking. The Bible was without a doubt her first source of readings in the remote town of Vicuña. Years later she would state that her passion for the Bible was the source of her enlightenment. Various Bibles accompanied her, from the Old to the New Testament as well as a copy of a Protestant Bible that her mother owned. Reading and discovering offered Gabriela the possibility to weave the space of dreams.

She said in one of her essays that she did not like desks and that she preferred to write on her knees, looking at the sky. She also read haphazardly on a portable wooden tablet that she would place on her skirts. To read and to create, to imagine and to narrate were the guiding stars in her constant wandering through the landscapes of the Americas and Europe. Maybe books were the guiding lights that showed her the way, little clues in a life full of uncertainty and changing directions.

In her wanderings throughout the world, Gabriela Mistral created libraries. Very little is known about them including when she began to form these libraries. We do know that books for Gabriela were small nations and great universes that transported her to unknown spaces and gave her the possibility of imagining, touching and being awed and filled with happiness. Little is known also of the generous influence that Gabriela shared with her books. That is to say, her labor as a schoolteacher kept her in touch with those students most desirous of contact with books, other voices, and other destinies. One of the most pertinent documents is a

text of Pablo Neruda's memoirs in which he related Gabriela Mistral's generosity in sharing her books with him, especially those dealing with Russian literature of the nineteenth century.

For Gabriela books were friends, voyages, and surprise companions as well as tutors who guided her in her eternal search for wisdom, and they contained the most diverse topics, from Creole cooking to the classification of American flora and fauna to metaphysics. It is said that her range of reading was quite varied and not very homogeneous. In-depth readings of her works show constant thematic and poetic changes as well as a constant attempt to capture in one voice all that the literary experience had given her.

Let's remember how difficult and arduous it was for Gabriela Mistral to be with her beloved books. Her childhood was poor and reading material was scarce. The provincial libraries always had scarce resources as is still the case. However, the books mentioned directly or indirectly in all of her writings were texts she handled constantly and fluidly.

Gabriela Mistral's libraries did not remain intact. Just like her peripatetic history, they suffered damage and loss. Her keeping in touch with her loved ones and the land she missed and her correspondence are also a reflection of the time in which she lived and the books she read.

The first signs of Gabriela Mistral's existence were in the bookish world. The reading circles in Chile that had been newly inaugurated during the 1920s were the equivalent of the reading circles in the United States. Reading was for Gabriela a way of liberating herself. It was the beginning of a being part of and participating in the world. To her, books represented ideas, speech, and a way of not being silenced. In her early correspondence, Gabriela urged people to read and said that reading should be available to everyone, but especially to women of lesser means. Libraries and collecting books were for Gabriela a way of recovering silenced voices, both hers and those of so many other women who dreamed of books. Reading was the equivalent of having a say, of creating alternative possibilities for living and being.

There are only two active libraries belonging to Gabriela Mistral. I refer to active in the sense that these two libraries can be touched, smelled, and maintained. As I mentioned before, almost all of Gabriela Mistral's libraries in her consular posts were lost, left behind. The books that remain are true treasures and can be found at the Gabriela Mistral Museum in Vicuña, near her birthplace. In this library, donated by Gabriela herself, we find the first texts she read, some Bibles, some family photos, and scarce correspondence. This was the most beloved place for the poet. Beyond the library's small building, one can see the hills, the pre-Cordillera, and the sun of Elquí that invades all with its presence. The collection of books is small, no more than one hundred books, but they are a central part of understanding the destiny and the legacy of her readings.

A well-kept secret about Gabriela is the Barnard College Library in New York that was donated by an alumna, Doris Dana, the current executrix of Gabriela's documents. Very few know about this library, probably the most important one in existence. Maybe this is due to the fact that although the years Gabriela spent in New York were her happiest, they were also her most private. Her time in New York was a very prolific one in terms of letters, prose and the book of poetry *Lagar,* as well as *Poema de Chile*. This is a period in which Gabriela lived surrounded by books and new poems, and it is a phase of her life that literary critics are only now beginning to explore.

Gabriela Mistral maintained a close relationship with Barnard College, Columbia University, and the city of New York, where she died. It is not surprising that in this city, surrounded by the voices of immigrants, given all human possibilities as well as cruelties, Gabriela would find her voice as Federico García Lorca had found his years before. Let us remember that it was Columbia University that published Gabriela's *Desolación*, her first book of poems published in the Americas. As for Barnard, Gabriela taught at Barnard in 1930 and Doris Dana graduated from Barnard in 1944. Upon her return from Stockholm, after receiving the Nobel Prize in Literature, Gabriela participated in various con-

ferences at Barnard. All of these imply a strong connection with this university that has done so much for women's education.

According to Doris Dana, before her death Gabriela owned a collection of more than 6,000 books brought from different places she had visited as well as beautiful books that had been given to her by others. Of this collection, Doris chose approximately 1,000 books, which now form the private library of Gabriela Mistral donated to Barnard College that we can see and touch and, sitting next to an enormous window, we can experience her presence, sure and profound.

I felt great passion upon entering the Gabriela Mistral collection, as if I had entered a secret and magnificent room, a jewel in the Isle of Manhattan and the island of Latin American literature. The books are located in shelves protected by noble and heavy glass. What surprised me and awed me the most upon gaining access to this collection was being able to participate in Gabriela's eclectic passion, her extraordinary lucidity that leads us to imagine rapid, reflexive, deep, and curious readings. I would not know where to begin to uncover the essence of this exploration of Mistral's library. I can only say that her books reveal a deep and dynamic preoccupation with the world that surrounded her through a religious and metaphysical exploration as well as an understanding of what it is to be American. The most numerous books are those that deal with being American. They search for the complex identity of this continent, a central theme in Gabriela's writings.

I have caressed many of these books as one might caress the hand of the person who read them, held them, and loved them. To examine a poet's readings and her books also means approaching texts of love, texts that reveal her predilections and the alliances she formed with her books. Some of the books are marked in blue ink, the color preferred by Gabriela. In these markings, Gabriela forges delicately her passions. There are notations that say "theme," foreseeing other possible readings and a source of inspiration for other poems. There are texts where she wrote "Not worth it" indicating that reading these books no longer made sense to her and in some instances she simply wrote "nonsense."

Doris Dana knew how to choose the books that Gabriela loved. For example, she chose books by Dostoievsky, Rilke, Martí, Emerson, Maeterlink, Unamuno, Darío, and Victoria Ocampo. This collection also includes a variety of books for children that not only show Gabriela's passion for children's literature, which she also wrote, but also represent Gabriela's desire to learn English through these books.

It is impossible to describe the experience of being in this private and intimate library that puts us closer to the heart of the beloved books. Gabriela was a wise woman, for she chose each of these books delicately and her books were her companions, her muses, and her elves that possessed the verbal magic she so loved and to which she gave herself. Suddenly, I come across a poem or the beginning of a rhyme saved on the inside cover of a book, as if it were a game to her. Each reader who explores her library, and its more than a thousand books, will find some of her secrets and passions as well as her own history because all books are a reflection of the soul that chooses them.

A journey through this small yet enormous library helps us understand Gabriela's most eclectic passions such as her botanical readings, an extraordinary source of possibilities that she retells in her lengthy *Poema de Chile*.

For Gabriela, books and reading were new findings, interminable paths, possibilities of encounters and faith. She wrote her poems and her letters calmly, and maybe that is how she found her history, through reading. She used to say that reading her beloved books was a form of "marriage of intelligence and senses." Her books were eclectic, but Marcelo Coddou says that "the marrow of her libraries was always the American book," texts such as those by Sarmiento, Martí, Darío, Asturias, and Reyes. Few writers of her era assumed with such force and intelligence her vision of the world, her desire to be part of America and understand it and meditate upon it. Gabriela Mistral's library at Barnard exemplifies her findings. The library, Gabriela affirmed, is like a plant nursery. All of the texts in her library communicate Gabriela's passion for books. The library is for Mistral a tree of life where all come to learn and to season, to love and to grow as

well as to forge the possibility for tolerance. It is a living library, sheltering books that whisper and talk, that portray with clarity a particular way of thinking and a way of being in the world and being a participant in the reading of these books. I felt great emotion being next to Gabriela's books and thinking that her mischievous and tender hands had held them. Literature existed in Gabriela Mistral's palms and wandering feet as well as in her travels throughout the tree of life. She was passion woven with histories, sources of words, and memories.

I invite you to enter and peruse each of the pages marked by her predilections, by her most beloved friendships with Victoria Ocampo and Alfonsina Storni, and her unforgettable blue penmanship that weaves a passionate coexistence with books.

Translated by Monica Bruno Galmozzi

Liliana Lorca

The decade of the 1970s in Latin America contributed to the making of history not only due to the turbulent military dictatorships that besieged it but also due to the contributions of women who began unfolding their own stories and who were their own extraordinary protagonists. From the world-renown testimonial by Brazilian writer Carolina de Jesús and her diary of life in the shantytowns of Sao Paulo (*Child of the Dark*) to Rigoberta Menchú's *I, Rigoberta Menchú,* narrated in the first person and giving us insight into her own life and at the same time the collective history of the indigenous universe, to the intimate and surreal diary written by Frida Kahlo, the women of Latin America have brought forth the possibility of daring to memorialize their own lives and sharing their memories and putting the intimacy of their private selves into the public eye of their nations. At the same time, they enrich the memories of everyone around them. Through diaries, letters, cookbooks, and sketching notebooks, they have shown us the unknown events of their everyday lives in the loud and powerful voices of women telling their own stories.

Mexico has been notable in the production of important women's biographies such as Margo Glantz' *Genealogies.* At the beginning of the 1970s, Margo Glantz appeared in the spotlight of Latin American culture. Her book recovered the history of Jewish immigrants as well as the histories of women of the middle-class who earned a living writing and recreating the memories of their arrival to the New World. *Genealogies* narrates the life of her father, a Russian Jew named Jacobo Glantz, and through him she inserts herself in the life and history of Mexico. Years later, Elena Poniatowska, with her book *La flor de lis*, tells of the travels and voyages of her family, descendants of the Polish aristocracy. She even writes about her own arrival to Mexico when she was eight

years old and did not know any Spanish. Elena has also been generous in recreating the history of others as she does in *Hasta no verte Jesús mío* where she narrates the story of a welder, Jesusa Palancares, and also in her book *Tinnisi Tinnisima*, the novelesque memoirs of Tina Modotti, the Italian-American photographer,

To recreate one's personal and intimate life as the life of other women implies a great act of courage and a willingness to be a part of the historical experience in which the protagonists are women themselves. That is why I celebrate being able to invite you to enter the world of Liliana Lorca, in which both the private and the public selves address the complex and hybrid identity of her nation.

In Chile women's memoirs have not had the same tradition as in Mexico or Argentina. For that reason alone, Liliana Lorca's book, *Honerable Exiles: A Chilean Woman in the Twentieth Century* (U Texas Press, 2000), represents an important and original contribution to the literary and cultural history of Chilean women. Her book also makes us ask why, in a country with such a deep cultural traditions and outstanding literary women such as Maria Luisa Bombal, Amanda Labarca, and Gabriela Mistral, there is such a lack in the production of autobiographical diaries and memoirs in comparison to other Latin American countries. This thought allows us to place Liliana Lorca as one of the Chilean pioneers of this genre and a unique figure. However, we should note important antecedents such as Gabriela Mistral's *Poema de Chile*, which occupies the space of an autobiography written in verse throughout the Chilean territory, with special emphasis on the flora and fauna of the nation, or Violeta Parra's *Autobiografía*, also written in verse, which emphasize the political and social struggles of the Chilean peasantry. Another example, Elena Castedo's novel *Paraíso*, is a valuable autobiographical text that narrates the history of her family's migration from Spain to the south of Chile. Last, but not least, we have Patricia Vergara's *Diario de una mujer irreverente*, a precursory text written by one of Chile's most resounding political women's voices. Nevertheless, Liliana Lorca offers the reader a rich tapestry of women's life at that time,

as well as in the past, because Lorca's voice is both audacious and pure, vulnerable and daring.

Liliana Lorca's book is the personal and intimate history of a unique woman and, at the same time, it is similar to the story of all women: a woman who, throughout her life and in her luminous voice, takes us back to the beginnings of Chile's feudal history through her own genealogy. The Lorcas were originally from Spain and the Bunsters from the British aristocracy. Liliana Lorca's memoirs begin with these two family portraits: her Spanish ancestors who settled in remote islands near Chile and the English ancestors who travelled directly to Valparaiso. From these two branches, the history and life of Liliana Lorca emerges as she traces her existence from North America, specifically San Francisco where her father held important political offices and participated in the creation of the railroad, to the years spent in several countries, but somehow always returning to Chile, the place of her true origins.

From the very beginning, her story is that of a perpetual traveler, born in the United States, who constantly returns to Chile to visit her cousins and experience customs which are alien to her. The space that Lorca inhabits is cosmopolitan and international, but at the same time it is a space always surrounded by native soil, the regions of her ancestors that she gets to know through sporadic voyages and nostalgic reminiscences. Despite her cosmopolitan travels, Liliana Lorca, a daring young woman, grew up surrounded by the customs of a society that forced women to display certain behaviors especially modesy and propriety. Throughout her memoirs, which span London, San Francisco, Ecuador, Germany, and Holland, we travel with Lorca and sense and feel her tribulations, her personal trajectory, as she desperately struggles to occupy an important cultural site in a society that is very cautious in allowing women to have professional lives. Liliana's tenacity and her creative spirit manage to forge the possibility of a public space and a public voice regardless of the constant presence of a hostile and cruel figure: her mother—a dominating, eccentric woman who is not likely to be an accomplice to the sins and virtues of her own daughter.

At no time do these memoirs penetrate deeply into the zones of home life or the roles assigned to women. On the contrary, her point of view becomes more critical, discerning, and modern as she chooses a life of defiance and freedom, uncommon for her times, but also displays the great subtlety and irony of a woman who questions her own era. The historical time in which Liliana Lorca came to prominence coincided with the 1950s and 1960s. According to Kirkwood in *Ser mujer politica en Chile,* women did not appear to be political actors because they had not yet developed a consciousness of their situation that transcended class; women identified only with members of their own class rather than with all women as a gender. Upper-class women, for example, viewed those of the lower class paternalistically, founding "people's closets," which offered charity to working-class women and women in marginal areas rather than uniting with them to work for a common goal. Although the differences between women's groups remained unresolved, they united on the issue of women's suffrage, and in 1949 women achieved the right to vote in national elections. Once this goal was achieved, however, women's organizations seemed to withdraw from the political arena.Rather than developing their own political agendas they identified with men's. They were not autonomous political actors. Nevertheless, women began to vote regularly and to participate in the political parties.

Feminists who have studied Chilean women's political activity claim that their participation in politics increased in the 1950s and 1960s but was well concealed. During the 1950s and 1960s, the power of labor unions began to rise, due to the rise of the middle and lower classes under the liberal capitalist governments. All sectors began to organize much more and this affected the women's groups. For the first time, labor unions were able to speak to workers and women's groups.

The tone of Liliana Lorca's memoirs is familiar and pleasant. At times it seems impossible to stop reading because the reader is carried forth by the luminous presence of this adolescent woman who presents herself as an "outsider" but who, at the same time,

is an exile like any other. She also tells us that her memories are hers alone and no one else's.

A historian could question the specific details of my narrative about the Lorcas and the Bunsters of Chile, but who can refute the truth of oral histories, passed down throughout the centuries with hardly any changes in a country of earthquakes and gigantic waves, without mentioning the political changes and the disappearing official documents? Family histories are the most trustworthy sources of information.

That is the style of these luminous and picaresque memoirs, graced with humor and at the same time, a reflective and very moving tone. It is the family history that Liliana Lorca wishes to remember, entwining the political history of Chile at the turn of the seventeenth century, the time of arrival of the Lorcas, with the sweet descriptions of the first garden that she had in San Francisco, her beloved childhood city: "San Francisco, the city of my first six years, left deep impressions. There we lived on Washington Street which was lined with identical houses with views of the bay and its shimmering blue waters, dotted with sailboats and great steamboats" (20).

Lorca continues with her vivid descriptions of the people that inhabited these houses: "Mother always hired Chinese cooks and maids in San Francisco. I was allowed to sit with them and they talked to me about the food they prepared." (23) Add to these images descriptions of World War I where the personal memoirs turn to history and politics:

> The war continued in Europe and the anti-German propaganda was becoming widespread in the United States. Descriptions of the atrocities committed by the Kaiser's troops were seen in all newspapers and magazines. These stories were read out loud with angry comments articulated by my mother and her friends. After hearing these stories, I looked at the photographs. (22)

Thus, the personal memoirs of Lorca's life mirror the inner memoir of an introspective garden that is always juxtaposed with the story of her nation and world and her own search for her

identity as a woman traveling through the spheres of public life and her public self. We must remember that in spite of its isolated geography, Chile had a powerful historical tradition of women's groups and literary circles that encouraged the education of young women. I am certain that Liliana Lorca was a part of this inspiring movement.

In 1919, the year the Women's Reading Circle was established, feminists also discussed women's position in the National Council of Women, a nationally organized women's group. There, activists such as Inez Echeverría addressed the need for women's and children's education. These two groups gave birth to a feminist initiative that became, in 1922, a major campaign to gain civil and political rights for women, that is, the incorporation of women into society as full citizens and as the framers of their own political, civil, and judicial identity.

Also in 1919, the President was petitioned to enfranchise women and the Chilean Women's Party was established. The Party called for reform of legislation concerning women, suffrage, and civil rights for women; improvement of conditions for women and children; guidance for and protection of children and pregnant women; and women's right to be independent and autonomous in all political and religious groups.

In 1931, women were granted the right to vote in municipal elections, and the years that followed saw the emergence of a number of women's organizations. Two groups were established in 1936: the Movement for the Emancipation of Chilean Women and a group called Feminine Action, which was associated with the Chilean Women's Party. Their goals were conservative, concerned mostly with traditional women's issues such as child care, health care, and maternity laws.

The great beauty and depth of Lorca's voice is at once intimate and diaphanous, especially when she recreates her own childhood. At the same time, she intersperses the great episodes of Chilean history, her political achievements, and the way in which she became part of this civil society where women were becoming active participants.

The narrator in this memorable diary oscillates between intimate and lyrical memoirs and the historical and political memories which make up the history of Chile and its various presidents: Arturo Alessandri, the dictator Carlos Ibáñez, and the brief period with Salvador Allende. From Liliana Lorca's personal point of view, the reader will understand clearly and with humor the decrees of Chilean politics and its cycle of dictators.

Liliana Lorca's voice is that of a fighting woman who, without being pretentious, enters public life and, although she never mentions it, alters the culture of her country and of Latin America with her various offices as editor and translator, such as the time she spent in Santiago working for the prestigious publishing house, Zig Zag, and later *Ercilla,* the magazine that since the 1920s has played an important role in Chilean culture and the way in which Chilean society was perceived abroad. The presence of a typewriter and the possibility of communicating in a variety of languages exemplify Liliana Lorca's ability to cross borders—not just geographically, but also through her enlightened writings and work as an editor and a translator.

Liliana Lorca's life is memorable and passionate. Through her translations for Zig Zag and during the next decade for *Americas* magazine at the OAS, she created a harmonious vision of what the American continents should be. We can also see clearly the visible and invisible views of a woman at the beginning and at the end of one century, her audacious loves, such as the one with the distinguished painter Roberto Matta, and her marriage to Enrique Tagle, which ended tragically. Through all of these episodes and tribulations, we hear the voice of a fascinating and courageous woman who confronts the limitations of her era through her talent, tenacity, and creativity and her gender emerges victorious.

As in all intricate memoirs there is a backdrop of pain that surrounds the story, and in this case it is the complex relationship between mother and daughter. This conflict could be perceived from the point of view of various generations desperately struggling to understand one another. The family conflicts that arose in relation to Lorca's love affairs with Roberto Matta, while

living in Paris, lead her to affirm that during those turbulent romances:

> I owed it to myself to find an environment for
> my own independent growth and the develop-
> ment of my own identity. I felt stifled and vic-
> timized. For months I felt a mutilation, a depri-
> vation, a loss of sense and direction. This con-
> tinued until my friends forced me to face the
> mirror and they set me on the right path. I dis-
> covered that I could once again love with the
> same passion that I had felt in giving myself com-
> pletely and enjoying life. (115)

It is in this spirit of risk and courage that Liliana Lorca appears with the strength of a woman who has decided to live her own life and not that of others. As Jill Ker Conway points out, at the time of Lorca's establishing her independence, there was no literary plot convention, no archetypal pattern in the culture, which told what their lives were about. They could never appropriate the *Odyssey,* for their trials were too severe. The absence of an attendant male version of Penelope was too obvious and the chances of triumphant recognition too remote.

Here, in the fullness of her youth, she takes up the typewriter as her tool and immerses herself in one of the most productive, as well as creative, moments of her life. Her premature widowhood will lead her to the United States where we once again see a woman alone, fighting for her destiny and that of her children, working as director of the Spanish magazine *Americas* and then as translator for the State Department, spending some time in Chattanooga, Tennessee, in an unstable marriage—foreshadowing the beginning of a new life as a mature woman.

From her childhood in San Francisco through her numerous residences in Europe, the most memorable being the ones in Belgium and London, we can share the life of a passionate woman with a powerful feminist consciousness and a desire to create her own life. Each page of her memoirs offers us private visions of her childhood and adolescence in Latin America; yet, at the same time, it is the life of a woman who struggles against the preju-

dices of her time due to her gender and her permanent exile from the country of her ancestors, a country that first welcomed her and later isolated her. Liliana Lorca's memoirs remind us of Rosario Castellanos' early writings and her struggle to vindicate Latin American women as well as those of the middle class who emerged full force in the decade of the 1970s.

Liliana Lorca is a skilled creator of mosaics of intimate lives as well as the more complex mosaics of a nation in social and political turmoil. Each time, she links the history of her life with that of the nation more closely. Chile, the beloved country, rises before us as a country with a long cultural tradition but also as a place where women's intellectual destinies are yet to be forged. In Liliana Lorca's writings, there are few and brief comments about the situation of women in Chile. Except for one episode that shows the struggle for the right to vote in 1949 there are no other comments. Liliana Lorca also does not mention in great detail the dark period of Chile's military dictatorship. We only find one sad mention of the socialist government, and one must otherwise read between the lines, meditate upon what is left unsaid, because in the deliberate silences of Liliana Lorca's memoirs, we can also find our own stories.

Honorable Exiles is a tribute to the strength as well as the fragility of the human spirit, since for Liliana Lorca both the weaknesses and the virtues of human beings are expressed in the same vein, somewhere between the lyrical and the everyday, demonstrating that a life really lived contains both joy and sorrow, fears and visions. Liliana Lorca is candid, loquacious, and simple. She speaks to us from the heart and it is precisely this that moves us: her direct manner in the telling, the lucidity with which she composes the tapestry of her sorrows and triumphs. In the end, Liliana Lorca's life was different from her cousins' lives: she did not spend time embroidering her monogram on her trousseau but, rather, dedicated herself to composing her future and that of the future generations, that of the Lorca women, her two daughters and her granddaughters.

The final sentence of her memoir reveals the spirit of Liliana Lorca: "There are many things I could do. It is just a question of

waiting for the opportunity to step forward and say 'I can do that.'"

I invite the reader to find enjoyment and to meditate on her inner happiness before the pages of this simple, haunting, and complex diary: the story of a woman's life ,similar yet different from all women of her time and beyond her time. Thus, Liliana Lorca joins the *Honorable Exiles* to become a part of a greater tradition of Latin American women who narrate their own lives and the adversities they have had to face. Most of all, she speaks to us about how her personal and private life can coexist with the public life of a nation where women voted for the first time in 1949. The face of Liliana Lorca and her life are the story of a woman who fought for freedom, for the right to love and to be astute at a time and within a society that denied public spaces to women. With shrewdness, love, and gentleness, Liliana Lorca, in *Honorable Exiles*, shows us the way and invites us to join in her travels, letting us know that although throughout history we, women, have only filled the roles of the marginal and the exile, we are no longer marginal and exiled. Now women write their own stories, like Liliana Lorca, and their portrayals of their own selves and destinies are both fragile and victorious.

Translated by Monica Bruno Galmozzi

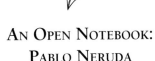

An Open Notebook:
Pablo Neruda

I do not know if the island created itself or if we created histories about the island bit by bit and turned it into something other than a little island of fishermen. Throughout my childhood I grew up knowing a poet lived on the little island, Isla Negra, and that he spent lots of time walking among the wildflowers that surrounded his estate. The poet's legend grew every year. We knew his name was Pablo Neruda, but people often referred to him simply as the "Poet."

I thought working with words was a marvelous job, a never-ending act of watching words grow, of tossing them around and then organizing them. The sole thought of creating metaphors and writing in images fascinated me. Thus my love and passion for poetry were born.

My parents, with great effort, had built a house near the Chilean coast in a small fisherman's village called El Quisco. Our home was small and had a gigantic fence made of native stone around it. On sunny days I used to rest my face against the warm stones. The house had an ocean view and to me it was a pleasure just to be able to hear the ocean and imagine its histories and passions, the old ships coming into the port or going out fishing.

Our whole childhood was spent in that little house surrounded by good spirits and small lizards that often came to our balconies. We used to look forward to the times when my mother promised us a trip out to Isla Negra. The island was only a couple of miles away from Quisco, but the mere idea of walking there filled us with joy. I always felt like we were going on a pilgrimage.

During these trips I learned things that would later be an integral part of my life. I learned about the importance of making an effort, the significance of a long journey to reach your destina-

tion and the feeling of walking toward a specific goal or destination. The second thing I learned was the powerful feeling that arriving somewhere could have. Mother would always tell us we were almost there, soon we would be at the Poet's home and we could hear his words and the voice of the bells that often rang when the wind blew.

Along with the illusion of the arrival, we had the knowledge that we would be filled with joy. Mother had told us to fill our pockets with a little bit of lavender and pebbles and agates from the road. She told us that these few belonging contained the whole universe and would ensure our happiness. I, who had gotten used to losing things as a child every time we packed our bags, understood the wisdom of my mother's words.

For many tourists, the island was one more place in Chile's insane geography where they could go and sit in the sun. For us the island represented our dreams and daring journeys.

Isla Negra still looks like a portrait from last century. It is possible to find a wonderful combination of countryside and coast. The carts roll by on dirt roads and the sea surrounds everything as if it were surveying its realm. Since the 1930s this island has been home to poets, clowns, and theatre groups, and became the vanguard for subversives and dreamers. One piece at a time, Pablo Neruda built his home there.

The Poet's home became for us a place of pilgrimage. During the nefarious years of the dictatorship, the house also became a symbol of a free country that was now enslaved. My mother, who never lost the desire to play, would enjoy going into the Poet's home where she could see old locomotives, bells from some lost churches and hear the sound of the sea, playing games with the guests.

Although the poetry that Neruda wrote in that home during the 1920s and 1930s was solemn and heartbreaking, to me Isla Negra always represented things as they should be: cover, shelter, happiness, and an every-present peace. His home was built with a poet's eye. Many times it seems the house was a product of skilled artisans, soft and hard woods and mysterious pieces of boats that held secret histories.

Poetry, for many members of my generation, was not only an intellectual action but also had a very deep evocative power that helped us live in the symbols, dreams and illusions that were so necessary for the youth of a country. Neruda was instrumental in the daily formation of poetry. He helped us imagine things with peace and passion as well as the carelessness of youth. He taught us to learn to savor and enjoy the taste and mystery of certain magical foods, such as artichokes, made immortal by his odes.

When the military coup of 1973 took place, Neruda died. People say he died of sorrow. They say he would no longer look at the ocean, that he had closed the balcony doors. He began to imagine storms and began the descent to that wintry garden that he had already foretold. It is important for us to realize that the poet's death coincided with the death of our illusions. The violence of the new regime denied the freedom of poetry. For my generation, Neruda's death had a sense of finality with regard to the illusions with which we had grown up and we knew that this new form of censure and violence within our political history would deform us, would make us more vulnerable and fearful of one another. The new regime would make us a silent citizenry, a citizenry threatened by the various monsters or Medusas that we thought surrounded us. I remember the horror we felt during Pinochet's regime knowing that every day someone would disappear or someone would have to leave the country in search of happiness and peace.

Neruda's home was closed and a dark and menacing sign was hung on its door. It read, "House closed. No visitors allowed." A fence went around the locomotive and the bells stopped ringing. We were all living in a fatal silence.

Sometimes when I visited Chile I would spend a few days at the house of a friend, Eduardo Vera. His grandfather was a Spanish sailor who had given some of his lands on Isla Negra for Neruda to build his home. Eduardo's home was across the street from the Poet's and they were true neighbors and friends. For many years I watched as a strange caretaker cut the branches and cared for the lawn next door. He would get angry when children wanted

to look at the bells. We could not touch anything or say anything. I thought that living under a dictatorship meant living in the darkest silence.

History altered all of our destinies. We became a generation of exiles, refugees or simply lost souls searching for a way home. When we finally returned home, Neruda's home had been re-opened. The locomotive had been painted red and the children were swinging from the bells. I had the certainty that poetry ruled once again. I looked at the artichokes and could laugh again. I understood that Neruda had taught me how to caress, how to look at things with a new sense of awe, how to laugh and dream. Poetry had returned to Chile and the doors and the balconies were once again open on Isla Negra. The ocean was everywhere filled with happiness and peace. I smiled because in my pockets I still carried lavender, pebbles, and agates from the road, and, now, I had a notebook as well.

Translated by Monica Bruno Galmozzi

A NECKLACE OF WORDS

Since my early childhood I have been intensely curious about specific internal cataloguing systems that didn't necessarily obey the prevailing system of the times. For instance, I would organize my dolls according to the textures of their dreams or catalogue books by the seasons in which I read them. There were the winter books, which above all else included gothic novels. Among these were books by the Brönte sisters translated into Spanish and novellas by María Luisa Bombal. And in the summer, Pablo Neruda.

I also had a great passion for objects that others might consider useless: the handles of broken cups, rusty thimbles, and the missing stones of jewelry. It was a realm that responded to my own way of comprehending things, a kingdom inhabited by ghosts, spirits, and imaginary conversations with a world of beloved and never-to-be-discarded objects.

I am trying to explain the reasons for my passion for anthologies, for gathering, arranging, cataloguing, and selecting the works of others—and in this process, for receiving the criticism of those who were not included, the criticism of other critics who were not selected, and, more than anything, my own self-criticism for not having remained with the childhood pleasures of arranging a system that obeyed my own personal canon.

I must, however, be true to myself and say that it is precisely this game of assembling and disassembling and of finding lost voices that resembles most closely my earlier desperate searches for the cups with lost broken handles. The process is similar—to a search for the apparently invisible, to investigate the fate of apparently useless things, to weave and unravel stories, but more in the manner of the mischievous Alice in Wonderland, who

opened a magical door to the enchanted world of words and reading. However, as Dana Gioia poignantly observes:

> Poets who compile anthologies should be scrupulously honest in including only poems they genuinely admire. Anthologies are poetry's gateway to the general culture. They should not be used as pork barrels for the creative writing trade. An art expands itself by producing masterpieces, not mediocrity. Anthologies should be compiled to move, delight, and instruct readers, not to flatter the writing teachers who assign books.[2]

I have lost count of the number of anthologies I have published. As numerous as they are, I do not wish to be crowned as "the queen of anthologies" so that others will later depose me. I think that perhaps I would not have felt as motivated to prepare anthologies had I spent all of my life in Chile. My personal history and my circumstances as a writer in exile have contributed to my passion for gathering together the writings of others. Having left my country of origin at a young age, I feel compelled to reflect on my life and assume with even more vigor my usurped identity.

In the 1980s I established a vibrant dialogue with the editors at White Pine Press that has endured to the present day. From this union arose the first of my anthologies, symbolically entitled *Landscapes of a New Land*, a brief collection of short stories that highlighted some of the most outstanding Latin American women writers among these Maria Luisa Bombal, Elena Poniatowska, and Yolanda Bedregal, a prominent Bolivian poet who also wrote in prose. The selections for that anthology have the cadence and texture of prose poems that are delicate in their choice of language. They allude to that which is invisible and that which has the potential to create a sense of wonder between reality and fantasy.

Many years later I realized that this first anthology, with its extraordinary lyrical stories, was the anthology of a poet. The stories all had to do with a Latin American continent submerged in the dichotomies that constantly separated the powerful from

the marginal. The story "Jimena's Fair," by the Maine resident and Peruvian writer Laura Riesco, alludes to this universe of land-lords and workers on a ranch in a Peru still dominated by colonial structures. In Silvina Ocampo's story "The Servant's Slaves," the Argentine writer proposes an alternative reality where the women with real power are the maids.

The collection represents a diverse array of women writers grounded in the basic literary tradition, including pioneers like Ocampo, who together with her husband, Aldolfo Bloy-Casares, and Jorge Luis Borges, developed the Argentine fantastic genre. Joining the older generation are the voices of younger writers like Cristina Peri Rossi and Alicia Steimberg, who are without a doubt the most prominent authors writing today in Uruguay and Argentina.

This first anthology, which was well received by the critics and above all by the prestigious review journal *Choice*, inspired the others. Motivated by these masters of the short story and by a universe inhabited by witches and seers, I decided to travel to the Southern Cone, often known as the zone of fantastic literature. There I started to compile my second anthology, entitled *Secret Warriors*, presenting stories that were longer but, like those of the first anthology, conserve that extraordinary exuberance that comes from elaborating with wonder the unimaginable, that which has the appearance of the everyday but is really the contrivance of magic.

I was fortunate to meet many of the authors, to share their lives and their writing, and to come to understand that there was very little difference between living and writing. Populating the pages of this next volume were stories by Ocampo and by a younger generation of writers: Isabel Allende, Elvira Orphee, Alejandra Pizarnik, Olga Orozco, and Peri Rossi. Among these were several poets who chose prose as their medium for writing about the ineffable.

To date I think that very few anthologies have assembled a similar selection of voices. In gathering the material, I was not in the least motivated by an academic desire to recover the chronology of a specific literature or the specific chronologies of the au-

thors. I tried to recover a space, a time emerging from the literature itself, from the contradictory and so often disturbing region that unfolds in the realm of the fantastic. At the same time, however, I was exploring a geographic region that had generated another terror—the disturbing, dark side of military dictatorships imagined and real.

All of my anthologies have been determined by my own personal selections, by the desire to reveal things that have made an impression on me both within and outside of the text. These anthologies were motivated by a desire to talk about the Latin American woman writer and not by a concern over whether or not they would be well received by the public. I was interested in opening doors to unusual places in the realm of the imagination. Above all, I wanted to reveal the extraordinary power of poetic language in women's prose, a language that resists classification.

These anthologies have accompanied me in my life as a poet. They are not the anthologies of academics but rather a gaze through different, uncertain, and often ambiguous mirrors. Together with these prose anthologies, I prepared two others dealing with different themes—literature by Chilean and Mexican women. Regarding the Chilean volume entitled *What Is Secret?* I once again felt the need to look for women writers in my country and to recover their identities. I chose writers who had never been heard of and whom no one had published throughout the years. Among these are Marta Jara, Maria Flores Yañez, and Marta Brunet, as well as younger writers who have created a large part of their literature in exile, like Ana Pizarro, who lived in Geneva, and Ana Vásquez, in Paris.

What Is Secret?, whose title comes from a story by Maria Luisa Bombal, was a painful project. I had to eliminate certain phantoms from my own childhood as well as the trauma of exile. Above all, I had to try to be fair, not to allow myself to be swept up by a particular political tendency and to choose the best literature from my country. It was most painful for me to include in the anthology the writings of figures who chose to be complicitous in the government of Augusto Pinochet. They know who they are, and that is why I do not wish to name them.

For me Mexico has been the Latin American country par excellence. It is the country of market stands, of powerful herbs, of multicolored flowers. Together with several Mexican women, I wanted to toast this brightly colored country that had given us extraordinary men and women, from Sor Juana Inés de la Cruz to Octavio Paz.

Poetry has been the catalyst of my anthologies. That is why I could not prepare an anthology of poetry until I took a one-year sabbatical from Wellesley College. It was a happy period submerged among the unpublished verses of young women and of older long-forgotten ones. The title of the collection says it all— *These Are Not Sweet Girls*. The poetry contained in its pages is exuberant and brilliant. It has also maintained for me a strong sense of enchantment.

Creating anthologies requires a tremendous amount of continuous effort. It is impossible for me to count the number of years that I have spent on each of them, the number of phone calls that I have made, and the endless headaches in searching for the copyright holder of each item I have chosen to include. However, when all is said and done, it has been worth the effort and trouble. I have chosen to dedicate myself only to women writers, which is also a personal choice. This literature written by women conforms to my way of seeing, to my way of touching, and to my experience as a reader. I empathize with their vision of the world. I also feel an almost ancestral connection to them that dates back to my origins, to the first stories that I heard as a child from the voices of other women-grandmothers, mothers, and maids.

I think that creating anthologies written by women is a way to recover their voices, not to abandon them to oblivion, and to offer also a brief consolation to the many who have said and continue to tell me, "I didn't have time to write," "I didn't have time to tell my story." These anthologies present stories that assume a collective imaginary, a sharing among readers, authors, and translators—a country of women who are sisters.

If all this seems idealistic or cliché, that is fine because I cannot be any other way; it would be to deny my history and my

destiny. I grew up in a family of survivors of pogroms and holocausts. A miracle of history saved us and gave me the desire to make sure that the voices of others would not be buried in silence. This is why I also decided to compile *House of Memory,* where the voices of Jewish women of Latin America unite to create new lives in the other America as well.

If I cannot resist the creative impulse to string together poems and prose, to assemble them, to join them, I also cannot resist the impulse to generate a means for inserting women into a canon that belongs to the national culture, a canon that does not deny them but that incorporates them into the literary mainstream of their own countries and histories. To fulfill this purpose, two central texts emerged. The first is a collection of articles dedicated to several Latin American women writers with different artistic visions. *A Dream of Light and Shadow* combines works that reflect on the intersection of history with the individual creative and personal experiences of the writers. Complementing this volume is *A Woman's Gaze,* a collection of essays about women painters and photographers. Thus, literary expression joins with expression in the plastic arts.

Anthologies also have the capacity to tire the anthologizer, but the magical and passionate flame that burns with the desire to disclose the secret collections of our own mind does not disappear. The anthology that has brought me the most happiness has been *Map of Hope.*

After many years of hard work, I wanted to make an offering to this century. I already had experience uniting and threading together communities of women, and now I wanted to unite the planet—an ambitious project that was looked on with suspicion by certain colleagues because it was such a massive undertaking. Nevertheless, because of my passion for the written word and toward communities of women who write, I began to collect the writings of 77 women from various parts of the globe whose themes focused on human rights and literature.

I was certain that the women writers I wished to include in *Map of Hope* would collaborate with me and support me by yielding their copyrights and agreeing to cede all royalties to Amnesty

International. I was correct in my assumption, and I did receive the support of many, among them Nadine Gordimer, Adrienne Rich, and Nawal El Sadawi, women who have written against fascism, racism, domestic violence, and forced exile.

Joining these living writers in the anthology is the voice of a very young author who has accompanied me throughout the years. She is Anne Frank, the girl who wanted to be a writer but couldn't. Like her, there are thousands of women who cannot write because of political, economic, and personal circumstances. It is in the spirit of giving a voice, of generating spaces and articulating the presence of women in literature that I have pursued the practice of compiling anthologies and assembling them according to themes, passions, and words selected with love. The creation of an anthology is an act of love that has the power to eliminate our abysmal solitude and make us part of a larger human family. Perhaps this has been my purpose—to anthologize, to create a community of women who write and who see themselves reflected in common texts, and to create a community of women who read and also see themselves reflected in common texts, populated by a passionate geography, a necklace of words.

Translated by Celeste Kostopulos-Cooperman

First appeared in: *Multicultural Review*. 9 (June 2000) 22-25.

Works Cited

Agosin, Marjorie. *A Dream of Light and Shadow*. University of New Mexico Press, 1996.

——. *House of Memory*. The Feminist Press, 1999.

——. *Landscapes of a New Land*. White Pine Press, 1992.

——. *Map of Hope*. Rutgers University Press/Penguin, 1999.

——. *A Necklace of Words*. White Pine Press, 1997.

——. *Secret Warriors*. White Pine Press, 1992.

——. *These Are Not Sweet Girls*. White Pine Press, 1994.

——. *What Is Secret?* White Pine Press, 1995.

——. *A Woman's Gaze: Portraits of Latin American Women Artists*. White Pine Press, 1997.

Gioia, Dana. *Atlantic Monthly*. May 1991.

The Cartographies
of Love: Families

To Imagine a Ship

To imagine a ship
rigorously dark
silent, in pain
like borrowed steps
of unhappy fugitives.

To imagine the ship
secret watchman,
leaving port,
behind, the fate of the dead,
decomposed Europe.

......

In this ship,
that will cross the nameless sea,
the landscapes of horrific memory,
are the Jews
barefoot, naked
their only belonging
the possiblility of life
of living life.

They travel, audacious,
mute
Carrying candelabra of seven arms
and the memory of happiness.

To imagine the ship,
Hiding pale and sleepwalking women,
Dressed in garments of death
Dreaming of amber.

.....

To imagine the ship
and a shroud of stars

a sky full of echos and names
still to be named.

To imagine a ship
Someone says:
Land, and it is land,
Light,
a soft touch in the wind
a game of chance
tongue of a god
now present.

Santo Domingo,
Hispaniola,
Columbus and Juan de Torres.
Jews of old.
Jews of Sefarad,
Jews dreaming of the sea,
and their seafaring raiment
rescue,
like an open palm
the land
opens
to receive,
palpitates.
They, men and women,
all of them
quietly sink their feet in the sand
and the pleasure is morning and night
and the pleasure is pure wish.

To imagine the ship
on this Shabbat of glorious arrivals
the wind murmurs syllables of our ancestores,
grandmothers return with challah from behind
barbed wird.

Translated by Laura Nakazawa

The Angel of Memory: Helena Broder

On nights of the Southern Hemisphere, your body was open like a smiling balcony that rocked to the rhythm of the wind, numbing the luminosity of days. It was a wind striking, clear as if messengers of angels. Thus you lived, perched on balconies, waving your hands in the light, waiting for news from the war, the Red Cross, the fate of those dead and alive. Maybe you loved the trees and their abundant fronds. You were a queen while you gazed at the amber grass at our corner house; that house on Simón Bolívar 4898, where you lived with your son, Joseph, my grandfather, and grandmother Josefina, whose true name was Hanna.

I played with your hair just as did the birds and the leaves. It seemed that everyone loved your hair of light ashes, your locks like darkened porcelain. I loved to gather up your hair like a delicate crown, to cover you with small necklaces and your beloved garnet bracelet. It was then, when you saw yourself as a lady of Vienna, when I ventured to ask about your city. How was your city Omamá Helena? Where did you stroll on sunny, festive days? Which were your favorite parks? Did you dream with its crystal fountains, your feet like water and moss among the roses of Vienna?

You hardly talked about the city you secretly loved and of which you invoked fragrances and imperial avenues. Often you said that it was a noble city, that occasionally you visited its parks where you imagined that a Kaiser, vulnerable and humble, also traveled, equally dumbfounded, in front of the majestic constellation of palaces or the perfect symmetry of colorful roses. It was that perfection, that obsession with order and silence that led a nation of Austrians to participate in the Nazi murders.

In Chile, you never spoke of the war years. The world was divided into before and after; however, from those years I have

kept the most austere and elegant of silences. Your memory is not fragile. You do not forget when the decrees, the detentions, the summons to go to the forced labor camps arrived, when you found your son on his knees sweeping the streets of Vienna, while the passersby mocked him, and called him *Swine Jew.*

It was that night in 1939 when you decided to leave Vienna. Before the trip you went to visit Isidoro Halpern, your beloved husband, deceased in 1932. My mother used to tell me that you carried a small mahogany stool to the cemetery. His grave was under a wide, generous tree that swayed at your sight. There you sat for minutes, hours, nights and days that blended into each other, there you whispered to Isidoro Halpern all the secrets of love. That dark Vienna evening, when, speechless, the sun decided to leave, you said good-bye to Isidoro and to the guardian tree.

On a cargo ship that left Hamburg at dawn, you sailed from Europe, slashed with rains and ashes, arriving in South America, where the Pacific Ocean was a rose-colored band with sinuous waves, like the body of a woman in love. When you set your eyes in the new land, the first thing you saw were the hills of Valparaíso. You arrived at dusk, when lights are small fireflies and savage flowers are bent to greet you into the twilight of unexplored dreams.

Few belongings were in your wicker trunk: a down coverlet and your white vessel for Passover. My mother remembers with certitude the date of your arrival in Chile, in 1939. You arrived with your translucent tulle bonnet flowing in the wind, a delicate neckline insinuating the softness of your neck, still fresh, with delicate breasts, your silver candelabra and the garnet bracelet inherited from the fate of all our migrations, now resting peacefully in my hands.

I know more about you from the stories my mother used to tell when she was by your side. As the years pass, memory does not become diluted; on the contrary, it becomes stronger, and this is how my mother recalls so many things about you, of your velvet bedspreads and garnet growns. It suddenly seems that you come into the rooms, with your quiet steps, your face of a lady

from another era, and you teach us to dance. The possibility and risks of memory bring me closer to your history, to what my mother remembers of you and chooses to tell me. My memory fills with small braids, golden papers, cut out napkins over empty tables where addresses were jotted down and you imagined that very soon life would be a glorious encounter.

I dedicate to you my words and my voices because poetry is God's breath over syllables, because poetry is the most certain gift of our survival.

I have written this book for you, grandmother Helena, *The Angel of Memory,* because you are an angel who lives in the deepest and clearest regions of fear and faith; because your spirit prevails sweet and strong, in love with the miracle of life, and it is present in each one of these pages. To know you better I decided to go to Vienna with my mother and traverse with her streets and arteries, corners crumbled by the memorable and nonexistent oblivion. I do not know if I found you everywhere, but I did find myself through your history.

Years have revealed that history is a miraculous chance and that the premonitions of the living and the dead continue with their movement, both visible and silent. You did not find anything about your family but you lived with the hope that they were still alive, that it was still possible to return to Prague or Vienna and find them. During those years in an American landscape you refused to speak Spanish. You said it was the language of the local people, but the maids saw you smile and curse in Spanish, though the instances when you cursed or raised your voice were rare, as you used to say that silence is golden. Why did you remain silent for so many years, grandmother? Why didn't you speak of your sisters in Vienna, dressed in iron with reddish braids, who populated your dreams? Why have you never talked of those sisters from Prague who, one day, while strolling on the bridge of King Charles, were taken as the day grew dark and bewildered?

All your silences are the reason for my hope, my search, for these words that today I offer to you and to others, to my children and their children because, above all, you loved alliances,

families, the peace of generations. When I was eight years old you left this life even though your spirit and your scent of lilacs still remains with me just like your photograph, which appears in the most unlikely places when I am convinced I have lost it. My mother says that on the morning when they went to give you your breakfast you entered a very deep sleep, your face full of light, and you left this earth.

Of all the days of my happy childhood, I remember that day, sealed in a great silence. They closed the shutters of the balcony, birds left, they covered all the mirrors, and your dresser was still with your hair among the brushes which seemed to become thinner and lighter. Your son, the aristocrat who in other times had washed the sidewalks of Vienna with a broom, came and took your mink coat but, luckily, left the garnet bracelet that today I wear on my wrist. Years went by, and like you, we became part of other migrations, history decided our fate. We arrived in North America and, like you, we learned to love another land, we learned another language even though at night we dreamt of the Andes and the vast avenues of Santiago de Chile. Now I understand how you must have longed for Vienna, and the ochre buildings, the perfect manners on Shabbats when you strolled with your prayer book by the parks full of roses and nobody called you dirty Jew.

Your memory was entwined with mine like a lock of childhood hair that is kept in the pages of a cherished book. It was there, waiting and hoping to bloom. It was then that I decided to call you and to invoke your spirit to travel through your city. Perhaps in this year 2000 culminates a century, inexplicable and luminous in its destruction and austere faith.

I wanted to return to you, to take possession of this city that is now yours and mine, this city to which I return, which expelled you without remorse. We arrived in Vienna a dark and rainy October evening. The wind seemed to narrow the yellow buildings that you once told me occupied countless blocks. I observed the city with the distance of your gaze, knowing that everything familiar would be one day torn down like a deck of cards without peace or equilibrium. I was surprised by the eerie

silence around the city as if traffic moved at a ghostly pace. I was surprised by the order and elegance somewhat vain of women and men dressed in black suits. I could not help but shiver in your city, in the city of my great-grandmother where she loved so many and took a ship to Chile in search of life.

I am in your city but I don't see you. It is as if you too had disappeared with all the other Jews. It is an uncertain history. I come here to be with Helena Broder and I make sure that nothing in this city belongs to her, that there is no possibility of return for the living or the dead.

It was difficult to sleep that night. My mother tossed and turned for endless hours in that small bed with giant feather pillows. The softness of the feathers did not help her to sleep. I looked at her and felt grateful that she was by my side, just as when I was a small child and was afraid. Now we were both afraid of the inexplicable difficulties of the century, however conscious of being part of a miracle or a gift.

At night I perspired, sleep eluded me. I was only able to sleep in the very early hours of the morning, in a heavy drowsiness, with a voice that was telling me: "I am Stefania. Why have you forgotten me? Go to the cemetery and I will be there." Stefania's voice came through words. That is, words wrote the dream in the form of a musical score that repeated the message with cadences and sure rhythms. That morning I asked my mother: "Who is Stefania?" Pale, she replied that not long ago a far away relative had written to her that the great-grandfather that we were going to visit, Isidoro Halpern, had a pianist sister named Stefania, who had died in Poland years before the war. I then realized that Omamá Helena was present and had sent us a sign, a message. I was anxious to listen to that message and fill myself with those words, I started to feel as if I was living in her time, as if I went back in time and saw Vienna through her eyes.

The next day, the sun was gloriously resplendent. Autumn welcomed us with all its fragrance of moss at the beginning of a redeeming dryness. The earth had a sweet smell and my mother said it was your fragrance, the city smelled of Grandmother Helena, a scent of lilacs and violets and fresh leaves asleep in the

grass. Mother and I went towards the cemetery. The Jewish section was through the third door. I had a feeling of happiness because I was going to visit my great-grandfather and leave him gardenias and laurels, but, above all, I was certain that I would find someone from our family that would talk to us from the grave. My great-grandfather was more alive than ever and I felt the movement of his skin under the earth, inviting us. Suddenly I understood completely that those Jews dead in Europe before the war are the most profound connection to that nefarious past. Mother and I entered the cemetery where two kind elderly men welcomed us. We gave them your name and, efficiently, a computer found you: Isidoro Halpern, dead in 1932. You were in the thirteenth row, tomb 39. Mother said: "How do you feel about visiting your great-grandfather?" I had no words. The emotion overcame me. Speech was progressively difficult. A Turkish taxi-driver, surely sent by the gods, left us alone while he also searched for row thirteen. Isidoro Halpern and all the other Jews that died more than seventy years ago were in the rear section of the cemetery, the oldest and remotest part. There, it was possible to feel the quiet presence of rest and peace.

Mother and I held hands. It was a mute gesture, an alliance beyond mother and daughter, an alliance between migrations and destinies, an alliance that takes into account life and survival as a gift. But you, great-grandfather Isidoro, were not there. We rested our hands on other tombs with other names. The ivy had covered the abandoned tombs. The names of those resting there were in shadows and oblivion. Nobody visited them, only some remote relatives had left stones before their own bodies were charred in the forests of Austria, Germany, and Bohemia. I felt that all the Jews of Europe were resting on the threadbare meadows, where nobody watched over them, where nobody left stones to protect the warmth of their dreams.

Little by little we were losing hope of finding you. We did not want to leave the house of memory or the doors of faith, the solitude or delight of being in front of your house. We walked. The earth was fresh and humid, our feet sank into the leaves populated by distant steps. An intense ray of sun fell suddenly

on my mother's hair and face. She deflected her gaze and in this gesture of shifting the head I saw you, Isidoro Halpern. I saw the inscriptions with your name in Hebrew and German and we knew that the angel of life had fulfilled our request.

My dear Omamá, this story is not part of a poet's imagination. I believe it was a messenger of God who illuminated mother's face and she turned toward your name. How important it was for us to rescue your name and say: Here lies Isidoro Halpern, a good and noble man, dead before the war. Mother and I embraced and we saw the tree. We joined our hands and laughed, completely happy and joyful. It was your tree, the one that protected your visits, sheltered you from sun, fog, and rain. It was in front of that same tree that we prayed in silence, giving thanks for this gift of sun and light and the breath of God.

Dear Omamá Helena, wherever you are, we have gone to Vienna to bring you this story of God's light over mamá's face and the name Isidoro Halpern. We returned to Vienna at the end of this millennium to find ourselves and to find you. From the bitter and sweet earth we understand the destiny of our migrations. We understand your arrival at the port of Valparaíso, your silences, your secrets. But here, Omamá Helena, we are safe because we have not rejected the past, because your memory and ours, my mother's and mine, are only a ribbon in a bouquet of lilacs.

We returned to the city with the absolute certainty of having lived an incredible miracle. We did not try to interpret it or think about it, only in going to your house to visit you. We wanted to know where you had lived and what you did in the mornings after buying bread and flowers. In which parks did you rest your feet, where did you buy flowers and Shabbat's candles? Your house was still intact. It was there that you lived with Isidoro and your two small sons, Joseph and Mauricio. Your apartment was number six, facing an interior courtyard and a large tree. From here, dear grandmother, you left a rainy afternoon in 1939, all covered in sadness, on a train for Hamburg. I wanted to retain in my mind that door, those thresholds that, like guardian angels, protected your arrivals and your departures.

Part of the magic is the desire to open the box of surprises, like someone open to change and sounds, to the pleasure of clothes on the skin. Even though you and I coexist in these two worlds, those questions that you silently asked weigh upon me. Where is Stefania, the one who left Poland with piano melodies in her hands? Today I dreamt of her. I have dreamt of her every night since our arrival in Vienna, until the light came to lead me to that inscription in the tomb of my yearnings.

Now I do not ask myself why I have come to Vienna. I am absolutely sure that it is to honor the dead, all the dead, gypsies, Jehovah's Witnesses, Jews, my aunts whom I never met, the memory of my great-grandmother that returns so often and kisses my forehead while praying in German—the language of fear, the language of home.

Helena Broder, angel of memory; Frida Agosín, teller of stories; thank you for being with me, Marjorie, daughter and grandaughter in this tree of life, in Vienna, this city of spirits. Through you I understood that returns are possible, as it is possible to recreate memories in front of a park or a fountain with murky waters that, by the simple act of naming them, become clear.

Translated by Laura Nakazawa

Estefania

In order to speak of her, it is necessary to explore the cavities of dreams, the deep sites of evening forests. To speak of her it is necessary to go back to the genealogy of a people in exile among the shadows. To speak we must think about sleep as the absence of the lost body.

My mother and I traveled to Vienna in mid-October. Autumn welcomed us and the wide avenues of that Vienna did not seem to have been touched by the specters of war. However, once we arrived there, to the city of my great-grandparents, I felt the presence of Jewish ghosts filling the avenues, emanating from that Jewish plaza where my grandfather and uncle had been forced to clean the pristine avenues with soap. History may exist before the eyes of those who discover their own memory within history.

The memory of the Jews in Vienna is the memory of the ghosts and those who remember them. Maybe that is why my mother and I returned to Vienna in search of grandfather Isidoro Halpern's grave, in search of Helena Broder's fragrance, she who loved wild berries and lavender, she who in stupor left home in search for life.

My first night in Vienna with my mother, after an arduous journey, I had trouble sleeping. The bed was sharp and small as if it were a small frozen coffin. The enormous down comforter slid from my body. The night was austere, silent and dangerously long. Suddenly, I was able to descend into the chambers of a dark dream. I remember it vividly. In the dream, the moon looked like an ancient lady lighting the way for the dead. I could see small red threads sliding from her mouth. It was a moon that struggled between the plenitude of life and the opacity of dead things.

In that dream, I was descending through a forest very close to the roots. I moved as if sunk in a fugitive land. I could only feel

that I was descending deeper and deeper. My hair was covered in roots and dead and dry leaves. It was a dream where all recognizable signs were lost, where there was neither space nor caution. It was a dream that smelled of stale time and, as I walked, I felt like a bird without a nest in the shadows.

Suddenly, in the midst of all this confusion, the acid taste in the mouth, the lips, and the skin, filled with cracks, I felt suspended and distanced from all possible concepts of time and place until I heard a voice. It was a voice without any recognizable sounds. It was a voice that made its way through the leaves. That was the first thing I heard, the sound of the leaves, as if someone were preparing them for a bonfire or maybe they were already in a bonfire, a deep and fertile fire, devoid of human life.

A clearing began to open up in the forest. The voice spoke to me directly. It came from a music book. It was a piano score that I recognized as Schubert's. The voice said, "I am Estefania. You have forgotten me. I am Estefania. Tomorrow, go to the Jewish cemetery of Vienna, door number three, there you will find my brother, Isidoro Halpern, your mother's grandfather and your great-grandfather. Why have you forgotten me?" The voice and the music disappeared with the same speed as they had appeared in my dream.

Mother said I had a hard time waking up the next day. It was past nine in the morning when I woke up, and I generally get up at the crack of dawn. My hair was a mess, as if it had been in the presence of the haughtiest of bonfires. My mouth was dry and smelled of dry leaves left behind by the summer as it makes its journey into the land of the dead.

My cousin Rose Halpern, great niece to Estefania, says that Estefania survived two bonfires. After the devastation of the first one, she began teaching French and giving piano lessons. She liked to play Schubert's *Impromptu*. She was educated at home with tutors. After 1939, when Helena Broder, Isidoro Halpern's wife, traveled by boat to Chile, to the coasts of Valparaíso, we know nothing more of Estefania's life. Rumors say she moved to Budapest and then was deported to Auschwitz in 1943. We believe she died in Auschwitz in 1943. Like all genealogies of my

people, this one is also truncated and contains blanks where the dead were forced to dig their own graves.

At Rose's home in Skokie, Illinois, she shows me a photograph of Estefania and she is exactly as I imagined her after my dream. Estefania had long, thick hair like the sun and the shadows. Her eyes were violet. I recognized her immediately. Her gaze and her presence were not foreign to me. I could feel her voice had come to say, "I am Estefania. Do not forget me."

Now, at night, I light a candle for Estefania, a candle that represents six million other candles. When I light it, I think of the lives that were lost. Remembrance and memory are part of our dead and the ghosts that I share with you, readers of this history that is impossible to create or conjure.

Translated by Monica Bruno Galmozzi

Sonia from Odessa

My great-grandmother Sofia, who came to be known as Sonia in Chile, and then decided to embrace her heritage exemplified by the duality of her two names, loved, more than anything else, to sing loudly and in Russian. The years of pilgrimages, forced exiles and numerous pogroms did not halt her passion for the language that was attached to her like an umbilical cord uniting her to a motherland intolerant of the Jewish presence. Sofia arrived at the remote and rundown harbor of Valparaíso around the year 1903 with scant possessions: a small suitcase of worn leather, valerian drops to calm her spirits and a balalaika that she would take out every now and then to give voice to her love or sadness, which according to her were almost the same thing. My other great-grandmother on my mother's side, who escaped the Nazis in 1939, didn't know how to sing but she recited Goethe out loud and said German was the most gracious language for poetry.

My mother, heiress to the secrets and traditions of Sofia from Odessa and Helena from Vienna, learned both languages. Spanish, however, was her most valued treasure, which bound her to the country in which she had been born, despite the several languages that she had acquired as a child.

Languages imposed on us in new lands reflected how much we had lost in our former countries through centuries of persecutions. As a child this plenitude of idioms from countries that would later become part of yet other countries confused and irritated me. I stared in astonishment at my great-grandmother Sofia singing in Russian, my other great-grandmother Helena reciting in German from the balcony, and my grandmother Raquel swearing at the whole world in Yiddish. All of these women of my lineage had come from other places but were united by a passion and common desire to always cling to the languages of their birth through which they could recover their own usurped identities.

The Babel of languages that was heard in my house helped me reflect on the meaning of language and diaspora. I saw how easily languages traveled from one country to another, opening new frontiers and closing others. But I also understood that the language of childhood was the most beautiful and intimate site of memory and affection.

The songs that great-grandmother Sofia sang before I fell asleep and the poems that Helena Broder recited to me in the early morning hours made me love words as well as the confusion of languages that prevailed in the house. Even the house-servants who spoke Mapuche learned to curse in Yiddish and we laughed out loud.

It soon became apparent to me that Spanish would be part of my memory and history as a young Jewish girl living in Chile. Identifying myself with the language of the country that received my great-grandparents, when other countries shut them out, became for me a sign of belonging. At that time I devoured grammar books and read everything that had to do with the history of the Spanish language. I also read about the Sephardic world. I must confess that I would have much preferred to be Sephardic rather than Ashkenazic, to be called Perez or Rodriguez instead of Agosín. The reason for this is both simple and complicated. Being Sephardic in Latin America stirs up less confusion and queries. No one asks about your genealogy if your last name is Perez. However, the names Agosín or Halpern stir up curious questions that constantly evoke the condition of being foreign. The truth is I didn't wish to be a foreigner in my country as were the generations of women surrounding me. The Ashkenazic presence was always enveloped by the spirits of uninvited ghosts and by the feeling of being separate from others. The Sephardim on the other hand already possessed a vast tradition in the Spanish language that accompanied them for more than five centuries.

Being Sephardic was like being part of a community whose language had united it through several centuries of exile. But since I cannot change my heritage nor travel the same paths of my family, I continue to be an Ashkenazic woman who dreams about being Sephardic and possibly from the shores of Salonika, Sarajevo, or distant Aleppo.

During my school years, I passionately read Judeo-Spanish poetry, which, without a doubt, had an enormous impact on my own vocation as a poet. It is inspiring to think that during the Middle Ages these beautiful verses flourished and reached extraordinary proportions. If Hebrew was and continues to be the language that brings us closer to prayer, Spanish has been the language of poetry, of blossoming verses rambling through the gardens and the plazas. I still remember the trip to Seville and to Cordoba where I felt nourished and amazed by the greatness of the poets who, despite the fact that they wrote in Spanish, were faithful to the traditions of biblical poetry: among these illustrious individuals who continue to inspire through their verse are Samuel Ibn Nagrella ha Nagid from the caliphat of Cordoba, Ibn Gabriol from Granada, Ibn Ezra also from Granada, and Yehuda Halevi, born in Toledo.

This glorious tree of voices, was my compass, my lighthouse, during my childhood. It not only showed me that Spanish was part of my Jewish heritage, but it also helped me to no longer feel so alone and foreign in the confusion of languages that were spoken at home

With the passage of time and the unfolding of my own story and migrations, I managed to prove that this strong desire to cling to the Spanish language would become my most essential strength. In the seventies, my family and I repeated the gesture of solitude and exile that previous generations of our family had made to Chile in the first half of the century. We immigrated to the United States, to the other America that had not received our relatives

When we came to the States, I felt linked to the lives of my great-grandmothers who could not separate themselves from their songs, their recipes, and the memories of lands left behind. Who was I now in this new language imposed on me by the avatars of history? How would I survive the madness of exile? From the new solitude that was encircling me like a wall, I somehow intuited that the Spanish language would cure me from the hollow pain of exile.

I used to console myself by believing that if my ancestors had succeeded in preserving their language, faith and songs for more than five centuries, I also could do the same in Spanish. I would be a Jewish author writing in Spanish and living in America.

In those moments I remember the figure of the great traveler Benjamin de Tudela who in the seventh century transported fabric, thoughts, and illuminated manuscripts through Asia and what is now called the Middle East and left us his extraordinary *Itinerary of Rabbi Benjamin*. Having him and the poets of medieval Spain to guide me in my new life, I not only learned English but also continued being and writing in Spanish, which linked me more to my Jewish heritage.

I have come to the conclusion that just as Spanish has been a way for me to discover Judaism as part of a much larger Hispanic tradition in Latin America, there are also other writers like me who continue writing about Jewish themes in Spanish, recreating the worlds of the Mediterranean basin as well as those of the shtetls. The Spanish language is a fundamental part of the writings and identities of Jews in Latin America, from the novels and stories of Ana Maria Shua and Alicia Steimberg to those of Isaac Goldemberg and Isaac Chocron; there is also the narrative of Clarice Lispector who wrote in Portuguese but was from the Ukraine. Being a Jewish writer in Latin America is also a way of connecting with the early experiences of Spanish Jews before the expulsion of 1492 and a way to continue the bond and carry the flourishing language of Sephardic heritage to diverse areas of the globe.

Many times at night in the Northern Hemisphere I remember my evenings in the south: the indigenous music that could be heard in the yards, the Hebrew prayers, the curses in Yiddish, the Ladino songs and the confluence of languages that seemed like a river flowing and rippling through the landscape. But then in the middle of my daydream and in the confusion of languages that seem to me to form a part of the sefirot, the divine emanations that were so important during the Judeo-Spanish Kabalistic period—the Spanish language appears like a victorious queen presiding over all the other queens and she says to me, "welcome, you have arrived home."

Translated by Celeste Kostopulos-Cooperman

First appeared in *I Carry My Roots With Me: Touchpoints of the Latin American Jewish Diaspora*. Washington, D.C.: 1999 29-31.

A Frail Suitcase

She was always ready to travel with her tiny and fragile suitcases, which had survived so many journeys. Her suitcases were threadbare, worn by the vague time of uncertain travels. That was my grandmother, Sonia, who in the middle of any conversation, except for serious ones dealing with evil eye or lower abdomen pains, would interrupt, half-innocent and half-irate, and ask, "Is that good or bad news for the Jews?" And when they would tell her that the news could be good or bad, she would fill her suitcases. She had packed her shoe collection many times, always hoping for better luck and for my grandfather Marcos to pick her up on the sidewalk outside their home. When he returned from his business trips (he was a tailor), he would say to her, "Sonia, don't worry, the news is not bad for the Jews yet." And they would return, hand in hand, to their home.

This is a tradition of the Jewish people, those uncertain travelers, ready to journey at a moment's notice to leave the past and the memories of many seasons behind and go in search of a new life. The stories of Moses' descendants are very similar among themselves, and through their lives we have learned to recognize the motives for fleeing and the dates of these journeys. Certain families, especially ones like mine, are proud of the fact that they are special, that they possess a history which is extraordinarily important to them and to the communities they founded.

I do remember and memory can often be dangerous, capricious, and manipulating of the facts, especially when we deal with stories that were overheard and disseminated orally. I will tell you some things that characterize my family as different and so give us a certain air of mystery and marked sophistication. For example, there is the history of the Drullinsky family that traveled from Poland. This family's reputation is uncertain, but some were street vendors and some had shady dealings. There is doubt

about their real last name, and our tongues get confused over the Drullinskys and the Deresunskys. And yet, I tell you their story to continue with the tales of uncertain travelers. Of all possible belongings to take on a long journey across the Pacific Ocean, the Drullinskys brought a chest of drawers that was so big that they had to call to customs inspectors and three moving men so that the chest of drawers, originally from the town of Jolem, could make it to the coasts of Valparaíso. The stories say that the family's children traveled in one of the drawers.

When on various occasions and family dinners they retell the story of Aunt Adela Drullinsky's or Deresunsky's chest of drawers, my grandmother, Josefina, says, "But I have the best of all stories to tell of how we reached this remote and quiet country." She then becomes very serious, and when she feels really at ease she takes out her dentures as well so she can speak more freely. Then the tale begins: "When my father, Marcos Agosín, wanted to find better luck and fortune, he decided to travel to Chile. We knew very little about that country, lost in the winds and surrounded by water. We thought the best way to arrive would be to cross the Andes on mules. And that is how, I, Josefina Agosín, with my mother, Sonia, and father, Marcos, arrived on the Pacific coast, not by sea, but by land with two guides who, for a small fee, helped us with the crossing. There isn't much that I remember about that journey other than the intense loneliness I felt at night and the stories my mother told in Yiddish and in her very poor Spanish. This is the story of how the Agosín family reached Chile, not on a luxury liner, but atop simple mules. That is why some of our family members are embarrassed and try to erase this story and tell people that we arrived aboard luxury liners and dressed in the latest fashions." Only my grandmother dares tell the truth as she tells about that trip on a mule which brought them to freedom.

I do want to comment, however, on two of the most beautiful stories about my grandfather, Joseph Halpern's, transatlantic crossing and later that of his mother, Helena Broder, my great-grandmother and the angel of all my memories. Theirs is a story

that has to do with passion and not poverty, so other family members should neither feel embarrassed by it nor doubt its origins.

My grandfather Joseph Halpern was a truly good-looking gentleman. He had green eyes, his gaze was deep and penetrating, and when I looked in his eyes I felt as if I had gotten lost in the most sumptuous of forests. In Vienna he frequented the coffeehouses, and women of dubious reputation would sing love songs to him until the wee hours of the morning. He fell in love with one of these women who sang like a nightingale and who attracted him like a lamp erupting with love. This kind of love between a rich Jewish man and a cabaret singer/danger was very dangerous. One day, drunk and delirious with love, Joseph Halpern, around 1920, decided to placate his love fever and travel from Hamburg to the farthest corner of the world—which just happened to be Valparaíso, the same port that saw the arrival of the pirate Francis Drake and the same port that watched as the love between Maria Graham, captain Graham's widow, and Lord Cochrane blossomed. This is where my grandfather arrived with many other strange and eccentric travelers, but the best part of the trip was that the journey was motivated by passion alone. When he got off the boat, it was nightime and he saw the mountains around Valparaíso illuminated. The lights seemed interwoven, and he remembered Pauline's voice, that faraway nightingale, and realized that this was now his life and his future. He found a job in a factory that produced some wonderful cookies, Huke, and then he grew friendly with the town's most well established tailor, Marcos Agosín. It was thus that he met my grandmother, Josefina, who had arrived on a mule to Valparaíso but was now a refined lady of Valparaíso's aristocracy. Now she traveled in an elegant carriage, and her family was among the first to possess an automobile when they arrived in that region.

Voyages were definitely part of our sign, and they also were part of the Tarot card readings that served to appease the deep sorrows and temper the horrors. I tell you this in order to relive the most memorable voyage of them all, the one destined be filled with miracles and life. This is a journey that saved thousands. I

had not been born yet to tell you all the details, but I have heard this story told at all family functions and now I share it with you:

My great-grandmother Helena had remained in Vienna when Joseph went off to Valparaíso. My mother remembers that she used to send beautiful postcards from the Pratter written in her elegant German penmanship. She always started her notes with "Meine Liebe." Since most could not read German, and some could barely read, the postcards were saved in a box and were set aside in a drawer where the ritual tools were kept, a candelabra and the Torah that my grandfather had brought with him. The story that led Helena Broder to travel across the Atlantic began in 1939. Suddenly she heard squeals and explosions. At night the garden was razed, all the windows were broken, and there were pyres of books everywhere. My great-grandmother was returning home from a party. She had on a floor-length, sequined evening gown and a brooch shaped like a dragon. She also wore earrings and rings with garnets, which had been a gift from her cousins in Prague. When she arrived at her house she found her son, Mauricio, prostrate and bleeding after having been beaten by the Nazi police.

That night, Helena Broder decided not to pack any of her belongings or say her farewells. She knew that she no longer existed for her neighbors and that she had become a disappeared woman. She knew she would never return to her home and smell the fragrance of her lilies. She took care of Mauricio's wounds and traveled all night by train to the port. She then took a boat that would take her to South America to be with her other son, Joseph. Unlike Lot's wife, she did not look back on the fights of a Europe condemned to oblivion, a Europe that only survives in memories, that one day she would decide to talk about. She knew that in the New World she would lead a life filled with the illusions that consume those who have been given the chance to live again. In Hamburg a good-natured German man gave Mauricio a camera as a gift. It was this very expensive and unique camera that Mauricio would sell in America and make a small fortune.

According to various versions, Helena Broder arrived on the Pacific Coast of Chile in September of 1939. My mother is the

one who often tells me this story sometimes to calm us down when we cannot sleep or when we are happy and celebrating. She will retell the story on 4th of July picnics or Yom Kippur when we went to the sea to throw rocks into the Pacific Ocean, not as a means of atoning our sins but as a way to count our blessings and name those who have gone before us.

When Helena Broder arrived in Chile, she had not seen her son Joseph for over ten years, and his life had not been very easy in the South of Chile, a town called Osorno. Even in this new country he was a constant traveler because he was a salesman. He worked very hard to obtain the money necessary for a Chilean visa at a time when the government was very strict about allowing admission to dangerous immigrants.

My mother and her brother traveled all night from the south of Chile to the central region to receive the foreigners, the relatives whom they had only met in portraits and well-traveled postcards. That night, my mother fell asleep to the sound of the train enshrouded in fog. Upon waking she found herself in Valparaíso. Stories tell that most of our relatives who had moved to Chile were already in that area as well as many of the Jewish families who would someday become related to ours. Joseph Halpern was anxious to see the arrival of this ship, and he decided to hire a tugboat to get closer to the ship and be able to hug his mother.

My mother, with a knot in her throat, is the one who tells me and retells me this story and I, in turn, tell this story to my own daughter. I imagine the story through my mother's eyes and then I see it reflected in my own little daughter's eyes as she stares at me in amazement while I tell her our family's story. "The sea," says my mother, "looked like it was made of light and dark foam." It has become a turbulent and distant memory. The sea would roar and then apparently calm down again. The port was filled with cheering and anxious faces all trying to or believing they could distinguish the profile of a loved one aboard the ship. My grandfather said that he was shaking, cursing and screaming in a very thickly accented Spanish. The ship was getting closer to the coast and yet it seemed to remain poised in the distance. Suddenly, the ocean became very still and clear and Frau Helena

appeared wearing white gloves and a tulle hat that moved with the wind's every whim. It was so beautiful to see her there, like this, golden and moving, playing with the enchantments of light and shadow. My grandfather approached her. He blinked once before shaking all over and gaiving her the most tender kiss. Helena looked at my mother and recognized the granddaughter she had never met. She kissed her forehead and said that she would learn to name the new stars here, in the new continent. The two of them, arm in arm, walked to the ocean and the safety of Valparaíso's coasts that had so lovingly welcomed my grandfather a decade ago and would one day welcome me with my parents when I was three months old and arrived in Chile for the first time, having been born in Baltimore, Maryland. Regardless of all the voyages, arrivals, and departures, Helena Broder's arrival in Chile still remains the most remarkable and permanent mark in our memory.

When I think about my own journeys or my arrival in North America, I stop and think about Helena Broder and the uncertainty of her trip and the fate of her home and her belongings, so hastily left behind in Vienna. Whatever the fate of these belongings, my great-grandmother survived and so did we. The plan was to eradicate us from the world and from history. And yet, Santiago de Chile welcomed Frau Helena who prayed in German and, during the days of the dead covered her mirrors while invoking the histories of our people and our lineage. I take with me, on all my journeys, the candelabra from Vienna and the key to the front door of our home in Chile. It is a privilege to be able to look at them and hear the voice of other lives we no longer live but which are palpable with every step we take and every story we tell. They have little to do with trips we choose to take but rather with ones we are forced to make, like all exiles.

When people ask me if I like to travel, I smile and ask them, "Is that good or bad for the Jewish people?" and I always keep a suitcase ready.

Translated by Monica Bruno Galmozzi

First appeared in *Shofar* 19 (Spring 2001) : 1-5.

Josefina

Her voice still retains the freshness and delight of her life. She is over 93 years old and I listen to her strong, proud and decisive words. She is my grandmother and I could spend my whole life listening to her, moving my head when she talks about the names of certain exotic trees that only grow in her memory. Sometimes, when she talks about how alarming it is to have a socialist government, I say to her, "Don't talk about these things grandmother." She, my grandmother, crossed the Andes on a mule and she took one of the first transatlantic voyages between Buenos Aires and Europe. I think that hers is the history of the permanence of things. Her existence is like a fixed country, anchored in her own memory, in the fissures. She is the most clear example of tenacity in my life, of belonging to a place, and her mere existence demands veracity. Sometimes, the country slips through my fingers and I clearly remember certain fragrances, especially in the wintertime, when the body is a sovereign in repose.

She is there, like a tree of life, the one we used to read about in Hebrew School, that golden and luminously open tree, like my grandfather's face on autumn days. The tree of life also reassured me of the permanence of times gone by. It gave me comfort to know that the plenitude of this tree's foliage and its seasons were part of my history. When the girls at the English School would look at their religious stamp collections, I looked at my tree of life, which represented my origin and my joy.

My grandmother, Chepita, whose real name was Josefina, never changed with the events leading to her crossing the Andes. She was not like the rest of the family who felt nostalgia for another time or imagined homelands left behind. Grandmother had arrived from Buenos Aires when she was very young, crossing the Andes with her relatives. Everything about her and everything said about her evokes permanence and the possibility that

she was not a foreigner. When she wanted to pretend a link to the aristocracy, she used to say she was *porteña* (from Buenos Aires). In reality, her arrival to Buenos Aires, the Atlantic crossing, and the arrival to the New World from the pogroms were choices and not mandated by necessity. Truth be told, grandmother was Chilean. She was more Chilean than *porotos*.[1]

More than any other family member, grandmother accepted being Chilean and the eternal dilemmas that my family would come up with throughout at least four generations with regard to identity, the destiny of the Jews, anti-Semitism and Holy days. Many years went by during which I wondered if grandmother had chosen to live outside of Judaism by choice or in order to find a more suitable way to survive in a Christian world, as my mother used to say. I finally concluded that my grandmother had not arrived to this state by choice or through meditation. She simply took life by the edges with that powerful intuition that dominated her life and made her both tender and perpetually enigmatic.

Grandmother did not say she was a racist, but she did look down on the Asians, especially Koreans who arrived in cargo ships to Chile without any belongings. She did this without stopping to think that she, herself, had arrived to this welcoming land under those same conditions. She also disliked the indigenous Mapuches who were predominant in the urban areas searching for a better life. To this day, however, my grandmother has lived side by side with my nanny, a Mapuche woman who loves her above all and whom she loves as much. I write about my grandmother because to me it is like writing about humanity: a life full of contradictions, marvels, and lost illusions. I will tell you a little about my ancestors, armed with the knowledge that memory is ambiguous and doubtful, but some vestiges of memory have remained in me through the voices of others.

My grandmother's father was Marcos Agosín. He arrived in Chile from Argentina and was a tailor, the only job Jews were allowed in czarist Russia. Little by little, due to his good presentation, he conquered and managed to occupy a prestigious place in society. He was not just a poor tailor anymore. He became honorary consul to Valparaíso with the few Jews that had arrived

to the coasts of Valparaíso and founded the first Jewish community in the central area. His house was always open to refugees and wanderers who arrived in this part of the world that was unknown but filled with beauty and mystery. At that time, my grandmother lived in opulence. She attended the opera, where she sat next to Caruso, dated Salvador Allende, although she always disliked socialists with a passion, and in the midst of all her social engagements, she met and married my grandfather, the "crazy German," as he was known. He was an elegant and passionate man, a man whose eyes seemed to find all the lost cities and all the faces of the sea.

I do not know how they got married since they were like oil and vinegar. Grandfather was a dream builder, eternally in love with the most surprising landscapes and the sweetest words. Grandmother was a pragmatist, not a romantic at all, and constantly worried about accounts and her green notebook where she noted how much grandfather owed her (and he always owed her something). Grandfather also had a green notebook, but his was filled with his dreams.

Since the wheel of fortune is very fickle, just like memory, grandfather Marcos lost his fortune playing cards and also lost his consular post. On a very dark and slow night, he abandoned his home at the Polanco Palace, the one that faced the sleepy hills of Valparaíso and the fragile boats that bobbed like mummies in the waters of the Chilean coast. Then, my family decided to follow a path through unknown and rocky lands. I am referring to Bolivia, the region where the days are hard and golden. Grandmother followed her own mother to La Paz. Little does she say about this period in her life, and it is the first time she seems sleepy and silent, as if she wanted to protect herself from these stories—as if not talking about them would avoid the most despondent sadness. The happy and strong grandmother I know thought that memories brought bad luck and bad omens.

Bolivia was a mysterious period for this family of tailors. Grandmother said that the dust enveloped them like a strange heaviness, a disturbance of the mind and of memories. My grandmother buried a two-year-old daughter named Eva in the tablelands of Cochabamba. My mother was only a little girl of three at

that time. Very little remains of that history and very little is said, as if all had been relegated to the most intense oblivion. When I began to write about my mother's life, the episode about her sister Eva came to life amidst sobs born from the deepest darkness. This little girl who had died of an untreated ear infection was buried alone in the tablelands. They took her in a white cart. They were very poor then, so they wrapped her in newspaper. When I pray for the dead, for the disappeared along the Chilean territory, I light a candle for dear little Eva so she does not have to spend the nights alone in the tablelands.

From Bolivia, grandmother, grandfather, and my mother continued their journey. They went to the south of Chile this time, looking for better opportunities. Since my grandfather spoke German, he decided to try his luck in Osorno, a small town in southern Chile where Germans and Nazism were the official norm. Much remains to be discovered about the dark history of southern Chile and its ties to German Nazism. My green-eyed grandfather, worried about saving Jews and making his family prosperous again, journeyed through various towns as a traveling salesman. Grandmother had a small store where she sold everything from bread to medications. During the freezing nights in the south of Chile, my grandmother knit socks, scarves, and coats to sell. She also speaks very little about this time in her life. I think that it is through my mother's story that these empty spots in my grandmother's life become more visible. Bolivia and Osorno were parentheses in a life of extraordinary struggles for social, economic, and moral survival.

In Osorno, grandmother took care of going to the dilapidated hospitals and looking for beds for the World War II refugees that came to her home. My grandfather gave them violet sprigs, and grandmother gave them scarves that she never really managed to sell.

I think that grandmother did not want to articulate the pain. She refused to name it and that task became part of her family life, safeguarding the memories and feeling them, turning them into words, making them real. My grandmother went mute when faced with the atrocities of life and she decided only to talk about events that brought her happiness. From her own lips I never

heard the stories about Bolivia. All she said is that the wind of the desert made her cry out loud.

What I do remember about my grandmother are the happy moments. She had a sixth sense for being centered in happiness. For example, when we lived in Santiago, she would tell the whole neighborhood that it was my birthday and she used to walk through the neighborhood with a gigantic cake lit up like the birth of a new day.

Grandmother skipped a few chapters about her life though: for instance, the return from Osorno to Valparaíso in 1943 and the move to Santiago, where they prospered and were happy. They lived in a large home on a corner lot with marvelous palm trees that turned into great winged queens who hugged me, kissed me and covered me with the Southern winds.

Grandmother reached the pinnacle of happiness in this house. There were all the neighborhood friends who would stop by and chat for hours. There was Master Julio who would come trim the rosebushes and sing love songs. Above all, I was there, her granddaughter who idolized her. Grandmother was happy out loud. God's silence and darkness terrified my grandmother. She said that the habit of pretending deafness was not a habit but a way to derive great pleasure from speaking loudly. She spoiled me very much. She would buy me my favorite ice cream. She let me go alone to the corner and once to the center town in three different buses to buy two newborn chicks that were later devoured by a cat who lived nearby. My grandmother wanted to make me happy. I do not know if she cared about others as much as she cared about my happiness. With grandfather she was happy in her own way: the rituals, the green accounting notebook, the trips abroad, and the suitcases they would bring back filled with precious objects, dolls, velvet dresses, books, and golden stamps.

How could I not love her and be with her? Grandmother was not too affectionate, but when she saw me she looked like a weeping willow. She would cover me with kisses and questions. Many years went by during which we lived next door to each other. I grew up and did not ask many questions. Grandmother did not talk about the old times, and that is why she was so different from my other relatives. In order to forge her present, grand-

mother decided not to talk about the past but to live the present of each of the seasons. She was and continues to be an avid radio listener and reader of royal families' histories. Here her fantasy takes full flight and she talks about princes as if they were her own subjects.

When we left for North America, grandmother did not once chastise my mother for following her husband. I did not understand why our parents were taking us away from our idyllic lives. During the more than twenty years I have lived without my grandmother, we wrote many letters to each other. It was then that I discovered that my grandmother's true calling was to be a writer. She wrote very detailed letters about life in the neighborhood, the history of the maids and neighbors and their new lovers. However, my grandmother could never dedicate that much time to the past. She could not remember the pogroms, and she told people about the trip over the Andes as if it were an anecdote.

Many years went by and we grew old. My grandfather died and my grandmother left the house in Santiago to return to her initial nest, her brother's house in Viña del Mar. The number of letters back and forth diminished. Her eyesight became more fragile, but we always received news from Chile that I still keep like precious trophies.

I have spent the past few years composing the fragile family tree and researching the destiny and journeys of my great-grandparents, the cousin lost in Sweden and my grandfather's Viennese love affairs. Grandmother is still the present, the permanence, today. She does not wonder like the rest of us if being Jewish has left a mark on her. Grandmother wants to be Chilean and that is why, when I feel the most fragile, like a lost soul without roots, I invoke my grandmother. I see her walking down the streets in Santiago or going to the ports, wandering on the rocky coastal roads of Valparaíso and Viña del Mar. She is always in Chile. She is not a traveler by choice and her permanence ensures the continuity of mine. She always awaits us on the balcony. She takes me by the shoulders and tells the whole world that this is her North American granddaughter.

Translated by Monica Bruno Galmozzi

[1] *Porotos* are string beans. In Chile the word is also used colloquially to refer to "little runts."

Frida, Friduca, Mami

Before you appear, a delicate fragrance infiltrates the corridors of the house where dark and secret things dwell. Mami. You are always there with your scents that change with the rhythm of the seasons. In the spring, orange blossoms rub against your childlike bare knees. You tell us stories. "Girls," you whisper, "we are disobedient sultanas dancing through the palaces of Cordoba and Granada."

Your games ranged over the centuries, through the secret thresholds of so many spoken and unspoken stories. In the summer you smelled like the almonds that fell on the moss surrounding the house or like the nectarines and cherries always in blossom. You rested in the winter, and decorated the house with violets, the flowers of old women. But even when you, too, were old, you thought you were different, as if you feared making an alliance with the laments of time.

Who were you, Friduca? Were you that angry woman who threw the enormous Santiago telephone guide at father because he came home late? Or that other woman who, frantic with happiness, undressed and drank Portuguese *vinho verde* while she sang boleros in German from the balconies?

So much of your story is wrapped in small, mysterious, and smoke-filled postcards. When we asked you to tell us tales that were not about dragons and magical coaches, you said that some day in a bed full of feather pillows you would tell us true stories that were more frightening than ghosts. Some day you would tell us about a childhood that lay suspended in somber whispers and frightful secrets. Many years would pass before we knew what stories persecuted you in your frequent nights when you wandered through the house in search of restless ghosts or of girls like you who wore yellow six-pointed stars on their coats.

In the summer you would bring us to the Pacific Ocean, Like your mother you were afraid of rickets. You believed in the sun and in the constellations that you often pointed out to us and named out loud. And now, under this foreign Northern Hemisphere sky, I remember the three Las Pascualas, the three Marías, and the Southern Cross.

In the beach house surrounded by cacti and lizards, we felt that we belonged to you, while in the winter, you withdrew from our laughter, or approached us restlessly, dazed, as if your body was calling you to other places. But the summer before our exile, your life and ours were not to be forgotten. We became your allies and confidants. We drank beer and you told us that the golden foam came from the gods. You also let us grow our hair long and wear white pants. That summer while we clung to you we also discovered who you were.

One night when the wind and the sea echoed unspeakable sounds, we asked you to tell us your own story, not one made up of fairies and dragons. You muttered, grew silent, and then said that you would tell it to us in episodes, like Sheherazade who had saved her own life by telling stories. So, you began:

"My father was an old Viennese gentleman. He loved Goethe's poetry, the German language, and pretty cabaret dancers. That is why he came to Chile, to the Pacific coast of South America, to escape from many lovers. When he saw the young brides, the white washerwomen, descending from the illuminated hills that the mules climbed carrying pitchers of water, he said this would be his country. He swore to love the Spanish language and Valparaíso Harbor with its run-down houses and midnight owls that adapted their song to the music of the sea."

You smiled sadly and continued.

"We belong to a persecuted and not necessarily chosen people. The history of our people has been distinguished by the most unnameable horrors of war. My grandmother Helena wore high-heeled shoes and loved strawberries. She lived happily in Vienna until she could no longer go to her beloved garden and had to embroider a Star of David on her coat. The restrictions against Jews began slowly, but eventually they lost their citizen-

ship. One restless evening, thanks to divine Providence, my grandmother and her children made the long journey from Vienna to the port of Hamburg where they boarded a steamship that would rescue them from certain death. The boat headed for Valparaíso where they would be met by my father whom you know and love.

"I will tell you," Mami said, "about the afternoon when we went to Valparaíso Harbor to wait for Helena." She choked from emotion and grew faint, as if this were part of a story she had carried deep within herself. Covered by goose bumps, she continued. "The whole family gathered at the harbor that day. It was Sunday and the street vendors sold balloons and sweets as though the city were in a festive mood to receive them. My father, wearing his Viennese gentleman's hat, paced. He was so anxious to see them that he decided to call a tugboat to bring us to the ship. At that time I was thirteen years old and my brother, Jaime, was eleven. We boarded the tugboat and the wind howled as it tousled our memories and brought us closer to someone who had been furrowed by grief, our grandmother, whose name I had seen only on faded postcards.

"And suddenly there was her veiled hat fluttering in the breeze. She wore an elegant velvet dress with a sequined dragon pinned to the neckline. She had few possessions but carried the eiderdown quilt that she had shared with my grandfather, Isidoro Halpern, in a worn-out straw basket. I kissed her on the cheek, and she prayed in German while kissing me on the forehead. In that instant, the wind stopped conjuring up secrets, and a passion for her arose in me that has never left me. My grandmother and I became inseparable. For years we shared the same room, the same laughter, and the German and Spanish words we taught each other. We also shared the silences, the memories, and the conversations with her dead sisters.

"In the evenings Grandmother Helena would gaze out the window that faced the tall palm tree in the garden and make strange shrieking sounds that seemed to come from her womb. It was very hard for me to reconcile myself with those perverted nights in which she would kiss the keys that she always carried

tied to her apron strings. When she became senile, she would put the keys in her son's pockets and accuse him of all types of wrongdoing.

"My dear children," Mami would say, "I have lived among the dead and among memories that tell only of the dead. I have lived among scorched gold teeth and false addresses. Nothing is known about the lives of my aunts. I wonder if they died from fright when they arrived at the camps of fear or if they perished in the gas chambers. Your whole life, you have asked me questions that I cannot answer. My childhood stories were not inhabited by angels with immense gossamer wings, and I never dreamed that someday my loved ones would return. I also have asked myself, Who am I? Where is my soul? Whom do I resemble in the family photograph? And why have I never returned to see my aunts? Like a pilgrim, I have tried to assemble the puzzle of my own history, to learn about those knives that cut into the darkness, and why my grandmother cried when she lit the Sabbath candles. I can't tell you anything more because my tongue was also stilled and because uncertainty was a mad truth that constantly threatened us."

That summer on the Pacific Coast was memorable and unique. Mami didn't enter her usual wrenching silences but continued talking to us. Shut up in her room in broad daylight, she told us strange things—like how her cousins from Prague had arrived at her house in southern Chile, and how her father would greet malnourished women refugees at the train station with large baskets full of flowers. I associate my language with her memory. Perplexed, we listened to her, although many years would pass and many more stories would be heard before we came to understand her. My mother was sometimes like a little girl, sometimes an eccentric woman who didn't like talking with the neighbors, but she would nevertheless engage in long conversations with strangers whom she would never see again.

In that summer of 1970 we discovered many things. I fell in love with a boy who told me stories about Che Guevara that were either true or false. My sister learned about the Berlin Wall and my brother about a camp on the outskirts of Prague where child

prisoners painted butterflies. My mother decided to devote her-
self to the joys of living. She spent hours contemplating the moon
and the stars scattered across the heavens. She ate strawberries at
midnight and happiness arose from sweet smells carried by the
gentle breeze. One day she took us on a walk to the sea. She said
that all great roads led to the sea. She told us to fill our pockets
with shells, imaginary crystals, and starfish, and to make wigs of
floating algae because through this delightful game we would
acquire the peace of the entire universe.

Mami taught us about the astonishment that is linked to the
unexpected and about the presence of certain warning signs that
should be heeded, in the secret rhythms of lizards in love or in
the iridescent face of sunflowers. That afternoon she told us about
the times when she would accompany her grandmother to the
Red Cross offices to wait for news of the war. She told us how at
the end of the Second World War, she and her classmates had
marched in a huge parade in Santiago, carrying baskets filled
with red carnations, how the sidewalks of the city had been trans-
formed into floral necklaces and red carpets in memory of the
dead. Perhaps she thought about how the Nazis had interrupted
the lives of her aunts forever.

It happened one day in the middle of the afternoon, when
they came home from piano class. Eva, her youngest aunt, was
taken to the Gestapo Office, never to return again. Somehow,
through these stories, I grew to understand my mother's silences,
her early-morning reticence, and her obsession with knowing
we'd all arrived safely at home, where she would shut the doors
and breathe deeply at last. I sensed that life was a miracle, that
we were forever being saved from an imminent catastrophe, that
life had its dangers. Mami told us this whenever she entered into
that place of profound exhaustion dominated by her solitude.

The winter passed, the violets blossomed, and autumn ar-
rived, covering the ground with a blanket of leaves that we stepped
on as we came out of school. The earth was like a screeching
violin playing an arpeggio for our mischievous feet. One day we
changed schools, no longer attending the British Institute where
we had constantly been made to salute and curtsy and where

once, as we left school, our classmates had surrounded us in a hallucinatory circle, shouting and spitting: "Jewish dogs, Jewish dogs." I remembered then what Mami had said, that life was full of unexpected dangers. I also believed that catastrophes were always just around the corner, waiting to happen.

Another summer arrived and we returned to the house at the seashore where Mami ate juicy watermelons. One day at the beach of the agate stones she said, "These stones remind me of the crystal street lamps on Castro Street." Lying on the sand wearing the copper-colored sweater that matched her hair, she told us about her father's precarious situation after he brought his mother, brother, and other refugees to Chile. He had fallen deeply into debt financing visas for their safety. But he had maintained his dignity, never letting on how bad things really were. He simply looked for another future in the crystal lamp business.

"My father bought antique glass in the elegant neighborhoods of the Chilean aristocracy. He arrived home daily with iridescent violet, mauve, and yellow crystals after an exhausting day as a street vendor. And all of us, including Grandmother Helena, climbed to an upstairs attic that almost touched the sky, where we threaded those crystals onto delicate wires. We didn't sell any lamps, but in the afternoons we opened the window to let the rays of sunlight enter the crystal room and listened to the teardrops of light chiming in the wind. Amid all our poverty, this spectacle of the floating crystal conjured a generous beauty." Mami began gathering the agate stones again, and as she opened and closed her hands, she counseled us to always appreciate the unexpected wonders and gratuitous goodness of nature. That was the last story she ever told us.

Then one day in the early seventies, the soldiers came to Chile. They wouldn't let my brother grow his hair long like the Beatles and they wouldn't let me wear pants. In our neighborhood, afternoon book-burnings became a common sight. The police were obliged to burn books that were considered dangerous. My mother remembered her grandmother's escape from Vienna on Kristaltnacht, and the destruction of her beautiful library. Where have the words gone?

Mami became more silent and hostile. She stopped talking to us and devoted herself to organizing the first "garage sale" in Chile. She said that refugees didn't need things. That is why she sold the tablecloths, the figurines, the dolls, and the fine china. She kept only a few silver trays brought from Morocco by a friend, a samovar bought from some Gypsies, some postcards from Vienna, and the blue-covered notebook in which she and Grandmother Helena kept the wildflowers they gathered on their secret walks. Our departure from Chile was imminent. It was then that I realized why Mami had taken so long to tell us her story. Perhaps she had been afraid that everything she told us would come true again.

Although I was too young to understand how things were, I understood that asking questions was forbidden, and little by little I began to penetrate a universe of fear and inertia. I realized that I should start saying good-bye to certain things, to beloved trees and streams. I decided to make copies of the keys to my house and desk. These would be the sacred objects of my memory as they had been for my great-grandmother Helena who had died in her late nineties with the keys to her house tied to her diminishing neck. Mother lost the radiance in her violet eyes and her voice became serious. She no longer walked around the house barefoot. At night, I heard her praying in German with the voice of an angry, dispossessed woman.

And one day we left. I don't remember precisely the hour of our departure or the month, as if my memory had been severed. We were all disoriented and speechless. I only remember that certain people came to say good-bye: our closest friends and my beloved history teacher, Martita Alvarado, who arrived wearing a red coat and carrying a white notebook that she gave to me so that I would write about the genesis of my new history. That timeless night we blended with the immensity of the heavy silence around us. Very few relatives came to bid us farewell. Perhaps they felt it was absolutely necessary to conceal our departure. Frida, you had already returned to take charge as you had done on the nights of grief and sorrow before we left. You kept saying that every journey is the beginning of a better life. Perhaps

this is how Grandmother Helena felt when she set out on her uncertain voyage to the Southern Hemisphere. We, too, were traveling to an unfamiliar country. No river would caress our feet as the rivers of the south had done, and never again would the scent of jasmine and violets emanating from our Mami tell us we were home.

The Andean range darkened as we departed. The sky was a basket of shadows. I felt that I was repeating the story of my Viennese great-grandmother and my Russian great-grandfather. Perhaps you were right, Mami; perhaps for a while it was better to learn stories of fairies and dragons than the true story of our fate, of the history of Jews like us, without a homeland. We had been driven into exile by politics, not racism, but like our ancestors we had become wanderers, travelers.

We came to North America. There the people laughed less and Mami, you seemed to laugh more. We lived in an empty house with plastic chairs. It was very hard to fill it because we didn't have any guests. Instead of singing boleros in German, you cheered up by dancing the cueca and the tango and by passionately remembering all that you had left behind. When other children made fun of my height you would say that they were poor little things because they didn't know that I was magical, a relative of Thumbelina. And when they laughed at our accent, you said that they were less fortunate than we were because they spoke only one language.

In the house in Georgia you planted *boldo,* bay leaf, cilantro, and violets, and we smelled your familiar fragrance once more. We learned to love this new land that provided us with shelter and human warmth. Miraculously, we survived once again, and learned to name other stars. Our happiness was hidden, less exuberant, but we survived.

Now in the U.S.A., I tell my children stories. They think I make all of them up, even though some are true. Sometimes I say: "Children come close, I want you to listen to me. Be my confidants. Come, bring the pillows from Casablanca, elixir from Cordoba and the fans from Madrid.... Once upon a time there was a mother who lived in a country with five thousand volca-

noes and many penguins… a beautiful and luminous country with blizzards and archipelago islands. That country had a wise ruler who died in a palace set ablaze by a powerful, conceited dictator. Like many other citizens, we left and crossed the mountain range in search of safety. Life is full of wonders, mysterious cliffs and miracles… ."

In those moments, I know that you were close to me, Mami, and I knew why you had to hide your stories. You are like a bridge to all those secrets. As I call you, the room begins to fill with the scent of violets and jasmine, and you tell me that it is time to leave the dead behind, to bid them farewell, and to sit down to eat at the table of the living.

The years have passed and you have remained near us in the earth that we seed, in the birds that visit us at daybreak. Above all, we have preserved your memories and your voice in this both strange and familiar room, in the foliage of the trees. Your stories have marked the path for all the possible returns, and here in the yard behind the house we see you hanging out the clothes to dry. We see you pruning the rosebushes, saying: this is where my responsibilities end; now it is time for you to tell *me* a story.

Translated by Celeste Kostopulos-Cooperman

First appeared in *Las Mamis: Favorite Latino Authors Remember Their Mothers*. Ed. Esmeralda Santiago. Vintage International, 2000 179-189.

Carmen Carrasco

When the fog begins to descend on the coasts like a soft sorceress dominating the immensity of the landscape and the privileges of the horizon, I invoke her, I name her, and I greet Carmen Carrasco. She is the one who comes to announce the omens, to retell the luminous stories to warn me to beware of something. Although when we were children we were forbidden to believe in ghosts or in the inexplicable things that often happened to Carmen, we noticed that the chicken soup would levitate when she was around or that jams would smile when she called them by their given names: raspberry of my life, elixir of my palate… It would be impossible then not to believe in Carmen Carrasco and the kinetic forces that surrounded us.

When I invoke her, I feel surrounded by a brilliant light. Her skin is young and transparent and I turn to look behind me, thinking it is she who is caressing my back. My childhood was filled with guardian women and magical women but none were like Carmen Carrasco. I have to be careful when I speak of her, especially in front of my Delfina Nahuehaul who is famous for being jealous and for cursing those who compete for a place in my heart.

I write about Carmen Carrasco and I wonder how to reconstruct memories. My memories of her are like footsteps that I must follow in order to rebuild her life. Did I really know Carmen Carrasco or do I invent her as the years go by? Do I make her grander and more magnificent? Memories, like history, participate in the fluidity of time. Memories are not static. They rebuild themselves and some times they are diminished when we remember them. At other times memories are quiet and calm and later emerge filled with sound and songs.

Memory is mischievous. It has its tantrums and its turbulent roads. There are many conflicting hypotheses about Carmen Carrasco's arrival. My sister swears she arrived disguised as rain and fog and that it was very difficult to see her behind her gigantic umbrella. My mother says she simply knocked on the door and said that a dream had led her to our doorstep. My grandmother Josefina is the only one who is right though. She says that Carmen Carrasco arrived in a cart with a purple donkey (it was very cold outside). Carmen had no belongings and she blended in rather well with the fog.

My grandmother who remembers everything says that Carmen Carrasco survived a great earthquake in Chillán. She was once a rich and powerful woman, and she lost it all, including her husband and son. My grandmother decided to hire her to work at our house in Santiago and did not let her go for thirty years—not until one day Carmen invoked the spirit of the purple donkey and the cart showed up to take her back to her land in the south of Chile. We were told she died after eating rare pork meat. I do not believe she is dead because every time I invoke her name, she comes to me. She shows up behind doors aboard a broom. Some times she is in the treetops. She rarely shows up when things are going well though.

When Carmen first arrived at my grandmother's house she began to teach me about life. The first thing she told me was that I must believe in ghosts. Carmen was not prone to make-believe, but to her ghosts and spirits represented the unexplainable. The unexplainable to Carmen included philosophy, music, and poetry. Sometimes it even seemed to include culinary arts.

Carmen Carrasco seemed to float through my grandmother's house. Her steps could not be felt, but her scent (a mixture of fresh herbs, cilantro, and oregano) would fill the rooms she had just vacated. Carmen wore an enormous gray shawl that seemed to cover her entire body and made her look like royalty. As the years went by, the shawl seemed to lose certain layers. It was falling apart slowly. It carried the weight of many years and the deep grooves of hidden things, of happiness and sorrow.

Carmen Carrasco loved life and did not question things. She woke up every day filled with illusions and determination to make the best of things. In the morning she would shell peas. In the afternoon she would sweep the sidewalks, and once she even decided to paint the balcony yellow. At times she would play the guitar while we ate. This was somewhat conflictive. My grandfather, a Viennese gentleman, and my great-grandmother, the angel of memory, would get very anxious with Carmen Carrasco's "singing." Their ears had been trained to listen to classical music, operas, and soft voices. Carmen's guitar interludes were a far cry from the Viennese opera houses and symphony halls.

Carmen sang on rare occasions. I think she realized this was not her forte and she would then redouble her efforts to shell peas and cook the best meal in town. While she cooked, she taught me the fine art of telling stories. I was very young at the time, and I like to imagine that I have not grown, that my hands are still a child's hands filled only with what is most necessary: the sun, fresh grass and stars. Carmen would call me "her little pea" and I would follow her throughout the house.

Together, our imaginations had no boundaries, but at times we helped each other figure out what was true and what was made up in our stories. Through her I learned to observe the most minute objects and events: the wind blowing over the chairs, a sleeping butterfly. I would make up small ideal worlds that would later turn into utopias as they became permanently engraved in my memories.

Carmen Carrasco had very fine penmanship that she learned from nuns. I went to a private school and had good grammar, but my handwriting was undecipherable. Everyone thought I would be a doctor, not a poet. Carmen Carrasco would dictate stories, and we would sit and let the breeze caress our faces while she talked and I wrote. She told me about the earthquake of 1928, the tidal waves of 1934, and the great fire of 1948. I discovered that writing about Chile also meant writing about its natural catastrophes and its people, overwhelmed by their geography. I began to write about nature and its unpredictable behavior. When

I thought I would drown in my writing about water and earth, Carmen told me, "One day you will write about your ancestors and how they arrived in Chile." Little by little I began taking down notes about my family, our history and our future.

Carmen told me so many stories. She would tell me about my mother and how some nights she would sneak out to go dance with military cadets all dressed in white. She also told me about my father, who played the piano as if the world would soon end and who used to talk to the little skeleton he kept near his bed as a reference tool when he was a medical student.

The stories that Carmen Carrasco told me found their niches in my head and in my memories. That is just the way good stories are. Just like good meals, they find their place and when they are ready they come to the surface to be savored.

As a child sitting next to Carmen I wrote poems about Chile, Gabriela Mistral, and my book bag. Carmen celebrated my every success and would hug and kiss me every day when I came home from school. My imagination took flight undisturbed by the din of television or video games. I began to write when I was eight years old. Since I was not very good at writing then, an older friend helped me type up what I wrote. I called it "Rita and her trips." It was a long story about a foreign girl and her adventures. I dedicated the book to Carmen and that night she made me a raspberry tart. It happened to be her birthday as well, the last one she would spend with us.

A week later, Carmen announced her departure in a clear tone that left no room for discussion. I cried for many days because I knew this would be good-bye forever, and I would remain alone with my notebooks and my now silent stories. We never spoke of her imminent departure and life continued among the usual dreams, premonitions, and stews.

One day, when I was twelve years old, the cart drawn by the purple donkey showed up. The donkey looked almost gray at that time. Carmen wore her measuring tape around her neck like a pearl necklace. She told me that she was not leaving me alone. I had a mission to write about our country, my ancestors and my life. She kissed me on the forehead and blessed me. Then she

headed for the mountains toward the land that witnessed her birth looking exactly the same as when she had arrived to our home. Her departure was one of the saddest days of my life or maybe it was only the beginning of what would be a nomadic life for me filled with loss. A few years later we left Chile for the United States. My grandparents stayed behind alone, suspended in the cruelty of time waving at us from their balcony.

When I visit Chile I go to her room because I want to feel her scent around me. I look in the mirror and her face stares back at me. Carmen Carrasco's bedroom has remained empty, but they say that on certain nights you can hear the sound of her sewing machine, gentle as a sigh. When I visit Chile I can almost see Carmen smiling at me through the trees, but I never heard the sound of her sewing machine. What I did hear was her voice telling me stories about her land and her past. That is why I decided to become a writer. No other job fit my hands as well as that of creating words.

Soon after she had left us, I took out my notebook out and began to write. My imagination took flight, and I wrote for hours on end. Even now when I write, I think of Carmen Carrasco and I relive the joys and sorrows of my childhood with her.

Translated by Monica Bruno Galmozzi

Delfina

When the drowsiness of dreams blends itself with the rain that falls behind the windows, I think of her and I await her. All I have to do is close my eyes and I can feel her arriving with the most unforgettable fragrance: a mix of rosemary, laurel and herbs boiled in water. She arrives and sits at the foot of my bed. She prays in Mapuche. She invokes my name to the sky, the earth and the hidden labyrinths of her ancestral memory. She is my nanny, Delfina Nahuenhual, from the deepest Araucaria, descendant of the noblest spirits. Above all, she knows how to listen to the voices that lead us from one history to another, from one labyrinth to another, from the ship of the dead to the ship of the living.

Delfina was the tree of my childhood. When the branches of my great-grandparents, and the dead and decapitated aunts, did not even appear in the faded photographs, there was Delfina, like the strongest of trees, ready to shelter us. She was short but firm and strong, like the tree that has survived and given us the possibility of hope and dreams.

I do not know when she arrived among us, but I do know she was a permanent figure in a home filled with hidden histories. Grandmother said that Delfina arrived in a magic cart, covered with white flowers. Grandfather claimed that the flowers had been given to Delfina by the funeral home, that she arrived to our house in a cart, because although she had a fish's name, she could not arrive to our house by boat.[1] Delfina is one of the many women who came to the capital in search of economic life. This better situation oftentimes meant working as a maid, inhabiting the ever-changing regions, surviving in dark back rooms. Delfina arrived at our house and never left. She became the guardian of our dreams, and, today, it is still possible to feel her returning from her day out, like one feels the arrival of a gentle rain.

She always brought us back gifts: figs, fresh fruits, or a lean cut of beef. From her I learned the importance of the objects of the earth, the foods, and the celebration of the seasons and of free time.

I spent my entire childhood at her side. I followed her around the house, and since I was often times too small, not only did I walk underneath tables, I hid under her skirt that seemed to be an herb garden where I found the fragrance of a woman who not too long ago had been a girl. I followed her through different rooms as she talked to the brooms that she placed in strategic places: under stairs, in bathtubs filled with water and light. To her, everything was magic.

At night, when I returned from school I did not do my homework but rather talked out loud like a crazed and restless girl. Delfina would only glance at me and say, "There is my crazy little one" and she would let me talk to myself. I talked to myself until the day I got married when, in order not to scare my husband, I stopped talking to myself and drank some whole grain alcohol with parsley leaves. Delfina always loved the lunacy of my words, the beauty of the voice that was constantly gesticulating, intoning delights and the imaginary world that for Delfina was the real world.

I would go to the kitchen with Delfina and she would wait for me with candles dipped in wine, their light playing with the warmth of the room. The hearth gave off the scent of times gone by. Delfina would sit next to the brazier in the dark kitchen with a kettle on the stove while she boiled chicken legs and prepared powerful potions. The stories that Delfina told had to do with the destiny of the ghosts and the disappeared, with the line that divides our history from that of the dead. She would tell us about earthquakes and their victims, about those lost in all of Chile's tragedies. Delfina repeated that we must celebrate tragedies and sadness as well as happiness.

Then, when the world returned to its calm and happy state found in the abundance of love, I would go back to Delfina and I would love her. I would ask her to tell me a story, and from those stories was born my passion for words, the lies and the possibility of changing the world of dreams.

That was my Delfina, like the smoke among the stories, an endless voyager through all times. I grew up next to her and she would brush my hair while she prayed with the songs of the Araucaria. We knew nothing of her language, her lost land, or her life. My nanny Delfina oversaw the rhythms of sleep and life. From her I developed strength. I never stop thinking about her, feeling her steps and saying that maybe I too was from her land, that I knew her secrets, her blessings and the power of believing in them. Many years went by and I knew an indigenous woman who was not afraid to raise a Jewish girl had raised me.

My nanny possesses the secrets and the signs. She knows how to mold clay and recreate its intonations, and I love her as one might love all that blooms and blossoms, as one might mold the passions of the heart and accepts its mistakes. She spoke to me about silence and the rhythm of the night that flows like a song. I recognize stars—the thickness of the night's rhythm—and each of their secrets becomes a privilege, the celebration of memory. At night, in strange lands, I look for her and finding her is very fulfilling. Now I recognize her footsteps and I glide until I am next to her. Many times I imagine her body folded like a thick braid and I approach her to listen to the wind's song traversing her body, and taking her to a place where I can again find her.

Translated by Monica Bruno Galmozzi

[1]Delfín in Spanish means dolphin. Delfina is the feminine of delfín.

MENDING THE WORLD

Torah

Like living water
and fertile orchard,
I thread my hand
over your face
in the gestures of faith.

You dance gently over your loved ones.
You are a benign queen,
making little curtsies.
You are a bell announcing the sacredness of day,
fleeting carrier of rituals.

Confident in your itinerant life,
all dressed in colors,
you unfurl.
Like a wind
over the eyelids of God,
a breeze
over the olive trees.

I kiss your noble mantle
All misty I flush before
our mutual presence.
You are Shabbat's bride
God's book,
men's book:
Torah,
golden and hesitant
in your alphabet
I am a believer dancing in a thousand mirrors.

Translated by Laura Nakazawa

Through a Field of Stars, I Remember

In the mornings the sparrows encircle a sky that fills me with wonder. Through beloved objects I greet the Andean Mountain range as well as the mutterings of Carmencita with her shawls as gray as the smoke that emanates from her freckled and beautiful skin. Carmen Carrasco gathers the golden leaves with a broom and frightens away the sparrows, omens of uncertainties, with her jet-black braid, while I get dressed to attend the school for English girls on the first day of class.

The school was only four blocks from my house. We lived in Nuñoa, one of the oldest districts in Santiago, a modest neighborhood across from the meat market that my father detested. The butcher, however, took care of us whenever we got sick, by always giving us the best cut of meat. This was in the year 1960, in my country, Chile, a long, strange, and beautiful piece of land.

Perhaps Ms. Stewart chose to have a school on Coventry Street because it reminded her of the cathedral of the same name and also of one of those elegant districts in her beloved England. Ms. Stewart spoke like a refined lady from the upper class and on that first day of school the sky seemed like a great lightning bolt accross the late afternoon.

My mother decided to bring us to school through those endless city blocks filled with old grandmothers buying bread and dreaming about lost youth. What I most remember and loved were the almonds and chestnuts scattered on the ground. Whenever I would get sad or frightened by the deep physical grief of absence, I remembered the almonds, the aromas and life on those four streets, and the ladies singing *boleros* while they swept the sidewalks dressed in black and oblivion. When we finally arrived at the immense iron door that said, "Welcome to the Union School," a very skinny woman with a voice that was both devil-

ish and angelic received us and asked us all sorts of questions. Her legs were very close together and I wondered if she needed to pee. She wanted to know what our religion was, and my mother, with her usual composure and grace, said, "Jewish." The very thin lady fidgeted and asked again, "Jewish?" as if to assure herself that we indeed belonged to that assuredly "chosen" race. Then she looked at us and said, "But you are so blond and your noses are so small!" My mother in turn responded, "Yes, even Hitler would confuse us and mistake us for Aryans." The woman wrote the word "JEW" in enormous red letters and said that I was excused from religious class. This saddened me because I wanted to hear the stories about that gentleman who rose to heaven. These were the last words spoken by that thin lady. Afterward, my mother left me alone, and at that English school, where my neighbors also attended, they taught us to carefully raise our skirts and curtsey.

Time passed haphazardly with a sweet tedious rhythm. At first the other children played with me, but gradually, as I stayed behind in the school's only playground, the girls began to whisper, since I wasn't allowed to attend religious class. I heard them say a multitude of things, among them, a painful chorus of ... "She is Jewish. She is Jewish. She is Jewish."

One afternoon they made up a chant and said that Jews could not participate in it. They began to sing: "Who ate the bread in the oven? The Jewish girls, the Jewish girls. Who is the rotten thief? The Jewish dog, of course, the Jewish dog." For many afternoons that song was like a stinging wound in my young girl's ears. When they sang, my head felt like it was ablaze with flames and evil omens. Sometimes I looked at them incredulously, asking myself if dogs could have a religion.

I thus returned home crestfallen and dreaming about the almonds and chestnuts that I would gather along the way, hoping to find Carmen grumbling because we had arrived late or had stained our clothes with dirt and acted like mischievous children. One afternoon, when my mother was combing the long hair of my Viennese grandmother, Helena, the one who never learned to speak Spanish and who sang and prayed in beautiful

Yiddish and German cadences, I told my mother about the song and about the girls who mocked me on their way to Catechism.

My mother didn't say a word. Instead, she decided to go to the school to speak with the director. There she was received coldly. After all was said and done, it was a well-known fact that I was the only Jewish girl in the English school, the only one who didn't eat pork, who didn't make Christmas cards, and the only one who didn't have a First Communion.

Oh, how I dreamed about that white dress with angel wings! I didn't have any of these things. I did, however, possess a past, a history, and the dates of sacred rituals that commemorated the lives of dead sisters without graves, with only imaginary stones and imaginary relatives.

The director of the school made my mother sit on a small, cracked wooden bench that wasn't in the living room, where she received important visits. When my mother asked her how she could allow the girls to sing that perfidious song, the director said that it was a part of Chilean lore, that it was sung in all the schools throughout the nation, and that this was how things were, impossible to change! My mother asked why they didn't sing about the Christian or Moslem dogs. The director wrinkled her brow and then showed her the exit. Dismissed from school, I despondently followed my mother. She dried my tears and arranged my hair the way all mothers do with their children. She also rinsed my cheeks with her kisses and I suddenly sensed a smell of almonds and chestnuts in the air as we returned home listless, silent, and certain about our heritage.

The next day I went to another school. This time all the children were Jews, and for sure their dogs were also Jewish, but not because of this identity, thieves who stole bread from the oven. I was happy at the Hebrew Institute where there were no iron gates or young ladies teaching us how to curtsey. Ms. Stewart was the true beginning of my Jewish education and of my awareness of anti-Semitism in Chile. She taught me that I would always have to defend myself for not participating in religious classes, in the Order of Saint Teresa, or in those activities or groups to which good upper-class obedient girls belonged. But wasn't I

also a good girl? Why couldn't I be like the others? Why did they spit at me whenever I waited outside? I carried my religion like a question, and I also carried within me the names of my dead relatives and of those who arrived in my country on freighters. One of them was my grandfather Joseph, Helena's son, who fled from a cabaret dancer, and others were refugees, like my uncle Mordecai, who had fled from the Gestapo. Whenever I would rush to my Grandmother Helena's side, she would tell me that it was necessary to say sweet words in order to ease the hollowness of the grief.

The Hebrew Institute was established in the fifties by the small Jewish community of Santiago. It was always outstanding because of the wisdom and high intellectual standards of its teachers. The time that I attended the school, it was truly "liberal" in the broadest sense of the term (progressive Christians also went there). We didn't learn about the miracles of Zionism but rather about life in the kibbutz. We also learned about social justice, prudence, and the benefits of socialism.

My years at the Hebrew Institute were happy ones. My sister and I would wake up cheerfully very early to go to school. We would drink coffee with milk and eat toast with avocado pear jelly. At that time, happiness for us consisted in waking up to the joys and rigors of everyday life, to the sounds of Carmencita or the sparrows. Our father would bring us to school at daybreak, around seven o'clock, because his chemistry classes at the medical school at the University of Chile began before eight. On the way to school, he would talk to himself out loud and repeat equations and strange formulas. In the backseat of the car my sister and I would spend the time counting the houses and imagining the lives of the men and women who lived in them.

The Hebrew Institute was in the neighborhood of Macul, a modest district of Santiago, very close to the Pedagogical Institute, which had one of the country's most politicized student centers. I liked looking at the sixty or so bearded men and the women dressed in black making peace signs and marching through the plush avenues. On numerous occasions we stayed late at the school because there were disturbances at the center, and the

police exercised their usual violence against the young idealistic students, many dreamers among them.

Political action, denunciation, and apprenticeship were the sacred lessons of my childhood. The despicable Union School had been left behind. Now I was among Jews like myself, and together with everyone I studied the Talmud, the Torah with its charms and wise advice, the poetry of Bialik and Sachs, and the stories of Selma Legerloff. In elementary school, I was an avid reader of poetry and fantasies, exploring the rich world of the imagination. Perhaps I always wanted to retain the illusion and sense of permanence in the world and of ways to dwell in it. Poetry was my closest companion. I loved words, those in Spanish as much as Hebrew, and I spoke both languages fluently.

My first great literary acknowledgment occurred when one of my poems was published in Jerusalem in the Sephardic newspaper, *Aurora Sfarad*. Another poem was published in a newspaper on Easter Island and a leper wrote me a letter after reading it. Poetry was like fate. It saved me. Words for me were like rituals, always sweet and generous. Mathematics betrayed me and numbers danced in my head. I was only interested in the number seven, in the principles of the Cabala and in alchemy. Logical and official symbols never entered my world. I let myself be guided by fantasy and intuition. This is why I survived by writing. What was the outside world like, where I existed as a thirteen-year-old Jewish girl in a Hebrew school? The truth is that the outside world did not at all appear strange to me. My Jewish education gave me an identity and life, but more than anything it gave me the possibility to love those of my neighbors who differed from me. The diversity emerging from Catholic, Protestant, and Jewish cultures was an integral part of my childhood. Refugees from the Nazi Holocaust and from Central America frequently arrived at my door, both in Chile and in the U.S.A. Among them were biochemists, beggars, and people of royal blood, like the famous and honorable Baron von Brand, my father's teacher. I remember that when he visited us I curtsied as I had learned to do at the Union School, but afterward I sang to him in Hebrew.

The great upheaval of my adolescent life occurred when we left Chile in the early seventies. Totalitarianism was looming on the horizon. My father's laboratory was shut down in 1971 because, despite his being a man of profoundly liberal ideas and a true socialist, he received money from the Rockefeller Foundation, a Yankee enterprise, to finance his investigation of enzymes and mellifluous formulas. Unable to work because of the threatening phone call he received for being Jewish or for supposedly "selling out to Yankee Imperialism," we felt obliged to leave the country. We traveled to another southern American region, Georgia, where I learned to speak with a drawl and I also discovered that the majority of North Americans, southerners in particular, were terrified by strangers and "communists." I was a stranger, and my entire family fulfilled the eternal tradition or curse of the diasporic Jew.

If my experience as a Jew in Chile was both disquieting and luminous, in the United States I felt more and more an outsider and not a kindred spirit to those who belonged to the Jewish community in Georgia. During the first years after our arrival as poor immigrants, when we lived in empty houses with loaned furniture, we weren't even greeted by other Jews in the synagogue because everyone was obsessed with Russian Jews and we were from Latin America.

At that time I remembered how we had been treated by Ms. Stewart. Now in our new home in North America, I was not only a Jew but a Latin American Jew, which implied, to others, less dignity. Gradually my parents began to keep a respectful distance from the Jewish community of Georgia. To this very day they still do not belong to the temple in their city. They have found comfort and solidarity among Colombian and Puerto Rican Catholics who share friendship and faith with goodwill.

I also distanced myself from that community, and I missed not being able to speak Hebrew, the language of my first poems and passions. Nevertheless, I understood that now I was a Latina and not that Jewish girl that they had called me in Chile. I also learned that oppression and pain go much further than the color of one's skin.

The years in Georgia passed by aimlessly, and I quickly found myself speaking in English and reading Shakespeare in a language I grew to love. I was also lonely—because in school they would say: "Don't talk to her. She is a Latina and also a Jew." The horrors of discrimination marked my childhood in Chile and adolescence in the U.S.A, but I wore both my Judaism and my *latinismo* like a deep blue shawl. I wore it with peace and dignity. My education at the Hebrew School was my most powerful weapon for defending myself against universal prejudice. Judaism and the diasporic condition of my family became an emblematic metaphor for lost and irrecoverable things. They also came to represent all that was worthless, because the gift of wisdom was in the ability to understand and forgive the ignorance of others.

From the United States, I passionately and profoundly began to love my country, to know her and embrace her. Perhaps I loved Chile even more than when I was living there. It was akin to recognizing the love one feels toward a mother only after abandoning her. This is how my country became part of the baggage of lost things that I carried to other places. Many times in other lands and mist-laden cities, I wrote her name in territories that also didn't belong to me. My human rights activism in Chile coincided with my passion for always forming alliances with marginal beings. I sensed myself as one of them. In the United States, in spite of my being blond and white, I had a Hispanic accent, and I was Jewish, which made things difficult. I became a fragile and vulnerable being. However, from this other America I had the most exquisite opportunity of my life—to develop intellectually and to go to libraries, to explore, to learn, and to be aware.

I was accepted at many universities, and behind their doors I found young people who shared an alliance with those Chileans who fought with pencils and paper and disappeared and died for wishing to be free. The experience of not having been one of "them," of not having disappeared, had an immense impact on my conception of the world. I was a survivor who must not succumb to a silence of complicity. Nor could I ever say, "I don't know anything about this. I don't want to say anything

about this." Not doing anything was as good as being guilty. It was like being part of that amalgam of ordinary people who perform evil acts.

I spoke through my writing. This was the site of my identity. I refused to feign the grief of others and also refused to imagine the torture, the terror, the slashed body. I only wanted to hear so that I could tell. Many of my verses and poetry collections, like *Zones of Pain/Las zonas del dolor* and *Circles of Madness/Círculos de la locura,* arose from the experience of hearing the testimonies of victims or of the disappeared or of the relatives of disappeared citizens. Their voices accompany me in the heavy insomnia of the night or in the luminosity of peaceful days.

When I reached so-called maturity and my voice began to change, when my walk became more deliberate and my anger transformed into a map of hope, I finally understood what my grandfather naturally showed me in actions but never told me in words: the fact that one must live at the service of others as well as with them. My political activism for the voiceless had certain resonances in the work of my beloved grandfather, Joseph Halpern, who lived in southern Chile and also in Santiago during the years 1938-43. At that time he devoted himself to gathering refugees who would come to our humble house in the south where the Sabbath candles were always lighted. This is how Kurt Goldshmild, Annie and Sharie Brinner, and Emma Weiss arrived. Their names are already a part of my history, of my life here in Wellesley where I also open the doors of my home to others in search of refuge.

It is difficult being a Jew and a Latina, but it is also quite marvelous to belong to a people with a long and wise history, a people who believe in the passion of memory and who carry the Torah and do everything possible to act justly. Perhaps I am following in the footsteps laid down by the Ten Commandments delivered by Moses, the patriarch, and also those of my father, Moses. Above all else, I have tried to fight against all types of foolish fanaticism. I have also tried to fight against the commercialism of certain Jewish communities, making Judaism a metaphor of human life that struggles against intolerance.

My son has the name of his great-grandfather Joseph, who saved refugees and met them at the station, and my daughter has the names of her great-grandmothers, Sonia from Odessa and Helena from Vienna. By naming my son and daughter after the patriarch and the matriarchs of the family, I sense their presence like a fragrance, a thread of memories in our lives.

Although my early years were defined by that ominous incident at the Union School, today the planet seems more gentle and benevolent. I wear my Star of David not so that others will point at me but so that I can share my identity of a courageous and persecuted people who left the smoking forests behind and made life flourish in the desert.

Sometimes, at my home in Wellesley, Massachusetts, I go out at night and look at the sky. I don't see the stars of the Southern Hemisphere, but I imagine them close to my soul as I hear a voice that says, "Your people will multiply like the stars in the heavens." This planet is inhabited by my people. I am a Latin American Jewish woman among many other things. I know the *Our Father and the Shema*. Above all, I am a woman who delights in thinking that it is through words that I can reach the stars.

Translated by Celeste Kostopulos-Cooperman

First appeared in *King David's Harp: Autobiographical Essays of Jewish Latin American Writers*. Ed. Stephen A. Sadow. University of New Mexico Press (1999), 189-98.

Reflections on Authoritarianism
and Anti-semitism in Chile

I await with great anticipation the visit of a dear childhood friend. Our lives, as well as those of a whole generation, were put on hold when I began my exile in 1973. I think that maybe all of Chile was put on hold at that time. Distance allowed us to get closer to our feelings and to the realms of memory. Our memories became more intense as the absence grew longer.

My friend lives in Chicago and is also a professor. When we see each other we hardly ever talk about our present lives in the United States or our North American–born children who speak Spanish with an accent. We talk about the past that was left behind… suspended, distant… detained as if in mid-flight.

The forced departure of so many Chileans was unsettling and inexplicable. Suddenly, whole families fled the country without leaving a trace. Others left behind houses full of possessions as if awaiting a return. These sudden departures filled us all with confusion and pain. The words and feelings left unsaid and the things left undone permeated the air around us and we were all filled with a dangerous feeling of nostalgia. I say dangerous because it tempted us to continue living in a past that no longer existed and it did not allow us to move on and emerge from an uncertain history.

My friend left Chile when she seventeen years old, and a few months later she married a man she barely knew. Fortunately for her, the man turned out to be kind and understanding. Other friends left Chile to go to their parents' homeland: Germany, Austria, the Netherlands, and Israel. As I write these words I realize that I am meditating upon the Jewish migration from Chile during the Allende and Pinochet years and I would like to take a moment to discuss the significance of my experience with anti-

Semitism and fascism. It is a history that is often mentioned, but always in whispers.

I believe that in the future scholars and academics will explore the life of the Jewish communities as they departed before and after Allende. We often used to greet and recognize one another as well as our political inclinations by our departures or arrivals. Politics and history were not only historical but also personal.

In this essay I am trying to explore the historical ambiguity and tenuous history of what happened to the Jewish populations in Latin America. Throughout most of history, since Columbus' arrival, the Jewish populations have represented a minute percentage of the total population, and in most instances they have distanced themselves (or been distanced) from the political experience of the countries they inhabit. An important example is that Jews are not allowed to be in the Argentine military and until recently children had to be baptized in order to attend private Catholic schools in Argentina.

The Jewish migration to Chile was not large due to the location of the country and the fact that a large port city like Buenos Aires, the most important port of entry, or Ecuador was nearby. However, those Jews who arrived to Chile did not view it as a stepping-stone to a better place or a temporary home. Unlike the Jews who traveled to the Dominican Republic or Bolivia and were awaiting visas to go elsewhere, the Jews who arrived to Chile had come to stay.[1] The focus of the Jewish migration to Chile remained the same for many years: the area around Santiago and some towns to the south of Santiago. The Jewish population in Chile was definitely a minority and in the last twenty years has only grown by about 20,000 inhabitants.

Discussing Chile and the Jewish experience in Chile is problematic and complex, especially during the 1970s. The great picture, from a highly personal perspective, would indicate that the Jewish migration to Chile was conducted in peace, silence, and with discretion, almost as if the immigrants wished to remain unnoticed. The Jewish presence in Chile was moderate, although beginning in 1933 there was strong pro-Nazi sentiment in Chile

and the nationalist party of Chile tried to support the idea that there was indeed a superior white race and that the Jewish element was always subversive. [2]

We must not forget that many years earlier when the Spaniards first came to America, they brought the Inquisition with them and thus commenced the persecution of the Jews in Latin America. What I postulate in these pages is that although the Chilean government does not have an official anti-Jewish stance, the fact is that it always perceived the Jewish presence as a problem. This goes hand in hand with a strong nationalistic undercurrent that does not allow diversity or cultural integration. Decades later, as we come to analyze Chile's history, we see clear connections between Nazism and racism and the influence of the military junta in Argentina.[3] We have clear evidence of Nazi settlements in the towns of Osorno, Puerto Montt and Varas. To date, there is still a strong Germanic influence in southern Chile that has also influenced the training of the military forces. The most evident Nazi stronghold is the Colonia Dignidad, about five hours south of Santiago, where secretiveness and fear of strangers is the norm. Very little is known about this settlement, but there is evidence that there is a strong link between the Colonia Dignidad and the training curriculum and activities of the Chilean armed forces.

Discrimination on racial, political, social, and religious levels exists throughout Latin America. Chile attempted to host a Worldwide Nazi Conference in 1999 because Chile has no laws against holding such a conference. President Lagos forbade this meeting from taking place on Chilean soil, but it still took place in a remote area of the Chilean coast, about two hours away from Santiago.

During the years from 1933 to 1945, the Jewish presence in Chile had a great cultural and social influence, although the Jews that arrived to Latin America were part of a small migration. In the famous Evian conference that explored the refugee question for Jews, many European nations met to discuss where to transfer the Jewish refugees. No country opened its doors with the exception of the Dominican Republic, then under dictator Trujillo.

Much has been said about his open emigration decision and it is generally believed that he did it because it was a convenient way of introducing a "whitening" element to his society, it would ingratiate him with the United States, and it would defer attention from the horrendous massacre of Haitians that had recently taken place.

The situation with the Jews and General Trujillo caused a great split within the Latin American framework. I dare say that this situation created a feeling of ambivalence between the Jews of Latin America and the historical circumstances that surrounded them. I would not go as far as to say that the circumstances created an absolute conflict, but they did create a history filled with anomalies and political deviations.

My family arrived at the port of Buenos Aires in the early 1930s and lived with the other Jewish refuges on Calle Once. Some of the Jews then left for the provinces. My family traveled to Chile and went to Valparaiso. Then they moved to various neighboring towns and even visited Cochabamba in Bolivia and Osorno in the South of Chile. Finally they moved back to Valparaiso and later settled down in Santiago.

Little has been written about the Jewish immigrants to Chile and their internal migrations from the provinces to the major cities. We must ask if these internal migrations occurred due to financial conflicts or if they were caused by discrimination. My family lived in Osorno, in the South of Chile, during most of World War II. I knew very little about that region of Chile until my mother suggested that I write about her life in the South of Chile. As I interviewed her, I realized that I was getting much more than just my mother's life. I was hearing firsthand accounts about what it was like to grow up Jewish in Chile.

My grandfather, Joseph Halpern, was a traveling salesman, and he chose the South of Chile because there was a large German community already living there. It is also significant to note how many of the German and Austrian Jews decided to settle in Chile's southern provinces where they found a sense of homeland, belonging, and identity vis-à-vis living with pro-Nazi sympathizers. My grandfather loved the landscape of southern Chile

and he naively thought that Jews and Germans could cohabit peacefully in this remote rural corner of the world. Unfortunately, he was proven wrong. My grandfather was never allowed to belong to the German Club of Osorno and had to deal with the strong pro-Nazi sentiments of most of his neighbors. The little town of Osorno was full of people who were extremely prejudiced against the Chileans and the indigenous peoples as well. Again, little has been written about the German presence in Chile and the Nazi presence before and after World War II. Friends from the area told me that many of the German colonists would travel to international waters where they would vote for the Fuhrer while other friends in the Osorno police department confirmed that groups of Nazi youths met clandestinely before, during, and after the war. These were some details of life in Osorno that I obtained from the interviews I conducted when I was writing *A Cross and a Star.*

There are many small and great connections between Nazism and the German colonies of southern Chile. All we can do is speculate and meditate upon their existence since all that transpired within them is veiled by silence and indifference. Many Chileans I spoke to denied that such a relationship even existed. There were some who assured me that the colonists were fully immersed in the Chilean experience while others told me that the Nazi influence was devastating to the Jews as well as the inhabitants of southern Chile.

The anti-Jewish laws established by the Nazi were echoed in some of the racial laws that were set in place in Europe during World War II and later in Chile. These were laws similar to those that existed in the Untied States to discriminate against blacks or the laws throughout Latin America that discriminated against indigenous peoples. The Jews in Chile during the military coup occupied a very difficult and complex and almost secretive place in society. Paramilitary groups from the United States duly trained the military government of Chile. One of the key conspirators in the Chilean and Argentine coups was, ironically, a Jew named Henry Kissinger, and the relations between the governments of Allende and Pinochet and the Jews were ambiguous and distant.

Historically, we can say that a vast majority of the Chilean intellectual elite participated in the election of Salvador Allende in 1971. A group of Jews, afraid that the new, leftist government would become an anti-Semitic one, decided to leave the country during 1972 and 1973. This same group of Jews returned to Chile once Pinochet was in power. I point this out to show that the Jewish community was as politically divided as the Chilean society. Phenomena such as these have occurred in other countries as well.[4] The inverse phenomenon is also important to note, as many members of the Chilean Jewish community, especially writers and journalists, decided to stay and live in Chile under the Pinochet regime.

From personal experience I have always thought that part of the Jewish ethic lies in their feeling of social responsibility and, yet, I confirm that this is not always true. Throughout history, the Jewish presence has not always identified itself with social responsibility.

The number of disappeared in Chile among the Jewish youth was small in comparison to that of Argentina's Dirty War. In Argentina there was a very specific mandate to persecute the Jewish population that dated back to Peron's era. The Jewish community in Chile did not unite to demonstrate against the disappearance of Jewish youths. Such demonstrations did not take place until a democratic government was back in power during the mid-1990s and it was looked upon with severe criticism.

Obviously, all Latin American governments, with the exception of Dominican Republic, closed their doors to the Jewish migration or the "Jewish problem" as it was often called. Opening doors to the Jewish immigrants was difficult for countries such as Chile, used to having a homogeneous population, mainly white and of Spanish descent. The Jewish presence within Latin American countries became invisible, almost anomalous, and, yet, the anti-Semitic policies were obvious in the migration policies as well as the pro-Nazi sentiment that reigned in countries such as Chile.

The dilemma that the Jewish populations faced during the Allende and Pinochet years was complex and until recently it

was very difficult to research and understand. Even today, a lot of what is said about the Jewish population in Chile and the anti-Semitic policies is mired in speculation.

The visit I so anxiously awaited from my friend led me to write these pages. She has made me think a lot about our generation and the fact we are a generation of dispersed souls. We are voluntary and involuntary exiles displaced throughout anonymous cities, looking for the privilege of a new life and always reliving our memories.

My friend and I have managed to reconcile ourselves to the two worlds we inhabit and yet, whenever we meet we ask again: What would our history be like if we had not left Chile?

Translated by Monica Bruno Galmozzi

[1] For important research on the Jews in Latin America, please see Judith Elkin's work, including *The Jews of Latin America* (New York: Holmes and Meier, 1998).

[2] There is an interesting article about Chile and the Nazi party written by Sandra McGee Deutsch, "Anti-Semitism and the Chilean Movimiento Nacional Socialista. 1932-1945," in *The Jewish Diaspora in Latin America*. ed. David Sheinin and Lois Baer Barr (New York: Garland Publishing, 1996).

[3] To find out more about Jews and Nazism, please see *Judíos en Argentina* by Felix Vivas Lencinas (Lerner Ediciones) 1994 or *Argentina and the Jews* by Haim Avni (Tuscalosa: University of Alabama Press, 1994).

[4] Little is known about the history of Chile's Jews, especially during the Pinochet regime. An important book that will help us understand the history of Chile is Alfredo Jocelyn Holt-Letelier's *El paso de la noche, nuestral frágil fortaleza histórica* (Ariel, 1997) and M. Garces' *Memoria para un nuevo siglo* (Santiago, 1997).

Between Worlds

To imagine Latin America, to feel its history encompassed by a collective memory that is in a continual state of change and rebirth, is to dare to understand that this continent—dreamed of long before Columbus' "discovery"—is a place for the imagination of poets, historians, artists, and scientists. Perhaps Latin America offers us a place to understand the meaning of "astonishment," a place where the magic of the real and the reality of magic are in daily evidence. To feel the presence of its intermingled worlds is to understand its history—not through a chronicle of events, but through the coexistence of parallel times and histories, through rituals and myths.

The pyramids of Tenochitlan, living symbols of Mesoamerica's reality, still populate the imagination of ordinary citizens and writers who live not only in two cultures but also in the circular space between them, the space that brings history into daily life as a vital, continuous, unfragmented experience. Perhaps to understand the historical and artistic imagination of Latin America is not only to understand its ongoing modernity and post-modernity but also its daily encounter with traditions that are linked to Europe, Africa, the indigenous world as well as the realm where all those races mix. From this exquisite amalgam of vigorous, exuberant cultures, the Latin American continent emerges as a landscape that is unique in the history of Western culture. Figures like Christopher Columbus, Fray Bartolomeo de las Casas, Eva Perón, and Pablo Neruda are not insulated within a vertiginous and dramatic historical account, but their names are part of the everyday cultural experience of those countries that, united by the Spanish language, have created an original culture with an astonishingly rich artistic legacy.

Behind these constellations of real and imagined characters, there are hints of the presence of immigrants from the Old World.

They were itinerant travelers, magicians, and painters. They presage the arrival of the Jews who fled from the Spanish Inquisition, who sailed in Christopher Columbus' ships. The history of the Jews in Latin America stretches back to that time. It is amazing to realize that the first Sephardic community in Chile was founded in the southern province of Araucaria in Temuco in 1908.[1] Those Jews arrived from Smyrna, from Turkey, and then from Syria. Even today, Sabbath candles are lit by both Jewish and indigenous people of this remote and eclectic community.

Jews lived next to the ruins of Tenochitlan in Mexico City. Their history stretches back to 1492, when those who were expelled from Toledo began their long journey toward a Promised Land that offered them the possibility of a new life. In the twentieth century, it is still possible to find traces of these uncertain travelers present in the voices of painters, musicians and poets, in the stories of Angelina Muñiz de Huberman, a descendant of Marranos, of "converted" Jews. Her words reach back to the voices of medieval Jewish scribes, to Jewish mystics immersed in the universe of alchemy, the mysteries of the Zohar, to the itinerant travelers typified by the ancient seafarer Benjamin de Tudela. That glorious Jewish wanderer carried with him the precious texts that have united Jewish people throughout the centuries. Along with other marvelous transformers of conventional reality—artists, alchemists, prodigious travelers guarding well their memories and their myths—he serves as a metaphor for the Jewish presence in Latin America.

At the same time, these carriers of multiple memories and complex identities cannot detach themselves from the shadows and light of the past, nor from their participation in the diasporic history of the Jewish people. In order to translate their disparate experiences into an American idiom, they can incorporate a range of references into their work—references from the shtetls of Poland and the Russian Pogroms. A verse from Jewish Argentinean poet Alejandra Pizarnik conveys this timeless condition of the Jewish Latin American artist, a condition that encompasses both being and non-being:

> Mother used to tell us about a white forest in
> Russia and we made snowmen and gave them

hats that we stole from our great-grandfather. I used to look at her with mistrust. What was snow? Why were they making snowmen, and above all what does great-grandfather mean? (Pizarnik, 1980)

If the themes of exile, imagination and memory form a constant in the Jewish art and literature of Latin America, José Gurvich's work exemplifies them. Journeying from Lithuania to Montevideo, Gurvich represents the perpetual traveler who, while he gladly enters into the experience of the new world, constantly returns to his roots, affirming his multiple identities. Similarly, the Mexican painter Saul Kaminer, in a series called *Cruce de Caminos* (Crossroads), mingles the magic and rituals of ancient Mexico with the primal elements of air, water, and sky, exploring in palpable materiality the essence of soul—the internal/eternal vastness. The artist Elena Climent and the photographer Grete Stern oscillate between America's dazzling presence and the relative sobriety of the European context. Between these two territories emerges an art that is both modern and traditional, a true cross-pollination, an art that demands thorough contemplation of the image and requires multiple ways of seeing.

For many people, a small country like Uruguay, so close to the giants of Argentina and Brazil, doesn't represent their view of Latin American art—a view that sometimes reduces even imposing figures such as Rivera and Orozco to the level of kitsch. But it is precisely small countries like Uruguay that daringly succeed in reflecting a cultural heritage that fluctuates between the European past and the Latin American present, reinventing itself as it paints and writes. José Gurvich's encounter with Montevideo was an urban experience arising from relationships nurtured in small cafes and in the barrios. In Gurvich's art, the imaginative lyricism of everyday life is forcefully joined to an architecturally daring geometry, the strong presence of forms, lines, and angles. At the same time, in its interior narrative, its vision of men and women walking, living among streets and landscapes, this art of the familiar suggests the great pleasure to be found in the world.

The encounter with Israel and the kibbutz had a powerful effect on Gurvich's painting. Until then he had been comfortable with the role of diasporic wanderer and with the possibility of recreating his ancestral past in Lithuania through memory and imagination animated by an active Jewish identity. This encounter initiated a new pictorial strategy for Gurvich, one suffused with an inner luminosity. The presence of Biblical figures, sometimes reminiscent of Chagall, evoke a mystical presence.

Saul Kaminer's work discloses a mythical and historical dimension similar to the one that Gurvich found in Israel. For Kaminer, however, the journey didn't require the same degree of physical displacement. Rather, it was an interior voyage in which he sought ancestral roots through an itinerary of dreams, through travel to symbolic cities where water, miracles and Judaism were woven into the fabric of that quest. The encounter with the past, with ancestral heritage, was experienced by both Jewish and non-Jewish Latin American painters and writers who succeeded in incorporating the religious and spiritual legacies of Latin America's indigenous world in the same way that Gurvich encountered and incorporated his Jewishness.

In his works, José Gurvich creates narratives of memory, the cosmogenesis of a symbolic culture in constant movement. From the oil painting titled *Sabbath or How Hard It Is to Be a Jew* to his final visions of New York's geometry, we sense the presence of light, the sinuosity of curves, the presence of characters or objects centered in their own impersonal reality. Through all these depictions, Gurvich dreams, joining the slow procession of the centuries to an art that continually creates and recreates itself. Like the traveler Benjamin de Tudela, an artist's living memory carries an image of what we are and what we can become.

José Gurvich and Moico Yaker interpret and reinvent the condition of being a Jewish Latin American artist—Jewish not only because of Jewish origin but also because to be Jewish is to inhabit the universality of the human condition. This culminates in a new art, a new culture that makes possible the understanding that the structure of identity is not static or arbitrary but flows

like memory; at the same time evident and hidden, it accommodates both the ancestral and the modern. It forms the exquisite texture of the New World, a Latin America in dialogue with the past and with the eternal present. The extraordinary audacity and originality of Moico Yaker's paintings exemplify what Latin American writers have been doing since the sixties: imagining and recreating a continent where the mythical past is interwoven with concrete reality, a continent that harbors both cabalistic wizards and the faithful friars of the Inquisition.

Moico Yaker's painting is lyrical, narrative and enigmatic. History is not depicted as a linear progression but possesses the ability to look at itself as in a mirror where past and present simultaneously fluctuate. In Yaker's painting, the unending travels of Jews through the various regions of Latin America, as well as to the remote areas of the Andean Peru, are intermingled with images of the jungle, the dark magic of dense treetops. We discover shocking and incredible events, such as a Jewish marriage in front of a Catholic church, a church crowned not by a Cross but by the golden Star of David, a place where the "official history" does not attempt to reflect itself but to disclose the parallel histories of a continent of uncertainties. Here, Jewish travelers went secretly into the Amazonian jungles seeking refuge just as the indigenous populations, persecuted by the Spaniards, also sought refuge and identity in that dense forestation.

In Yaker's work it is possible to live in parallel worlds, in a continuity of symbols and secret signs that coexist without conflict. On the contrary, they participate in the magic flow of a continent and its history. Some of the images that emerge from the Peruvian jungle bear the Hebrew letter that begins the word "Shekhinah," alluding to the feminine nearness of the Sabbath in the heart of the forest. Yaker has been able to brilliantly join Andean culture to the closely guarded secrets of the cabalistic alphabet. Here the biblical paradise is intertwined with the indigenous paradise and we ask, once more, if the persecuted indigenous tribes might not derive from the "lost tribes of Israel."

From within Yaker's pictures, the viewer can imagine the narrative of Latin America, the vitality of lost communities in the

Amazonian jungle wearing their talith and lighting their menorahs, while simultaneously honoring the magical and medicinal powers of jungle plants. Yaker's paintings are poems created by images able to articulate and contain parallel visions of alternate and similar worlds—and able as well to conjure the nearness of God in the Amazonian jungle through the mystical permutations of the letters of the Hebrew alphabet.

Defined and nourished by Jewish themes, Yaker's work helps us to look at and understand the migration of the Jewish people to the Latin American continent and the parallel layers that converge on that continent, joining the history of the Jewish diaspora with that of the indigenous Indian. Yaker provocatively whispers of that which has been secret and unsaid. He hints at the oppressive presence of a colonial Spanish past vis-à-vis the enigma of the "otherness" of the Jews, the Indians, the invisible ones of Latin America.

The poetry of the Venezuelan Jaqueline Goldberg reveals a certain affinity with the representation of memory in the paintings of the Mexican artist Elena Climent. In a series of evocative poems to her dead grandmother, Goldberg attempts to recover those absences, to reassert by means of her voice the heartrending pain of that which is forever lost, and she says the following:

> Luba, Monte Avíla, 1998
> I gather
> her heritage
> of broken times
> the sad labors of abandoning her dead.

And in another brief poem from *Luba*: "díalogo / de pasillos diurnos / rafz. Memoria que soy [dialogue / diurnal corridors / root. I am memory.]" Though Elena Climent does not directly identify the Jewish experience as a primary source for her work, it is clear that her obsession with the recovery of the inner crevices of memory expressed through her continual return to the house—inhabited and uninhabited by her dead parents—assumes a profoundly Jewish dimension in its relation to the recovery of memory that characterizes the enormous production of Jewish art in a post-Holocaust era. By recreating her dead parents' world,

Elena Climent participates, albeit unwittingly, in this space and this dichotomy. In so doing, she names and honors them just as other Jewish artists have done by writing books, creating art, making living altars, recovering by those means a universe left empty by death. Climent does this by creating domestic scenes— doors, windows, shelves, old books, forgotten cards. I am reminded of the work of post-Holocaust painter, Tatiana Kellner, one of whose paintings depicts two books held together by two arms, containing the history of the artist's parents, Holocaust survivors. Climent's parents do not share that history, but her father escaped from Franco's fascist regime to become an exile in Mexico. According to Climent, her New York Jewish mother didn't assume her Jewish condition, suggesting an absence of rootedness and a rupture with a past still present but increasingly distant and uninhabitable.

Elena Climent's paintings resonate with the traces of that which remains, of what is felt but cannot be named. To wander into Climent's iconography is to enter into an intimate, private space, to find the uncertainty of memory and the almost impossible task of recovering it. In spite of her attempt to encapsulate her interiors with specific details and to paint concrete realities— the known spaces of a colorful, delicate and passionate Mexico— Climent brings to the recreation of these spaces an almost fearful distance, evoking a world impossible to fully retrieve.

After 1998, when Elena Climent became an expatriate, living in New York City for extended periods of time and then in Chicago, her visual representations become more powerful, leading always to an encounter with memory and a conversation with the past. The paintings of her childhood home, the candles and sacramental altars, become a liturgy that grasps the Judeo-Christian world in a personal and innocent way. The rich qualities of the movements of a perpetual traveler breathe soul into these works. She herself states, "Upon returning to Mexico, to my childhood home, I started to roam like a spirit through the house, trying to recover something that had been taken away from me. I felt a piece of my soul was trapped in there, and by painting the house I was recovering myself. I wanted to be free." It is precisely

this past, the liberating space encountered in the search for the ghosts of memory in empty and full houses, that connect Climent's painting with Jewish culture and passion and the culture of memory.

Though the search for identity often appears in the form of real and imaginary scenarios, the Mexican painter inclines toward abstraction through colors and textures, through a space different from figurative space, but equally moving, as is the case in the work of Ricardo Mazal. Mazal's painting responds to the possibility of a universe that paints itself, full of small and great bursts, and through these abstractions the painter as well as the viewer participate in fluid, circular time. Elizabeth Ferrer states in one of her essays introducing Mazal's work: "In a sense Mazal's abstract paintings might be seen as a profoundly personal form of autobiography. While this kind of work certainly resists direct open reading, it is through abstraction that he has found eloquent means for molding the emotional with the intellectual."

Each one of these painters seeks his or her own roots, the intimacy at the heart of their own stories. But in Mazal's paintings there is a permanent dialogue between light and dark, peace and upheaval, clear and somber spaces. In a similar way, Saul Kaminer converses with clarity and obscurity, with a universe of poetic images that share the qualities of symbol, image, metaphor. A mythic universe, geometric and abstract, appears in his work, underscored by a hallucinatory and courageous use of color. The titles of his paintings, such as *Dos manzanas (Two apples)*, announce and delineate the encounter with a paradise full of passion and desire, of curvilinear forms where women's sensuality is both the image and substance of desire. These works create, in a two-dimensional plane, metaphors and symbol systems that are capable of telling, stating, declaring. Many of his figures are deep in conversation with the shadows, but it is those same shadows that permit the experience of luminosity encountered in each one of his paintings.

"What we do not see is what allows us to see." Edmond Jobes, a Jewish-Egyptian-French poet, is highly regarded by Latin American artists and writers, who often reference him in their work. Esther Seligson, one of the most enigmatic Jewish-Mexi-

can writers, translated his poems from French into Spanish. I believe that Jobes functions as a kind of bridge between the written word and the visual arts, between image and the language of image. This is the essential reason behind Jobe's hovering presence in Kaminer's paintings. Simultaneously, it seems to me that he presages the work of Victor Pimstein, a painter whose work remains in the shared experience between painting and writing, between the gestures of words and their whisperings. The following is a brief quote from Jobes, a premonition of Pimstein:

"El corazón del dialogo está lleno de los latidos de la pregunta [The heart of dialogue is full of throbbing questions]" (33).

Victor Pimpstein's work echoes the accomplishments of Jobes, his dialogue with silence and its traces. Pimstein's canvases are suggestions, premonitions, and stories for the imagination. The paintings communicate with each other, establishing a conversation between luminous shadows and their absence. These voices appear in the canvas as autonomous forms. They also function as a way of "writing" through painting, The trajectory of Pimstein's painting arcs through the question, "What is the nature of the relationship between the painter and his painting?"— between history and the eye that "sees," that recreates through art.

The prevalence of gaps and of obscurities seems to be part of this suggestive narrative. If the works of the painters cited depend upon the possibilities of expressionism, abstraction and materiality of the image, the photographs of Grete Stern, as well as those of Pedro Meyer—Argentina and Mexico respectively— suggest integral parts of the experience of being simultaneously American, Jewish, and foreign on the American continents. Grete Stern is one of the pioneers of photography in Argentina and one of the most audacious exponents of a European avant-garde that gave Argentina its international flavor. The photographs of Grete Stern do not attempt to Americanize the image of a Latin America created and invented by the Europeans. What is audacious in them is that her images belong to her uniquely daring poetic imagination, her reworking of conventional reality through the transformation of the photographic image. They play with the alteration of light that surrounds the expressions that she so skill-

fully coaxes from her subjects' faces. Grete Stern, from Argentina, and Pedro Meyer, from Mexico and Los Angeles, play with faces as autobiographical landscapes, They are artists of an atemporal avant-garde, carriers of modernity but also witnesses to a specific history, to specific moments of time. Grete Stern's work carries within it the Bauhaus school, but transforms and recreates it in Buenos Aires—a Buenos Aires that could be Berlin or Frankfurt but is not.

Pedro Meyer, through his passionate digital inquiries and by means of characters who deeply conform to an autobiographical process, has chosen to be part of this history, to be a witness and an actor in his own recreation of it. The titles of one of his more memorable series is *Hago fotografías para recordar (I Take Photographs to Remember)*.

Pedro Meyer is equally well known in Mexico and in Los Angeles. His career crisscrosses many borders, artistic and geographical. Meyer's black and white portraits of both common and extraordinary figures in the history of Mexico are images in search of space, place, and identity. His photographs are open, full of light, permanently disclosing the here and now, directly registering the immediacy of experience and feeling. His long journey from the classic black and white photograph to the variegated marvels of the digital camera has allowed Pedro Meyer to synchronize disparate histories and times.

In thinking about what connect Jewish Latin American artists, surely, just as is the case with Jewish Latin American writers, it is more than the commonality of their Jewish origins. The question is complex, daring, and revelatory. I would like to propose that the notion of a Jewish experience of all these artists is important, primarily from the perspective of their shared participation in the history of the twentieth century, and often from the point of view that integrates the marginal and the excluded. I would go so far as to suggest that the "Jewishness" of these painters is linked to the peculiar universality of Jewish experience. With the exception of Gurvich in his later years, it is altogether likely that these artists have not thought of themselves as "Jewish artists," but the forms in which they have explored their condition are imbued with

a sense of identity related to the Jewish condition, its sense of history, and its tenacity in the remembrance of it.

Victor Pimstein states that the Jewish presence in his art becomes more marked when he becomes aware that his work is a meditation on certain aspects of "the Jewish question." With each one of these artists we can discern the desire to be a part of a history—both present and past—and to recreate worlds where history is lived cyclically rather than measured in linear units. That is to say that history and modernity, memory and remembrance, coexist. From the barrios of Uruguay to the cabalistic ruminations of Jerusalem and Safed, from the intimacy found in the silent paintings of Victor Pimstein, to the riotous color and texture of Ricardo Mazal, from the dislocated interiors of Elena Climent—altars where the Jewish and Christian worlds share a common presence—to the photographs of Stern and Meyer, we are invited to participate in an atemporal time, a time both past and present.

All of these artists dialogue with their identity and origin, with the condition of being and not being a foreigner. They celebrate that enigmatic destiny. At the same time, their spirit searches for other narratives and images—from ancient Poland, from an imagined Jerusalem, from Aztec Mexico, from the Ashkenazim and the Sepharadim, from the Argentina of Perón, from the Nazis. And in all these creations and recreations, the Jewish experience emerges as a specific interpretation of history, of working with the fragility of memory and its texture. In this perpetual search for who we are, where we come from and how we live, these Jewish Latin American artists constitute a community—not in their consciousness of being different but in their understanding that this difference is the fruit of a rich and complex heritage that flows between tradition and rupture, light and darkness. Above all, the collective memory of the Jewish people is also the memory of the West.

Clarice Lispector, a Brazilian writer of Jewish-Ukranian origin, states: "To write is also to bless a life which has not been blessed." These artists have lived a life blessed by an ontological search and by their sense of destiny, which—just like the religious experiences—is revealed in creative moments. They walk

in the steps of what has been said before, searching for that which is essential, a voice, an intuition and a rhythm. They share the image that sees and the word that names, and in so doing they are—or they become—Jewish artists.

These artists maintain a particular affinity with poetry, a profound communion with rhythm and language, both representational and abstract. These works make it possible to tell the story of Latin America, from colonial times to the present, from persecution to refuge. These artists are able to explore their cross-cultural experience, not as a mystery or an obsession, but as a celebration and a communion. Possibly, what best characterizes these works is the synthesis of cultures, a meeting that joins the real to the imaginary the mythic to the religious, the Jewish to the Christian. From the autobiographical portraits of Grete Stern and Pedro Meyer to Elena Climent's hybrid altars or Moico Yaker's biblical dream of Jacob in the midst of the Amazonian jungle, these are daring works, testimonies to the vigor of contemporary Latin American artworks that are not meant to satisfy a market and that do not resort to clichés to create an ersatz magic realism. I believe these are works of extraordinary vision, whose greatest value is their audacious imagination, the universality of their gestures and the undiminished vitality of their symbols.

Translated by Monica Bruno Galmozz

First appeared in *Entremundos (Between Two Worlds): Jewish Artists of Latin America. Catalogue Essay for Singer Gallery* (Denver: Mizel Arts Center, February 3-April 13, 2001).

The community in Temuco was founded in 1908 according to the book *Los judíos en Chile*, Enrique Testa (Santiago Editorial nascimento), 1989.

Works Cited

Ferrer, Elizabeth. University of Texas Museum Catalog: 1996.

Jobes, Edmond. *En su blanco principio*. Tr. French into Spanish by Esther Seligson. Editorial Huellas.

Lispector, Clarice. *The Foreign Legion: Stories and Chronicles*. New York: New Directions, 1992.

Pizarnik, Alejandra, *Editorial*. Sud Americana. 1980: 80.

Women and the Jewish Imaginary in Latin America

In the markets of Guatemala, it is common to hear the indigenous women ask, "Ma'am, will you allow me to speak?" To allow someone to speak implies an invitation to be heard. To allow someone to speak puts us one step closer to the Latin American testimony of the past few decades. When I speak of testimony, I refer not only to the written texts, or rather the dictated texts to be written by transcribers and literary critics, but also to the multiple voices of the continent that insist on the urgency of granting the right to speak.

What I call the Latin American *imaginary* (the process of creation and expression) is full of texts that, due to their historical and social complexity, have been called "bastard texts" by philosopher Jorge Narvez. These are texts that have existed outside of the mainstream, apart from the established canon. Reflecting the personal voice, the eccentricity of their creators, these testimonial texts represent a canon that is yet to be defined. Though one usually thinks of testimonial literature in terms of such notable autobiographical works as *I, Rigoberta Menchú* or *Let Me Speak! Testimony of Domitila, a Woman of the Bolivian Mines*, testimonial works also exist in the genres of fiction, drama, poetry, collective biography, and oral history. In whatever form it takes, testimonial literature assumes the recovery of a historical memory, but it also becomes part of an ideological project with an ethical and historical function that has existed since the beginning of the *Chronicles of the Indies*.

To give someone the right to speak implies naming and being heard. To grant speech implies bearing witness. Within the Latin American testimonial discourse we must include the letters of travelers, chronicles of those who came to conquer and found that urgency to narrate. I refer specifically to the chronicles of the

Spanish Jesuit Bartolomé de las Casas, a witness who denounced the abuse of the indigenous people by Spanish priests.

To witness implies an act of resistance, a space where telling things transcends and transgresses invisibility. The work of Bartolomé de las Casas and his successors tells and recreates the voice of indigenous people during the conquest. This is the tradition that continues uninterrupted for over 500 years. The Latin American testimony has been an invisible part of the national history of all the countries of the Americas, as opposed to the official history of colonial and military triumph.

The twentieth century has produced great witnesses who not only grant the right to speak to others but also take this right for themselves. Laura Rice Sayer, in her essay "Witnessing History: Diplomacy Versus Testimony," states that:

> Testimony is not a genre; it derives from a long tradition of witnessing. We have always been oppressed and exploited. The doubling of this oral history into a public plea will mark the coalescence of a number of historical factors in economics, in literature and in politics. (70)

Along the same lines, Hugo Achugar says " . . .to witness comes from the Greek 'martyr,' which means to certify to something" (31). Thus, he who witnesses certifies and gives credibility.

If Bartolomé de las Casas was a witness for the indigenous peoples of his time, the challenge today is to have the indigenous people speak for themselves. We must reevaluate and revise what the testimonial genre implies: a questioning, hybrid mix that intersperses the act of being a witness with biography and autobiography, uniting in one voice a plurality of voices where the collective and the personal are indivisible.

We cannot just say that the testimonial texts of Rigoberta Menchú, Carolina de Jesús, or Domitila Barros represent the "narrative experience." Rather, we must reevaluate the fact that telling something and granting somebody the right to speak do not imply only approaching history, but they also mean surviving through one's writing and inhabiting one's self through writing.

The three testimonial writers mentioned above, all women, represent a peculiar alliance among the women who tell the stories and the group of intellectual writers who appeared during the 1970s and created a Latin American literature that blurred the lines between the imaginary and the real. That is to say, the voice of a silenced population—in this case, women—makes it possible for another population, also silenced by the great spheres of power, to speak and listen. This is an interesting phenomenon that extends beyond the conventional definitions of testimony, oral history, and writing. I refer to the great social movements of the 1970s, such as the Mothers of Plaza de Mayo, which were headed by women. Within these movements, testimony becomes life itself and the audacity of memory. The women do not speak, and yet they allow their bodies, their hands, or their steps to speak for them. The Mothers of Plaza de Mayo carry kerchiefs with the names of their disappeared sons and daughters embroidered on them. In Chile women created the *arpilleras,* tapestries in which they tell the story that has been silenced. To witness also assumes the gestures of oral history and the physical or material representation of one's history.

The impact produced by the Latin American testimony as a hybrid genre represents the "closeness of the subject" in relation to the daily routine, the zones of affection, the house and groceries, but also the symbolic property of the act of giving, saying, and enunciating.

Those powerful and effective documents try to legitimize the cultural and historical happenings of the silenced peoples, which may include the minute details of daily life as well as monumental political struggles. The Latin American testimony fights exclusions, the not so subtle prejudices against indigenous peoples and women. Moreover, testimonies offer something even more basic and hardly ever mentioned, which is to give thanks for being alive, for life itself, for the gift of words, and for the ability to create and use symbols to express a vision. Latin American women, whether indigenous or intellectual, have participated in the past few decades in a collective sphere of mutual recognition on a symbolic level. Although Domitila Barros has said that not all

women are equal, we could say that the plurality and power of more than 500 years of testimonial literature have managed to create a similarity, particularly with regard to Latin American women's experience: a unity framed within the experiences of indigenous populations and European migrations, a hybrid zone that converges in its diversity.

If the testimonial discourse has been characterized by women's voices, whether intellectuals, weavers, or laundresses, the 1970s also saw the immersion of middle-class women in the cultural and political happenings of their countries. Among those women who began to tell their stories were Jewish women. The Jewish voice, as well as that of indigenous peoples, union activists, and intellectuals, became part of the spaces and the gestures of repressed words.

One of the first questions asked of me when I arrived in the United States was, "Are there Jews in Latin America?" Jews, according to various stories, arrived in South America after the Inquisition. Since 1492 Jews have lived among the hybrid population of Latin America and have often found themselves in an uneasy coexistence with their persecutors. Those who escaped the Inquisition became a minority within the group of Spanish colonizers and settlers of the sixteenth, seventeenth, and eighteenth centuries. More recently, refugees from the Holocaust have lived among Nazi sympathizers and escaped Nazi war criminals. Obviously, the Latin American Jew exists within the space of marginality, of otherness, of being errant and belonging nowhere. While many would dispute comparing the Jews to the indigenous peoples of Latin America because of their distinct roots and cultures, I would argue that the two groups share an invisibility and a participation in a discourse that is completely alien to the dominant culture. For instance, Jews have been able to participate in the economies of the Latin American countries but rarely in the political sphere. Up until a few years ago in Argentina, Jews were not even allowed in the military and one had to have a certificate of baptism to attend Catholic schools. Thus, for Jewish testimonial writers, there are certain themes in common with the work of "other outsiders," such as indigenous people and women.

Among these themes are the feeling of otherness; the awareness of diversity; the wish to share a symbolic environment that includes the discussion of home, heritage, ancestors, and zones of affection; and the possibility of a discourse filled with imagination and alienation from the permanent condition. All of these themes are part of being a displaced person.

The emergence of Latin American Jewish women writers in the 1970s occurred first in Mexico. The outpouring of autobiographical testimonial literature by Mexican Jewish women took place precisely because Mexico is a hybrid of the indigenous, the mestizo, and the immigrant; Mexico's broad diversity generates an environment and a space for all texts. Moreover, Mexican women writers such as Elena Poniatowska have created through their autobiographical and testimonial works a space for other women's voices. The testimonies of Jewish women attempt to put in context a history that, pulled out of context, has become nebulous and foggy.

Angelina Muñiz-Huberman is probably one of the most neglected and extraordinary writers of Mexico. Unlike some of her contemporaries, such as Margo Glantz, Muñiz-Huberman does not appear in the Mexican women's literary canon and yet, like Glantz, she is one of the great figures in the literature of Jewish women in Mexico. Born in Spain, Muñiz-Huberman took refuge in France after the Spanish Civil War, and fled to her current home in Mexico during the Second World War. When she discovered in Mexico that she belonged to a family of forced converts (*conversos*), this extraordinary event altered her life and her writing.

Huerto cerrado, her first text, merges autobiography with historical and personal memory. This text has certain similarities to the work of Rigoberta Menchú, who begins her first autobiography with the declaration, "My name is Rigoberta Menchú . . . " Muñiz-Huberman begins by saying, "I decided to write about my life per my confessor's recommendation" (14). We then step into a monologue, as is the case in all testimonies, but this time Muñiz-Huberman speaks in the voice of a nun who enters the convent in order to survive, yet knowing that she is a *conversa*. The text is

insinuating, ambiguous, and fragmented since through confession, Muñiz-Huberman goes through a long trip that is a testimony of the oppression of the indigenous peoples as well as the Jews during the Inquisition and the Holocaust. At the same time she focuses on a constant dialectic. She insinuates, "I don't know where the trust was. If there or here." The text suggests the intimate dialogues with herself and the self-portrait that is ever present in the genre of testimonials:

> The Inquisition, yesterday and today. Always the Inquisition. In the Nazi concentration camps between 1939 and 1945, in Spain in 1939, in Greece, in Brazil, in Mai Lai, in Burgos, trials of sixteen Basque people in 1970, in Moscow, trials against the Jews. Where there is a man on earth, there is torture. (20)

Muñiz-Huberman offers the possibility of various interpretations. Her text serves as a critique of the subdued condition of women before their confessors, the patriarchy, and the Catholic Church. She also reflects on the condition of being a mestizo Jewish woman, a *conversa* whose family arrived in the New World during the Inquisition and who makes a journey through history and memory.

The text by Muñiz-Huberman suggests a new way of combining the unwritten history of the repressed Jews from their arrival in the New World to the present time, accentuating this double marginality of being a *converso* as well as an exile. She places herself at the center of this history and takes possession of it:

> After the exile, in Mexico, I felt the pleasurable pain, but without God. Who could believe in God after the civil war and the Nazi concentration camps? And it was the pain of being exiled. (47)

Interestingly and cleverly, Muñiz-Huberman's work also manages to insert itself within the canon, the texts of the colonial period where the discourse places itself and assumes the condition of an autobiography. Muñiz-Huberman's account parallels Sor Juana Inés de la Cruz's response to Sor Filotea. The great

difference in Muñiz-Huberman's case is that she is a *conversa*. And yet, like the autobiographies of the colonial period nuns, hers is also a hybrid discourse—confessions made at the confessor's request.

In *Huerto cerrado* Muñiz-Huberman navigates haltingly between private and public discourse and between confession and dementia, but she also uses trickery, which is the discourse of the weak. She utilizes what is canonically accepted—the testimonial and confessional discourse—to subvert the canonical order (both literary and religious), writing in the voice of a Jewish nun who questions authority and truth. With this approach, she places in full view the importance of the history of the Jews from the Inquisition to the present. The Jews, as well as the indigenous people, are brought closer together; they are exiles without lands, without a common place to assert their identities. Although the Jews focus on the Diaspora, so central to Western Jewish tradition, the indigenous experience shares with the Jewish the concept of marginality, otherness, and prejudice.

If Muñiz-Huberman speaks of the hybrid and ambiguous identity of the exiled Jew, the Jew as the tenant, by taking on the persona of a converted nun, Rosa Nissan approaches the same subject from the perspective of oral history. Nissan, author of *Novia que te vea*, was Elena Poniatowska's student during a workshop that the writer directed. *Novia que te vea* reflects a magical symbiosis with the testimonial work of Poniatowska as a guardian of memory and a loyal reporter of the events of Mexican political history through oral testimony.

Nissan narrates *Novia que te vea* through the voice of Oshinika, a Sephardic Jewish girl from Turkey who lives in Mexico City. Oshinika attends religion classes, prays to Jesus, and collects religious stamps. At the same time, she is a Sephardic Jewish girl, raised in a strictly Orthodox Jewish home. The interesting thing to note is that Oshinika loves the religious stamps and all that is Christian. However, she can be easily identified as a Jewish girl:

> Yesterday during recess, we were making little
> mounds of sand and when I moved to enlarge

> my castle, I stepped on another girl's castle. She got so angry she threw dirt in my eyes and screamed "Jew, Jew." When I heard her I got scared. The majority of the girls do not know this. They got together and after a little while there were a few of them screaming "You killed Christ" and they made signs of the Cross on my face as if I were the devil. (30)

Nissan's testimonial centers on the constant dichotomy between being Jewish and being "the other," the world of the immigrants and the individual who is a native of that place. We should draw a parallel with other testimonial narratives that we associate with indigenous literature. For example, Rigoberta Menchú is accused of being a guerrilla, but even worse, an *"indio"* (Indian).

In Nissan's text, the central image of the girl, persecuted at school, demonstrates the essence of testimonies. Through this scene we see the hybrid nature of Latin America, and the distrust of that which is not homogenous, as well as the loneliness of an immigrant girl. This loneliness is comparable to that of the indigenous girl who, in order to write and denounce what has happened to her, must learn Spanish the same way that Oshinika must.

Novia que te vea oscillates constantly between the voices of the Old World, centered on music, traditions, and customs, and the New World, which is diverse and hostile. One of the things that Oshinika says could have come directly from Menchú's mouth when she speaks of her community, its secrets and its life:

> I am the one who argues the most. I defend my community and our customs. With the support from my father's eyes, I feel I speak for him. Not even my mother tells me to be quiet or pinches me. (70)

If the testimonial texts cover the subject's life from infancy through adolescence, the rituals that are associated with communities, as shown in Nissan's book, also put us closer to the history

of the Sephardic Jewish girl. Oshinika oscillates between the Catholic world, the *mestizo* world, and the complex space of that which is Arab or Jewish; she represents as well the independence of a woman who will not allow her family to marry her off. *Novia que te vea* is maybe one of the most important Mexican testimonial novels in the last decade, an example of the evolution of Latin American Jewish literature, uniting the testimonial and responsorial voices of a child/woman, a Mexican Jew, and a Jewish Mexican.

Margo Glantz, the third member of this powerful trilogy of Mexican Jewish writers, chooses in her novel *Genealogias* a different perspective from that of the converted nun or the confused child. Glantz, a sophisticated literary critic, articulates a Biblical period when "we all assume" our genealogies to the end of time. Perhaps the most well-known testimonial text written by a Mexican Jewish woman, *Genealogias* goes back to the history of the fathers and mothers. Glantz inserts herself within a national culture in order not to be an alien to Mexican history, in contrast to *Novia que te vea*, where the constant dichotomy between "us" and "them" appears and reappears. Glantz shares with Nissan the sense of the family as the space for survival within a hostile new environment where the forces of class and ancestors are at odds with the complex Mexican reality. For both authors, there is a recovery of identity, a mythological and symbolic return to the past. Glantz journeys to the Russian *shtetl* and, at that moment, returns to Mexico and incorporates herself into that strange Jewish, indigenous, and Spanish *mélange*. To recover photographs and write about them is an act of discovery, of possessing history and its silences, but it also signifies the recovery of a Jewish heritage with the stories of the Holocaust and the exiles. This gives Glantz a sense of the duality that Mexico represents, as symbolized by the Virgin of Guadalupe, the Mexican and Spanish crucifixes, and the photographs and material objects of the Jews in Mexico. When writing about this duality, she says: "It is all mine and yet it is not and for those reasons I write these genealogies."

Glantz' novel encountered unexpected critical success within Mexico, and it was followed by a series of testimonial texts that

dealt with ethnic identity as the central issue. For instance, *La Bobe (The Bubbe)*, by Sabina Berman, focuses on the relationship between a grandmother and her granddaughter. This text, with its generational focus, also examines the rediscovery of religious faith through the broken past of the Holocaust. *Las hojas muertas*, by Barbara Jacobs, is another example of the search for identity, in this case presenting the testimony of a daughter of Lebanese immigrants to Mexico.

If the twentieth century is characterized as the century of the displaced, the refugees, and the immigrants, it has also been a period during which, within Latin American literature, there has been a desire to explore our identities, to visit the past to be able to touch the present. The texts described above incorporate the knowledge of the foreigner, that which is alien, the one percent of the Latin American population. Among the essential features of these documents are the alliance between truthfulness and fiction, the overwhelming passion of memory and remembering, together with the negotiation of dual and complex identities. They explore the national identity of Mexico in order to establish the voices of the immigrants within the great social pattern. They serve as a model for Jewish women writers in other countries, such as for the journalist Alicia Segal of Venezuela, author of the testimonial novel *Clapper.*

There is also in these writers a deep desire to narrate their experiences, to give testimony, to allow others to speak. This is, without doubt, a most important phenomenon in this troubled century. To write is perhaps to mitigate loneliness as well as to take possession of speech. The Spanish philosopher Maria Zambrano asks, "Why do we write when we have the possibility of speaking?" (11). But that which is immediate, born of our spontaneity, is something for which we are not integrally responsible. We speak because something hurries us along to do so, but through written words we are truly free. Each one of the texts mentioned herein is part of an interesting vision of what it means to be a Jewish writer in Latin America. I must point out that the heritage language, in this case Yiddish, is alien to the national language, Spanish, a characteristic that Jewish writers share with

their indigenous counterparts. But as both groups have claimed their right to speak—and to write—in the Latin America of the late twentieth century, they have enriched our understanding of this region in all of its complexities and contradictions.

Translated by Monica Bruno Galmozzi

First appeared in *Multicultural Review*. 8 (March 1999) 36-40.

Works Cited

Achugar, Hugo. *Ideologies and Literature*. Minneapolis: University of Minnesota Press, 1994.

Barros Chungara, Domitila. *Let Me Speak*. New York: Monthly Review Press, 1979.

Berman, Sabina. *La Bobe*. Mexico: Editorial Planeta, 1990.

De Las Casas, Bartolome. *The Devastation of the Indies: A Brief Account.* Johns Hopkins University Press, 1992

Glantz, Margo. *Genealogias*. Mexico: Secretaria de Educación Publicas, 1981.

Jacobs, Barbara. *Las hojas muertas*. Mexico: Editorial Planeta, 1994.

Muñiz-Huberman, Angelina. *Huerto cerrado*. Mexico: Editorial Oasis, 1985.

Narvez, Jorge. *La invencida de la memoria*. Editorial Aconcagua, 1994.

Nissan, Rosa. *Novia que te vea*. Mexico: Editorial Planeta, 1997.

Rice Sayer, Laura. *Ideologies and Literature*. University of Minnesota Press. 1994, 70.

Segel, Alicia. *Clapper*. Caracas, Venezuela: Monte Avila: 1987.

Zambrano, Maria. *Los claros del bosque.* Seix Barral, 1986

Where Esther Lives

Does Esther live in a transparent region of air, among pyramids and Meso-American gestures? Maybe she lives in the streets of Jerusalem, deciphering alphabets and the blank spaces between letters? Esther Seligson's presence is intangible in Latin American literature or, better yet, in Western literature because no one writes like Esther; no one is like her, and so it is impossible to place her and make her fit into literary or academic canons.

Esther Seligson is an extraordinary voice. Hers may be the most unique voice I have ever read, and as I read her I can feel her in the most ample meaning of the word encompassing knowledge and the soul. Seligson and her voice ably fuse those searches through words and intuition, knowledge and faith. It is impossible for me to speak of her objectively and rationally. I love her literature because it speaks to me as if it were a river, a word that comes and goes in my ears. I choose to write about her and visualize for the reader certain paths that encompass her written universe. I also would like you to read her work and find in her a teacher because she has been a great teacher for me.

Esther Seligson was born in Mexico City on October 25, 1941, but she could have been born in Jerusalem or Prague. I am very grateful it was Mexico, though, because she turned the Spanish language into a gesture of awe and beauty. Esther Seligson is a word searcher. She looks for ancient myths like those of Euripides and Penelope, and she looks for the origin of things and words. I agree wholeheartedly with the wise words of Juan Galván Paulín who says the following about approaching Seligson's texts:

> There are two fundamental aspects to Esther Seligson's work that can be identified throughout her literary production; aspects that I dare point out as the sustaining force of her particu-

lar brand of poetics and at the same time, influential in her critical task: one of them, which I consider to be the point of origin, is the *Sentence and Loneliness of Euripides*; the other one is the *Diaspora*, which I conceive, from my arbitrary interpretation of *La morada en el tiempo*, as a way of acquiescing to the apprehension and knowledge of the Being who is submerged in the despair in which reality and historical causality have placed her; that is to say, destiny. (*El cuento contemporáneo*, 3)

If destiny is historical causality organized by God's whims, Seligson's literature presents the possibility of words as a way of being, as a way of arriving at the beginnings of time and the origin. Words are the sites of reflection and texts are intrigues that participate in an act of revelation. If I could ascertain and decipher her work (which is almost impossible) I would say that Seligson's literature is a literature oriented toward invoking words as an act of revelation. That is why the arbitrary relations between prose and poetry disappear in her writing. The author, both poet and magician, participates in a fluid and circular text that always goes back to the departure and expulsion but also focuses on the possibility of searching for and finding clues: "Behind his eyes you could see the nostalgia of landscapes he never knew, within his arms was the space of shapes not held and in the middle of his chest a scream of voices that could never be expressed" (*El cuento contemporaneo* 14).

How Esther Seligson Searches

Her books are many, but maybe there is only one book that functions as the marrow of her creation and creativity from *Otros son los sueños* (1973), *Diálogos con el cuerpo* (1981), and *Sed de mar* (1986) up to her most recent publication, *Hebras* (1995). Her books return to the same place: the search for the origin of time and words, through God, yet it is not that arbitrary and conventional God of the Judeo-Christian faith but rather a God

that allows people to veil and unveil him, a God that contains all the words of memory and oblivion.

Her books are rare jewels and challenge the reader to luxuriate in a labyrinthine structure without a goal beyond the encounter, savoring the sensuality of the language. I find a possible path to Esther Seligson in *Diálogos con el cuerpo* and it is here that I find her the most, where she allows her inner self to show through a mirror of clear water. *Diálogos con el cuerpo* is a proposal of writing and life, the union between words and joy, a communion with writing. In "Vigilia del cuerpo," Seligson says,

> When the gaze explodes it becomes word and the word then demands an answer and becomes dialogue; a dialogue of caresses that return the gaze like a spiral of voice mutely articulated, intertwined in the fingers, the lips, the breath that courses the circles of the spiral, bubbles of pleasure, the joyous state of being like this, intertwined while looking and while being silent, the swaying of murmurs that enlarge the space where the eyes love with the word and the word loves with the caress. Even if we hid the gaze, the spiral could continue to be there, a current of nonfatuous fires, boiling dilated to the edge of each broken circle, a point where the faint recovers its impulse and goes up to be abandoned again, to shake the waves that being silent has removed from the eyelids, the nasal cavities, the edge of the lips, the throat that beats incubating its earthquake of words, of ready gazes to be converted into pleasure, the bursting and expectant dam. (61)

Diálogos con el cuerpo is an itinerary through the body of the text, the body of the being and the body of writing where the gaze that exists becomes a dialogue and comes to the calling that, as Seligson notes in her final paragraphs, is an absence: "mystical and unspeakable, Nothingness is an abyss to which we aspire and within which voice, gaze, Names and skin disappear" (63).

We return then to the initial words about Seligson's writing process: origins, searching, descent, and absence. We could translate this absence as the presence of a woman who writes not only within the Judeo-Christian tradition but also in an intense process of searching for the origins of life. *Diálogos con el cuerpo* is a journey through the sensory experience of speaking with desire and the crossroads of desire. As Seligson says in "Realización del cuerpo":

> Seeing, touching, listening, naming: coursing through a body is realizing the act of words and that they are mouth, tongue, ears, gaze and hands, that they feel, taste, listen and succumb, letter by letter, syllable by syllable and they mimic in their rhythm the original act of inhabiting space. A body is the home of the verb and in it we have the meeting point of the worlds of dreams and waking, the encounter with the memory of times that in their travel bags save fragments of all possible images, the traces of all gestures and sounds necessary to begin the search and obey the calling. One goes out toward a body like one begins a journey down an unknown path, sails full of portentous winds where the moon does not decline and the sun never sets, without any compass other than the guiding star and the obedience to a wise instinct that haunts those rumors whose sense will reveal the encounter with the object of the search, the cave of repose, the port where we can anchor the desire to recover the new horizon.... (67)

All approaches to Seligson's work presuppose not only the search but also the calling, the gestures of the calling, and the knowledge that this calling encompasses all states of being and not being, the origin and the return.

Sometimes I read her texts and I stop within them and I respond to that need to rest my hand on them because reading her books is equivalent to entering a cyclical experience of all of that which flows, that is fluidity and that is a living presence, the

open spaces of the mysterious alphabet that Seligson weaves and continues to weave since one of her most important books is *Hebras (Threads)*. In this collection of her stories, love becomes history, the hummingbird and the eagle commune because love is that familiar face "a map of remembering" (22).

Sed de mar is also a prophetic text filled with secret and resounding cavities. Through this book of ten *cantos* or poems in ten similar voices, Seligson approaches each story as if it were a crystal that crystallizes itself. *Sed de mar* represents once again the search. It is not a heroic search like Ulysses' search, but rather it feels like the diary Penelope would have kept, the diary of a woman who waits. This is my favorite book by Esther Seligson because it fills me with joy and I find myself elated in the possibility of this writing that reinvents history. This book reflects Seligson's genius as she invents and transcends stories like that of Ulysses and makes Penelope the character that embarks on a journey.

WHO IS PENELOPE?

Penelope is not the woman who weaves in order to unweave her loom, instead she is a woman who writes in order to rewrite herself. "Penelope," in *Sed de Mar*, is a text that relies heavily on phonics and must be read out loud. As you read this story, it reaches an amazing force that drags you with it and fills you with a richness that allows you to find its illuminating identity in words:

> An image, I chase an image whose name I cannot find. I chase a name whose letters I do not know, unpronounceable letters and I need to speak to you, Ulysses, speak in order to know if this time that I for myself is real time, if truly the wait no longer exists or has just fallen within another disenchanted parenthesis, if I am not losing myself in the words by virtue of not being able to hear them, by virtue of only hearing them within me without making them flesh, boneless, they are whirlwinds of vapor that my own breath disperses.... Speaking, yes, recovering that dialogue that needs no explanations to explain it-

self, the weaving with threads of small daily oc-
currences which accumulated in the silence and
which explode into words like prisms exposed
to the luminous rays and they open up and
change colors. (11)

Here Penelope is speaking directly to me because I, the
reader, am the carrier and receiver of these letters. I feel naked
before these words because in both *Sed de Mar,* and *Diálogos con
el cuerpo* Esther Seligson leaves deep imprints. I am the receiver
of these letters. Am I the one who must return over and over
again to read Penelope's words and secrets out loud?

In another text, Euriclea speaks, and she produces another
vision. She dispels the existence of words, of these letters, as if
she were discrediting the very existence of the writer. Then I ask,
where does literature begin? Where are the myth and the invention?
Curiously Euriclea gives us the guidelines of what is and what is not
writing and the ups and downs of saying and not saying certain
things, little riddles around the spaces occupied by the writing of
memories and forgetting: "And if I wrote, I do not remember
when I began to write or how the papyri arrived one after the
other, and the ink well, the pen, the drying powders" (*Sed de Mar,*
19).

Living in Time

If Esther Seligson's writing is a meditation on the search for
the origin and for love, it is also a poetics about love. The soli-
tude of Euripides and Penelope is symbolic of the search for
memories and histories as well as a destiny.

Now I pause and reflect on *La morada en el tiempo* (Mexico:
Raya en el agua, 1992). For Esther, this is one of her fundamental
books. Many times, Esther told me that of all her books it would
suffice to read *La morada en el tiempo.* I have read this book nu-
merous times in order to reach its depth and become part of it. It
is important to note that reading Esther Seligson's work does not
allow resistance or simply a linear exploration of her narrative. I

would dare say that reading her books does not allow for rest. Her writing demands an effort and a quasi-religious vocation. To read Seligson's work implies alliances and commitments. Reading her books, like reading biblical texts, implies studying.

La morada en el tiempo is a novel of great magnitude. It is extraordinary and striking. It would be puerile to say that it deals with … because her book confronts us with exile and human history. *La morada en el tiempo* proposes the history of the expulsion and the initial Diaspora that condemned the Jewish people to a perpetual Diaspora. If the Diaspora is the common thread in the text, we must say that the book is also driven by the power of memories and remembering. In this sense, I dare say that *La morada en el tiempo* assumes the condition of the dispersed Jewish people as an act of full remembrance whose greatest gift is memory.

This is a text full of journeys, beginnings, and origins, but like the preceding books that Esther wrote, it is also a text about resignation with one's destiny. We do not mean a silent and paralyzing resignation with a prophesized destiny, but rather a search for the real being and the exploration of the meaning of all things, the pain and the departures:

> And because hunger was great and the earth could not provide for them to live together, parting from one another in the heat of the day they each took a different road, brothers running away from one another. Nomadic blood. Rejected on all fronts and combat areas, accused of treason, pushed from right to left and from left to right, from north to south and east to west. When would they take destiny in their own hands? The teacher, clerk and copier by trade had learned how to read during his daily routine and when faced with death, did not fear it. Better yet, he knew how to find his way among pillars of rigor and pity and knowing the human heart – mirror of the mystic rose – attempted to fill his disciples with the desire of submitting to the will of Providence… (96)

If it is a "miracle to survive in misery," so it is to live, record, assume one's role as a man or woman and assume the presence of love in our lives:

> As the Lover of the Beloved I shall speak: You lit in me the devouring desire of your presence only to make your remoteness and your silence unbearable. Love promised in my younger years, why did you not know how to read in them the premature sowing of your seed? My steps were the shadow of moving sand. Why did you not plant lush gardens in its path? (115)

La morada en el tiempo is a text that must be inhabited, lived in and rested upon while pondering the destiny of things such as origins and divine time. One of the most beautiful parts of the books talks about Rebecca:

> Dream Rebecca. The one sought by Abraham for his son, seed of his own seed. Under a palm tree, in the shade of the sixth hour, near the well where the shepherds water their sheep and the women come to get water. Sitting on the ground, skirts gathered under her thighs, elbows on her knees, she contemplates the plains that spread at the foot of the hill. Empty. Nothing moves. Nothing interrupts the nakedness of the earth that undulates violet and amber. (115)

Darrell Lockhart collected a series of essays about Judeo-Mexican literature with writers such as Margo Glantz, Angelina Muñiz-Huberman, and Esther Seligson. He asks at the beginning of his article, "Where does Esther Seligson live, in Mexico or in Jerusalem?" Or is she a "pyramid of sects" as Hana Wirth Nesher states in her book, *¿Qué es la literatura judía? (What Is Jewish Literature?)* The search for the origin is not motivated by the birth of the Jewish being, but rather from a way of being in the world, of looking at the human experience under the lens of what it means and what is implied by being Jewish. As Robert Alter states:

> There is something presumptuously proprietary about the idea of dividing writers by their na-

tionality, ethnicity or religious background, as if they were a bunch of potatoes whose principal characteristics could be determined based on whether they come from Idaho or Maine. Obviously, the primary focus for a useful critique of any original writer has to be tersely based on their individual imagination that has attempted to articulate a personal sense of being and of the world through a literary mean and this attention to individual characteristics instead of the shared characteristics is particularly necessary to understand serious writers of the latter half of last century, many of which were alienated in one way or another from their original social groups. As a matter of fact, as we are reminded by the chilling confession about Kafka's auto-alienation, some of the more perturbed modern writers, and thus the most representative ones, have become alienated from themselves, persecuted by the fear that all affirmation or act of communication is a falsification, a treason.

La morada del tiempo is a Judeo-Christian text that takes on the search for God, man, the Divine presence and the mundane aspect of all things. It is a text where man's spirit travels through the tribulations of its own existence. It is a symbolic narrative where we see a parade of known or transformed characters, like Raquel Jacobo the Shekhinah, the luminous presence of woman as an embodiment of God, the expulsion of the Jews from Spain in 1492, allusions to the Talmud and the Zohar. In these affirmations we see the Jewish presence as a prophecy or revelation.

Who Is Esther Seligson?

Ilán Stavans says in "Visions of Esther," that Seligson "is an almost invisible character within Mexican literature." Weren't Rosario Castellanos and Sor Juana invisible as well? Maybe we could see the reverse of this question. How is it possible that to date no one has approached Esther Seligson? The critics have

denied her. It is absurd to think that because she creates obscure literature she does not have any readers. Weren't Clarice Lispéctor and María Luisa Bombal obscure writers too? Thus, I do not agree with the premise of Ilán Stavans' statements. The fact that minor publishing houses have published Seligson does not mean anything since at one point Borges, Cortázar, and Mistral suffered the same fate. And yet, the most miraculous happening of all was that Mistral won the Nobel Prize.

Esther Seligson incites me to think about the role of the critics with regard to certain women who are "dangerous, subversive and disobedient." Frida Kahlo was also an unknown until people suddenly suffered from "Fridamania" manipulated by the merchants and the media. I dare say Esther Seligson's literature is so extraordinary, lyrical, and daring that it does not allow room for manipulation. Seligson cannot be catalogued as a postmodernist or an ancient ancestral. Esther Seligson is the only one who writes this way. No one can write like she does. Very few translate with as much beauty and attention to detail as Esther Seligson when she approaches the texts of Edmond Jobes and like Jobes, her literature does not occupy any space because her writings imply a total opening or as Caillios says, "it is a continuous work as well as a work enclosed in itself; it is labyrinth of identities."

Esther Seligson is not invisible. She has won awards, lectured, written an extraordinary book about literary criticism where she is also magnificent, restless, lucid, and poetic. She wrote *Hebras,* a rare jewel that we should carry throughout our lives and love.

I, as the writer of this essay, have difficulty writing about Esther Seligson. I am filled with fear and danger as I write this. But please know that I have done this with love and the desire to unveil the darkness. Esther Seligson is like an illuminated manuscript and reading her books requires faith, effort and passion.

Translated by Monica Bruno Galmozzi

Works Cited:

Alter, Robert, "Jewish Dreams and Nightmares," *What is Jewish Literature.* ed.Wirth-Nesher. Philidelphia: Jewish Publishing Society, 1997.

Caillios, Roger. preface, Edmond Jobes trans. Esther Seligson *en su blanco principio*. Mexico: Collection sin Nombre, 1997.

Galvan, Juan. *Aproximaciones a Esther Seligson*. Mexico: Universidad Nacional Autónoma de Mexico, 1990.

Lockhart, Darrell. ed. Jewish *Writers of Latin America: a Dictionary*. New York: Garland Publishing, 1997.

Seligman, Esther.

———"Vigilia del cuerpo" *Diálogos con el cuerpo,* 1981.

———*El cuento contemporáneo*. Mexico: Universidad Nacional Autónoma de Mexico, 1989.

———*Hebras*. Mexico: Collection sin Nombre, 1995.

———*La morada en el tiempo*. (Mexico: Raya en el agua, 1992.

———*Sed de Mar.* Mexico: Artifice 1986.

Stavans, Ilán. "Visions of Esther" *Tradition and Innovation: Reflections on Latin American Jewish Writers.* edited by Robert Di Antonio Albany: State University of New York Press, 1993.

Jewish Women in Latin America

So many times I asked my grandmother, Josefina, if she met other women on her journey across the Andean Range from Nequen, on the Argentine-Chilean border, to the hilly town of Valparaíso, where she made her home among the rocks and the sea. Her memory is frail and she remembers the hardships of the journey and the songs of the muleteers, but not the women. This anecdote is emblematic of the situation of Latin American Jews and especially Jewish women: forgotten in the annals of History, not included in the national consciousness of society and made to feel like outsiders or distant neighbors. To quote the work of distinguished historian Judith Elkin in *The Jews of Latin America* she says, "Jews do not figure in the post-independence history of Latin America as currently written. Overlooked by Latin Americanists as too few and too marginal to affect the areas of development, they have likewise been regarded by North American Jewish scholars as outside the course of Jewish history." Elkin goes as far as to ask, "Is there such an entity as Latin American Jewry?" Yet, we must remember that the Jewish experience in the Latin American republics was diverse and the history of Jewish immigration to Chile is inextricably tied to the politics of anti-Semitism and economics and to the fact that each republic of the twenty-one countries is absolutely diverse.

I wonder if I may change the question and ask why such invisibility for the Jews, especially the women, of Latin America? I would like to say that perhaps the answer lies in their small number: less than 1% of the population of most Latin American countries, and in Chile they barely number 20,000. Yet, even if the numbers are insignificant, Jews have influenced and shaped the destinies of the Latin American countries in the areas of culture and commerce, and they exemplify the fact that Latin America

is not a monolithic construction of Catholics. The legacy of Spain's inquisitorial past and the difficulty of Jews living in a profoundly Catholic society has made their presence, and their alliances, ambiguous and complex.

I will speak to you about my country, Chile, and address issues of contemporary relevance in the lives of women. But first let me give you some background. Chile occupies an almost anomalous place in the wide spectrum of European Jewry because of its remoteness. The Jewish community has been very small there since the 1800s and the great distance between Chile and the rest of world trade resulted in a slower and later emigration. The first identifiable Jew in Chile Stefan Goldsscak, an engineer from England, arrived in the nineteenth century. The Ashkenazi arrivals at this early stage happened mostly individually, contrary to the phenomenon of the Sephardic communities that arrived together as families or in groups and settled in the Araucanian Indian territory of Temuco, calling the first Sephardic community Macedonia. The first Sephardic Jew born out of this community was called Enrique Testa and went on to become Minister of Defense in the Allende years. There are some Araucanian Indians who call themselves Iglesia Israelita and they practice religious rites.

As mentioned before, emigration was slow and intermarriages between Ashkenazi and Sephardic took place with great hostility and houses of worship were united. Little is known or has been investigated about the history of the Jewish women of Chile (no book-length study was found) and according to my research for this project I have learned that one can find most about Jewish women from archival records dating back only to the 1920s and these records are found in the Departamento de Estudios Judios. The early lives of the Sephardic Jewish women who arrived in Latin America are not documented, only the men appear in these documents. Most of my research was gathered from Pasi Programa de Asistencia Israelita and WISO. One of the issues I would like to pursue is that the Jewish community has a strong leadership in the hands of women. There are seven organizations in the country exclusively dedicated to women's issues

whose directors are women. WISO, the Women's Zionist Organization, the Association of Professional Jewish Women, the Ben Gurion School for Higher Education in Santiago and in the provinces, as well as the Hebrew Institute of Viña del Mar and Santiago—all are highly visible institutions run by women and directed by women. I would also like to point out Juanita Leibovich, first woman judge, Sonia Tschorne, Director of the School of Architecture, Jacqueline Weinstein, Director of the Agency of International Corporation, and Clare Budnik, Director of Public Libraries. I must add that women have had a great impact in the leadership of the Hebrew schools in which I was educated and must also say proudly that the graduates of these schools were considered the best in the nation. The women that ran these schools at first were Eastern and Central Europeans. Starting in the 1960s and 1970s the leadership moved to the hands of the Chilean-born. We must note, that as in most schools of Latin America, there is an ideological definition of these schools and it is very much defined by socialist tendencies. The Hebrew schools have a socialist ideology.

The older generation of Jewish Chilean women, especially the ones born from the 1900s to the 1930s, did not occupy public offices, but neither did other women at that time. The great wave of women's participation in the public sector began in the 1950s as Chilean women in general entered the work force. Presently, according to the censuses of the 1970s and 1980s, 97% of the Chilean Jewish women obtained professional degrees and are studying now. The participation of Jewish women between the ages of 25 and 44 in the work force is 71%. Eighty-two percent of the work force today was born in Chile, and they have had an important impact in medicine, law, and architecture, as well as the arts. Three Jewish women have been appointed as: judge of Minors, director of libraries, and director of the office of development, and women, such as Frida Modack, have had a very important role in journalism. Two Jewish women have, consecutively, headed the School of Architecture.

In spite of the very small number of Jews in today's Chile, women have important leadership roles and, in the area of poli-

tics, Jewish Chilean women began with a historical role. Thanks to the liberal position of Salvador Allende, an unparalleled number of Jewish men and women entered political life, such as Allende's Minister of Foreign Affairs, Volodia Taitelbaum; Defense Minister, Enrique Testa; the Minister of Education, Enrique Kirber; and the Press Attaché, Frida Modack. Allende also appointed Lucia Guralnik as the secretary in Chief of the Socialist Party, who committed suicide when her son was murdered by the secret police in 1974. Unfortunately, the participation of so many Jewish intellectuals was looked upon with disdain by the right wing, and their propaganda accused Chileans of being involved with Bolshevistic commercialism. After Allende's fall, the Jewish community became very divided, and I would consider this to have been a period of great tension and migratory patterns, similar to the sentiment of the 1930s when left-wing leader Carlos Vicuvia Fuentes wanted to allow more Jews access to Chile while Foreign Minister Miguel Cruchaga opposed this migration. Recently the Latin American world Jewish community accused Augusto Pinochet of discriminating and persecuting Jews in Chile. The names of approximately 20 Jewish women can be found on a list of disappeared people in early 1974. One of these women is Dina Arom, a promising young writer who was kidnapped in Argentina during operation Condor.

After almost 20 years of silence, Chilean Jewish women now occupy a very important and visible place and that their art is identifiably very Jewish, such as the works of Patricia Israel. Her powerfully provocative paintings with versions of Lillith and Eve, her ethereal invocations of the Shekhinah and the Prophets, constitutes the most visible Jewish painter of Chile.

In the performing arts Anita Klesky and Shlomit Baytelman have had an important role in national theatres and in a very small and at the same time extraordinary way they have tried to revive Chilean theatre. In the area of literature, the situation of Jewish women is of great complexity. Few writers have identified themselves as Jewish and, thus, have not explored their complex hybrid identity with the exception of Sonia Guralnik and, if I may say so, myself. Guralnik came to Chile at the age of ten and

began writing at the age of 60, in the early 1980s. Her work, which is not part of the mainstream of the Chilean literature, depicts the tribulations and emigration horrors of her life in *La Pensión de la Señora Gittel*. She also wrote an important collection of stories entitled *El Samovar*. To this date, she has been unable to find a publisher for *Sefiora Gittele*.

Chilean society, until the Pinochet dictatorship, was a flourishing artistic community with an important film festival, musical and theatre performances held at the seaside resorts of Viña del Mar. Jewish women had a prominent role as actresses, filmmakers and musicians and integrated themselves in the community.

Jewish culture in Chile, and especially in the neighboring Argentina, has survived in spite of political repression and the horrors of a military dictatorship. We must remember that in both Chile and Argentina, 10% of the disappeared were Jews. I would also like to mention the work of Lucia Weiss, sculptor of international stature, Lea Klimer, photographer, and Lotty Rosenfeld, a performance artist who has had a very powerful impact during the years of the dictatorship doing Acciones de Arte, which consisted of painting crosses on the pavement and stars with powerful statements written in them, such as: "Aqui se tortural."[1] These were some of the most daring forces in the resistance movement against the dictatorship.

Sonia Guralnik explores issues of displacement emigration and often the secondary role that women played in the Jewish household during her married life. Chile hasn't produced the multifaceted memoirs of Argentine, Mexican and Uruguayan Jewish writers. Veronica Zondek is a Jewish poet inclined to a more abstract and utopian language. She was raised in both Santiago and Jerusalem and returned to Santiago in order to write in Spanish. And, yet, both she and Guralnik remain odd, anomalous figures in the very politicized world of Chilean literature.

My own story is that I am a Jewish writer who lives in the United States and writes in Spanish. My contribution to this field is the writing of two memoirs dedicated to the lives of my mother and my father and, through their lives, not only honoring them,

but re-writing and reinserting the little spoken of and the little known life of the Chilean Jews. As a child I would always be asked whether I was Jewish or Chilean and, thus, my identity became always conflicted, always a matter of either/or and seldom both.

The history of Jewish women in Chile is transparent, illuminating and profoundly complex. The lack of archival records in Santiago's Documentation Centers and the fact that many settlers changed their names, such as my own grandmother, and the Catholic dominance over the country's political affairs, obscures the historical record of the country. Nevertheless, the presence of Jewish women is a vital one in a society that represents itself as homogenous. To speak and act as well as create as a Jewish artist and to redefine one's origin has been problematic and enigmatic. A constant hybrid existence where identity is not always so clear and the constant question about whether you are Jewish or Chilean, but never both, are ever present. The voice for Jewish women as a collective is yet to be created. What is most revealing is the fact that Chile has failed to recognize *otherness*. It is a society unconcerned with pluralism. The Jewish presence reaffirms the need for alternative options and the recognition of justice and the legitimacy of their contributions to a homogeneous society. The Jewish presence in Chile has forced the country to recognize the outsiders within.

Translated by Monica Bruno Galmozzi

Originally appeared in *International Working Paper, Haddasah* (Waltham: Brandeis University, 2000).
[1]"People are tortured here."

Works Cited:

Elkin, Judith. *The Jews of Latin America*. New York: Holmes & Meier Inc, 1998.
Testa, Enrique. *Los Judios en Chile*. Santiago: Editorial Nascimiento, 1989.

THE PERSISTENCE OF MEMORY: HUMAN RIGHTS IN THE AMERICAS

Traces

More than a memory,
or the place where memory lives,
like texture,
more than a presence,
among the flickering spirits,
in the wandering heart of night,
among the flames
in that unsettled place,
I found traces,
only traces,
cast-off, shipwrecked syllables,
shattered alphabets.

Fragments of memory,
vestiges and mute angels.
Traces, spinning, wandering, murmuring,
traces.

More than a memory,
traces
of fiery portals,
of streets, of cities,
only traces,
sublime traces
of meaningless humiliation,
traces of wounded steps,
traces of pillaged suitcases and plundered souls,
traces of a blue suitcase.

More than memory,
in the trace of that memory,
I sensed a voice
that demanded sacred silence,
the silence of poetry,
the gravity of poetry.
Only a voice,

submerged,
a voice whose only purpose
was to remember,
the persistent tenacity
of remembrance.

And in this voice,
beyond the fragile bounds of memory,
and the cruelty of silence,
the dead and the living convened,
to dance around tombs,
and the living, moving deftly like wise dancers,
over those graves of dead
and dreadful cities.

In the midst of those walks,
they repeat names, the frozen edge of language:
Auschwitz, Dachau,
Treblinka
"Work will make you free"

And in those names,
the trace,
the omen, the sign of the burning eyelid
and in that trace, an obliterated civilization
in the most perverse of scandals.

It is the trace of the naked Jews,
of the neighbors mocking the naked Jews.

Here in Yad Vashem
look at the million traces we have left behind
in these grottos of death,
in these gardens of death.

More than peace,
here in Yad Vashem
they demand, they glare, they cry out for remem-
brance,
to the gesture of remembrance,

to the light of memory
that is one voice,
a singular walk among the barbed wires
and the forest of pale roses.

Humble, arriving at Yad Vashem,
silence is gladness, peace
a star,
the stillness of the abyss and the precipice.
Someone lights a flame,
someone picks a flower
they leave traces,
lucid testaments of history.
Someone walks among the rubble
and listens to a lament,
a cadence,
traces,
a name,
people who wail and recount,
people who pray and shine.

Translated by Laura Nakazawa

Autumn of the Mothers

*Dedicated to Rene Epelbaum (1920-1998),
a founding member of the Mothers of Plaza de Mayo.*

It is impossible not to see them this autumn, every autumn, because their bodies move with the calm slowness of dead leaves. Or maybe they are dead leaves, fallen from the menacing nakedness of the sky. I think about them; I listen to them sweeping the Plaza de Mayo, detached but always earthbound. Sometimes they seem to be strange specters, sorceresses in this city of witches and oblivion.

The Mothers appeared searching for life, looking for their missing adolescents, and they became the conscience and memory of the nation. The Mothers of Plaza de Mayo are still with us: How can we not invoke them? It is difficult to forget them because there is something brutally innocent and truthful about their presence; maybe that innocence perturbs us. It is the innocence of beings like us, ordinary citizens whose pain has been caused by the state's terrorism—a pain imposed by a government that declared itself the owner of the laws of the nation and with impunity caused the disappearance of a whole generation. Sometimes I think that if we applied the terminology of the European Holocaust, we could say that what happened in Argentina was a Holocaust against the youth.

We, the young Latin Americans of the 1960s, have heard of them, the Mothers of Plaza de Mayo. The youngest of us have crossed rivers and mountains to march with them because their presence puts us closer to the truth, to our history, and fills us with the dream and hope of change. In the faces of those daring women we have seen our own disenfranchised faces. We have searched for them in that history that had suddenly been stolen from us, that was silence and death and despair.

If the presence of the Mothers of Plaza de Mayo was a problem in those ferocious days of the Argentine military dictatorship, when the citizens were divided between the military and the civilians, I think that the Mothers now represent a full transition to democracy—a dimension even more ambiguous for us, the spectators who listen to them and feel them almost languidly every Thursday at 3:30 in the afternoon. We are also part of that disenchanted generation who attempted to change the world and instead became amputated beings facing the abuses of a long dictatorship. In seeing the Mothers, we asked ourselves about our future as a generation, and, even more so, we wondered how to live that future among the military and the civilians.

Argentine citizens who have not been affected remain silent, hiding, doing nothing. According to philosopher R. Katz, evil must not only be ascribed to names like Hitler or Stalin, but must wear the face of those citizens "who were indifferent and who adhered to the voices of the general power." The Mothers refuse to be silent, to be anonymous; they make their personal pain a national entity. Their presence makes others uncomfortable—uncomfortable to see them, to feel them, even to be beside them, as I have done. We can draw a parallel between the people in Nazi-controlled Europe who hid the Jews during the Holocaust, who gave them food, and who did not turn them in, and the Mothers, who, although personally affected, have assumed that role of guardians of justice, truth, memory, and life. Thus the Mothers of Plaza de Mayo, from the beginning of the movement to the present day, have acted as the voice of memory or, better yet, as the ethics of remembrance because to remember implies a sense of responsibility, of tolerance, of a desire to make memory last for the generations to come, generations like mine made up of people the same age as those who disappeared. During these democratic transitions, those who remember are the Mothers, the affected ones, the ones who are still united in their struggle; they are the victims who have not found their sons and daughters, who fight to regain the nation's memory. For them, to forget permanently would be to deny life, the life lost by members of

that generation who attempted to change their world and gave up their lives to do so.

The Mothers of Plaza de Mayo have placed themselves within the fight for social justice initiated by their own children. The two generations represented by the mothers form a united front, forging alliances with previous generations. But we cannot forget that these activist sons and daughters were the product of homes that offered them incentive to seek social reform. The arrest and forced disappearance of the children in these homes was a way of isolating the children not only from their families but from the national mainstream as well. Making the neighbor's son or daughter disappear became equivalent to ripping apart both the family and, on a larger scale, the nation.

The search undertaken by the Mothers was one born from affection, and its structure was based on experience and daily routine, a space where the mothers, the children, and the grandmothers cohabited, ate, sang, and enjoyed life together. As soon as the state usurped their lives, the Mothers left their homes and imposed their condition as mothers, with the language of love, the daily and cozy words, on the public sphere. The political presence, the public search for missing children, not by the fathers, as was the case in Greek tragedies, but by the mothers, dislodged the whole of the Argentine political scheme, which had created a hegemonic image of maternity and the home.

Sociologists and historians question whether the Mothers were gender—and ideology—conscious when in April of 1978 the first group of fourteen mothers went to Plaza de Mayo to march, thus inaugurating one of the most daring human rights movements in Latin America. I believe that gender consciousness existed but did not follow the classic pattern of Western feminism. I will examine the role of women's and human rights organization in more detail below. The movement was born from personal feelings of affection and loss and the violation of the home, and it did not theorize around legal or social human rights ideologies. Yet the Mothers emphasized a few basic principles— principles that placed value on the well-being and dignity of hu-

mans beings while declaring that no one should be tortured or "disappeared."

One of the questions for the current democracies in the Southern Cone involves how to assume responsibility for memory. How do nations remember? What do they remember? What do they choose to forget?

What memory retains is that which history can integrate into the current system of values; the rest is ignored, "forgotten," although in some circumstances that which is forgotten can be recovered. The system of values acts as the selecting agent for that which is incorporated into "tradition." From the past, only those episodes that are "exemplary" or edifying for tradition, as it stands in the present, are incorporated. The Mothers of Plaza de Mayo here placed themselves within the light of social justice initiated by their own children. Other than scholars and journalists, little has been said about the movement as a way of rethinking the ethics and morality of the citizenry.

The Mothers offered a physical presence that defied fear, silence, and the daily and nightly horrors carried out by the military forces. Holding hands, sunk in the deepest collective pain, the Mothers forged alliances and assumed responsibility for the integrity of life. They represented a counterpoint to the evil of the military regime.

They also demonstrated their power. Their actions have made them not only witnesses but also rescuers of memory, of their homes, and of their country. To assume that the Mothers only march because they have been affected would ascribe to them a very simplified character. One of their most vital aspects is their collective conscience. The Mothers marched, and continue to march, awaiting answers.

The central role of the Mothers of Plaza de Mayo is that of humanizing memory, so that there is an alliance of memories, history, and life. With their photographs tied to their bodies and their kerchiefs whistling in the wind, the Mothers look as if they, too, are wearing uniforms. When they dance together, silently, it is impossible to identify each one of them separately. It is impossible to know who they are or where they live, but they are one

dance of life that transmits the absence of the other lives. Walking around with photographs on their bodies is also a way to give the disappeared a collective and dignified burial, the burial from the nation, but that at the same time asks that nation to take responsibility for the disappeared. There is in them the process of humanization, and of giving dignity to those gone.

Elizabeth Jelin, who has written extensively about social movements in Latin America, especially in Argentina, says that "any demand for justice consists of a desire to restore the damaged balance. In this general manner, the exercise of justice requires that one be conscious of the depth of the damage done in order to know what is necessary to repair it. Disappearance is effectively a form of damage. Damage of a very peculiar nature...." Disappearance, as a damage, implies the kidnapping of the body as well as the deletion of a world of knowledge. In this world we find fear and silence set in place by the military regime imposing a politics of denial—creating a history of deception, a history that tries not to judge its own past.

I would like to examine further the social movements in which Latin American women have emerged and their incursion in civilian society. The presence of women and their place in public life responds to a unique relationship that women have forged where affection and politics merge, where individual grief becomes the locus for communal resistance and leads to a communal concept of human rights. These are rights that, for the most part, have not been incorporated into the legal system but are instead interpreted as ethical and moral concepts.

The relationship between gender and human rights implies a stance taken on the right to life, the protection of pregnant women, the protection from rape, and the possibility of widowed women receiving pensions. The right to life does not spring forth from a moral concept of the universe, but rather from a vision of life where the human rights debate allows the possibility of a vindication of social, political, and civil rights. In spite of the advances made on women's rights since 1993, when the U. N. World Conference on Women stated that the human rights of women and girls are inalienable and indivisibly a part of human

rights, it is clear that governments have not paid attention to the severity of human rights violations that directly involve women, such as direct violence by the state, emotional and psychological violence in the family nucleus, sexual abuse and domestic violence, marital rape, female genital mutilation, and the abuses encouraged by unfair child labor laws.

In the case of domestic violence, we can say that it is undoubtedly the main source of violence against women. There are countries were men have the legal right to beat their wives, and in so many other countries domestic violence is not treated as a serious crime. There are other forms of abuse directly related to the treatment of women. For example, dowry disputes and deaths in India or the ritual of Sati, or widow burning. According to Amnesty International, dowry deaths are also reported in immigrant communities outside of India and statistics from the early 1990s show that the number of reported dowry deaths was 4,785. As recently as 1993, 5,000 women were reported to have died. Another important issue related to gender and human rights is the practice of female genital mutilation that occurs in some twenty countries of Africa, Asia, and the Middle East, as well as in immigrant communities in Europe and the United States.

If rape and physical and psychological abuse have been part of systematic abuses against women, in both the public and private sectors, then so too is the trafficking of girls and women who have been caught in the industry of sexual and domestic slavery.

Contrary to what I always thought, slave trade does not involve only Asian women. We can now see patterns of slave trade throughout the world that are due to economic instability. The market focuses on Moscow and Kiev, but it also runs east to Japan and Thailand where thousands of women work against their will. All of this terror reinforces the conditions that affect and link women to human rights, where economic desperation forces women to find survival in all kinds of odd jobs many of which lead to prostitution and mental and physical abuse. According to some reports of the Israeli government, many thousands of women who arrive from the Ukraine disappear as soon as they disem-

bark. An article in *The New York Times* opens with a chilling scene of a woman, Irina, who unknowingly responds to a classified ad in her town's newspaper that promises her financial prosperity. I quote the article:

> She was 21, self-assured and glad to be out of Ukraine. Israel offered her a new world and for a week or two everything seemed possible. Then one morning, she was driven to a brothel where her boss burned her passport before her eyes. "I own you," she recalled him saying. "You are my property and you will work until you earn your way out. Don't try to leave. You have no papers and you don't speak Hebrew. You will be arrested and deported. Then we will get you and bring you back."

This chilling account shows explicitly the relationship between human rights and women, and evidences the specificity of the violations committed directly against women. Even if we have eradicated "the disappeared," the clandestine prisons, and the massive rapes of women in Bosnia, then, apparently, our robust global economy is still up to a few tricks of its own—abusing the most vulnerable beings: women and children. If the trafficking of women presents another degradation of the relationship between gender and human rights, we also have to take into account an important variable, that encompasses the relationship between gender and migration. In an important article entitled "The Transitions of Immigration," Carola Suárez Orozco points out that investigations are few, but in general women migrate to accompany their husbands who are escaping political persecution and their migration is linked to their affection for their partner and, thus, their other family ties are severed. Orozco concludes that:

> Gender is one of the many factors critical in understanding the immigration experience. However, much of the research on immigration has focused on economic, demographic and sociological factors of work. Very little has been written about the psychological and cultural aspects of immigration. The immigration literature has

tended to take a male lens which focuses on the
social role of the world of work.

The extent of grave abuses against women throughout the
world such as rape, war, domestic slavery, refugee status and ex-
ile have made many non-governmental organizations as well as
some grassroots movements seriously commit their efforts to end-
ing all discrimination and violence against women and help raise
a consciousness that will pressure governments and educate ci-
vilians on issues of gender and human rights. Gender and hu-
man rights are also very much linked to the power and vision of
women's words, and we should pause here to think about the
imprisoned writers of the world such as the Central American
poet Claribel Alegria, exiled from El Salvador and Nicaragua. In
her voice, the protagonists of Central American wars are por-
trayed intimately and the public and private selves merge. The works
of Taslima Nassim, a poet and writer from Bangladesh, have a simi-
lar feel to them because she has been persecuted most of her life by
fundamentalist Muslims as well as Christians.

Beginning in the 1970s, the participation of women against
right-wing extremism began to create new cultural and social
codes infusing great vitality into the history of women and civil
social rights. The anti-dictatorship movement was all-inclusive
and diverse. The demonstrations managed to involve a great va-
riety of social classes, including peasants and indigenous women.
These movements created a unique vision of civil and social rights
and the responsibility of all citizens. Thus, the 1970s occupy a
extraordinarily important place in the timeline of demands for
women's rights and the pro-human rights' agenda. A confluence
between two powerful ideologies, with their many alliances and
tensions, created attention to the parallel histories of feminism
and human rights.

We should note that these movements during the decade of
the 1970s derive from the 1960s, when we began to see certain
practices like the mobilization of great numbers of peasants, the
new laws favoring the rights of domestic help, and women's
struggle, alongside men, to stop class discrimination.

These struggles for women's rights and human rights in the region did not appear suddenly in the 1970s. I must point out again the long history of violence against women, especially in Latin America. The silence of the women's bodies, battered in the privacy of the home, is a remembrance of the collective body, the mass graves and the tortured men and women under the dictatorship. Women, then, occupy the historical role of searching for those bodies in the physical and metaphorical realms of their vision and the right to the preservation of life. For the first time ever, the disappearance of people will also be linked to the massive genocide of indigenous populations, such as in Peru, which were never before denounced. This is very important since much of the lexicon of the women's human rights movement involves the concept of the sanctity of life and the preservation of a life violently taken away. The lexicon used by the dictatorship is one of terror and fear, one filled with images of night and fog.

It is the praxis, and not the theoretical foundation, that begins to create a powerful women's movement made up of women who were affected as mothers of the victims of repression—repression that was aimed at the nuclear structure of the family. Thus, the mother's movement throughout Latin America unfurls as a movement of female political imagination, passion and love. What is essential to these movements is that the women involved had lost all fear and that the movement transformed a personal search to a collective one. At first, the search was derived from the universal notion of women as protectors of their children—just one more personal drama. As the years went by, the personal searches of these women became the search of a civilian society, rooted in the concepts of democracy within their country and their homes. The subversion of the solitary mother becomes the image of the active, fighting mother.

The presence of the Mothers of Plaza de Mayo comes to vindicate as well as uncover similar human rights violations throughout history—for example, the experience of indigenous women who were raped vis-à-vis the experience of women activists. Here we see that the women's movement and the human rights' movement are not accidental occurrences but, rather, re-

sponses to a long saga of unified oppression and the struggles for class equality. Among the most extraordinary movements of the twentieth century we see the Mother of Plaza de Mayo—a movement that questions and makes us rethink the relationship between mothers and social struggles and to rethink the role of the Mothers, as connected to the role of women, not as passive repositories of cultures but as active transmitters. The Mothers began a new period in the collective imagination of Latin America, one in which change is effected through presence—through remembrance, through memory—as well as through nonpartisans political actions, or, that is to say, through the politics of ethics, which transcends parties.

Today the Mothers and other human rights groups are trying to create the House of the Disappeared, a museum of memories where archives and testimonial materials from the years of the so-called Dirty War will be gathered. All of these efforts have so far been in vain. Only in Chile, in Santiago, with the personal and financial backing of the families of the disappeared, have they created a memorial to the disappeared. The memorial is shaped so that on one side we see the names of the disappeared and on the other side the names of those who were executed during the years of the military regime.

If in today's Europe there has been an effort to remember through monuments at the various sites where atrocities were committed, in the democracies of the Southern Cone, where the texture of memory—its blisters and wounds—is always open, the governments have attempted to erase all traces of these memories. In Argentina, as in other countries, the government even went so far as to declare amnesty for the military personnel involved in the Dirty War. And Chileans often say, "I knew nothing of the matter."

The Mothers of Plaza de Mayo, from the beginning of the movement to the preset day, act as the voice of memory, or better yet, as the ethics of remembrance. To remember implies a sense of responsibility, of tolerance, of a desire to make memory last for the generations to come as well as for generations like mine who are of the same age as those who disappeared, generations who

became witnesses. During these democratic transitions, those who remember are the Mothers, the affected ones, the ones who are still united in their struggle; they are the victims who have not found their sons and daughters, who fight to regain the nation's memory. To forget permanently would be to deny life, the life lost by members of that generation who attempted to change their world and gave up their lives to do so.

What is the agenda of the Latin American women's movement? Is it their participation globally in the peace processes, in attempts to save the environment? In their ties to human rights? If our planet and the global economy are fundamental items on the agenda, then the legacy of democracy and the future are questionable. The Mothers of Plaza de Mayo could present themselves as a paradigm for other social organizations. We can see then that maternity is presented as a new social model—including maternal and relational thinking—as a new vision for new political thinking. The Mothers supply, in this new way of thinking, a civic responsibility to fight for truth and justice. From this perspective the motherhood movement transcends local history and becomes universal as the mothers begin to revolutionize public action and grief.

A deep chasm in memory is revealed as the past is unveiled and we discover the complicity of apparently neutral European countries. In Latin America not only is there complete denial surrounding collective memory, there is also a resulting lack of public sites at which one can mourn and remember. There are generals who ordered massive genocide and torture who, today, hold lifetime Senate positions. Human rights movements have been delegated to the confines of non-government agendas, and the women activists such as the Mothers of the Plaza de Mayo or those who make arpilleras, who made possible the changes to democracy and freedom, have become the ghosts of an uncertain democracy. Once again, what had promised to be a truly magnificent women's project and political agenda has remained hidden under the disguise of economic success.

What women and human rights movements have secured now is an acknowledgment that their loved ones are dead, disap-

peared, and killed by the military forces. The torturers remain unnamed and unpunished, and "truth and reconciliation remain blurry." It is emblematic that the new democracies have shifted their alliances to what is politically convenient since survival means maintaining an unprovoked military. Thus the presence of women and human rights are now part of an even larger struggle to preserve historical memory. They are not alone. This preservation effort has become part of the agenda of the shantytown dwellers and other who are challenging the official histories and the military interpretation of the past. Thus, the work of the Mothers' movement is a movement that tries to recover the memory of Latin America's darkest days and the struggle against forgetting. This is perhaps human rights' finest legacy.

In her article "The Home and the Street, Women and Culture in Latin America and the Caribbean," Ana Pizarro writes about the relationship of the Mothers to the culture of the streets in the sense that the street environment is also part of what the Mothers have tried to legitimize. If the street has historically represented what is masculine, the Plaza de Mayo has changed all that. The memory of the Mothers and their actions, or lack thereof, and of the passersby have established a poetic public discourse base, that is: to make the act of not remembering a violation of human rights. The reclamation of life comes through those that remember. The Mothers are our future. To emerge from secret houses filled with secret sorrows and to make the Plaza and the street a living memorial of the horror that they lived is to create an alternative to an existence filled with denial.

The last few decades in Latin America have witnessed the emergence of women as leaders for social change within their countries or in exile. From those ill-fated zones of oblivion, they rise, the daring, courageous women who carry the names of those who once were, walking forever in the memory of history. They have discovered the power to denounce, to humanize horror and its victims, through a nonviolent approach. They have encountered truth through memory. Memory is not only the act of mourning or lamenting, it is the most immediate way to recover the identity of that which was lost, the absence of the disappeared

body as well as all the ties of affection that bound us to that body. That is why many of the symbolic manifestations of the Mothers of Plaza de Mayo unify us, like the act of women ritualistically dancing together with the faceless silhouettes that they draw on the pavement surrounded by their slogan: "Give a hand to the disappeared." This is a bonding gesture with the missing body; it implies the reconstruction of that being who had a past and a memory.

If the survivors of the Nazi Holocaust speak of the lack of ties with a world that has been lost, a world where history is filled with pain and ashes, the Mothers of Plaza de Mayo create passion from memory. Their existence becomes an elegiac obsession with life itself. As they break the laws of oblivion, they seem so vulnerable and pious, marching silently like the ruins of times gone by.

To forget is also a human rights violation. We must remember that in these new democracies, truth and reconciliation are never equated to truth and justice. The Mothers and the arpilleristas became politically inconvenient and the struggle to remember could become isolated. The women's movement in human rights encompasses a struggle for historical memory and soul.

About the memories of the Holocaust survivors and their children, Marianne Hirsh writes:

> None of us ever knew the worlds of our parents. We could say that the motor of the fictional imagination is fueled in great part by the desire to know the world as it looked and felt before our birth. How much more ambivalent is this curiosity for children of the Holocaust, survivors exiled from a world that had ceased to exist, that has been violently erased?

To these words by Hirsh I add the social and historical project of the Mothers. But here the phenomenon is inverted: the world which has ceased to exist is that of the children, not of the parents. It is the mothers who attempt to rethink how life would have been if their sons and daughters had lived. In this way their

political militancy is also a way of living and regaining, of re-building and recreating, a world devoid of missing children, through the courage of not succumbing to silence or becoming passive accomplices. The Mothers of Plaza de Mayo have contributed to the civil future of societies in Latin America where ethical and responsible participation will be the basis for the consolidation of a just society dedicated to preserving the values of human life and dignity. It is the Mothers of Plaza de Mayo who are clear transmitters of memory and the future of this and all memories.

Translated by Monica Bruno Galmozzi

An earlier version first appeared in *Multicultural Review.* 7 (March 1998) 42-45. and was the basis for a lecture presented at North Eastern Modern Language Association, Philadelphia: 1998.

Works Cited

Hirsch, Marianne. *Poetics Today,* unpublished essay, 1996.

Jelin, Elizabeth. *About Women, About Human Rights.* Buenos Aires, Argentina: Entre Mujeres DiMogo Sur Norte. 1996: 137.

Pizarro, Ana. "La casa y la calle: Mujer y cultura en America Latina." "América Latina y el Caribe (The Home and the Street: Women and Culture in Latin America and the Caribbean)." *De ostras y canibales: Ensayos sobre la cultura latinoamericana.* Santiago, Chile: Editorial Universal de Santiago, 1994.

Suárez Orozco, Carola. "The Transitions of Immigration" David Rockefeller Center for Latin American Studies.

In the Heart of the Forest, Someone Remembers

I

Maybe all acts of remembering are profoundly connected with language and writing. Are not the spoken words or the silence of the words unspoken, the antechambers of memory? Australian poet Chris Wallace Crabb proposes that all acts of memory and writing imply a desire to search, to unearth and find traces. Is not the search for memories the origin and starting point of a trace? I remember and now evoke my first visit to Yad Vashem, the Holocaust memorial in Jerusalem, the monument to the dead and the living. When I arrive to this repository of memories, I find the residue of lives and obstructed civilizations.

The visitor walks about in awe. He can only attempt to remember, remember an official history that narrates facts and numbers. It is precisely on this path, marked by the death camps, where memory becomes more and more a breathing and pulsing entity. I think that memory is alive and active. Memory does not only remember; it also questions.

I try, through these brief pages, to illustrate and get closer to what memory means. Many times I have tried to write this essay holding a dialogue with myself and the self that remembers and whispers in my ear and tries to interject her memories. What is remembered takes us suddenly into the deepest chasm, hushed and still. To talk about memory implies entering the origin of words, language, and history.

Remembering is rewriting. In these pages we will go through a brief journey on the paths of memory. I invite you to walk these insidious and capricious paths with me.

II

All acts of remembering demand at the same time gestures of ambiguity. Memory looks for quiet and rest. That is to say, memory implies a search for what must be remembered. Memory has a capricious texture. It shows itself at times and then retreats and becomes elusive. It is sporadic or omnipresent. Memory is always individual, and yet memory would not exist without the collective search for what a collective memory means.

If only individual memory existed, we would never know those memories that imply morals—a memory that not only re-members but also alters. As Pierre Nora, the philosopher and historian, said, memory and history are not synonymous. Memory is life always carried around by people who are alive and in con-stant evolution. This is exactly what I would like to think about and ponder—memory as an act of living. Is the action of visiting the dead or evoking them a way of living memory? Pierre Nora also states that memory is something latent. Sometimes we forget it, but it always returns and belongs to us.

III

Is the memory of the Holocaust part of our history? Does this memory belong to a human collective? How about the memo-ries of Kosovo or Pinochet? I should add that the individual, in his/her vertiginous search for identity, chooses to look for memo-ries to remember. At the same time if one wants this act of re-membering to be a responsible one, one must be capable of in-volving memories of others, which would imply a historical memory.

If the Holocaust occurred almost 50 years ago, this century is closing with an obsession for memory, for memorials, for not allowing the crimes of dictators to go unpunished. If the twenti-eth century was marked as the century of horror and darkness, the twenty-first century is looking for the dialogue and the memo-ries, that is to say a dialogue with conscience.

I present another important reflection: All searches for memory and all ways of living memories require an act of moral-ity—present, true, and authentic. Remembering in and of itself

does not legitimize memories. What legitimizes memories is the desire to make that memory moral, active, and not a ritual. Let us not only build avenues and monuments to placate consciences, but let us live the search for that monument, for that trace in which we can all participate. Maybe all the lost manuscripts in the basements of the European ghettos were the modules of memory. They were a desire to articulate that trace which was not only a presence but also water, light, wind, life, and word.

The issue of the living and the dead and the forms in which we both inhabit this world is a constant tension in discussing the topic of memories. Is it possible to speak for the dead? How do we speak for them? How do we reach the subtlety of their silences, their whispers, the footsteps we hear? Is it possible to forgive on their behalf? To speak on their behalf?

The act of remembering does imply a constant dialogue with both the living and the dead. Sometimes the person who remembers is filled with the obsession of those who do not speak but are linked to his voice and lack of voice. This obsession is a search in itself, a path that asks how one can remember and keep memory moral.

IV

I integrate myself with my childhood memories, which are not diluted and grow like a swelling river. Rivers, for the most part, have women's names. Will the texture of memory resemble a river then?

Since my childhood, memory has officiated at all ceremonies, like the most loyal of friends. Memory lived in the words, the language brought from other lands, whose permanence existed like an invisible force linking us to the dead and the living. The women of the house were the guardians of memory because they were also the protectors of the family secrets and that which should be and should not be known, of what should be and should not be told. Then, I felt that memory had to accommodate itself to the events of the small and minute histories that took place inside the house, but it was also something grandiose that encompassed many houses like our own.

Were the memories of things in the house of a Jewish girl in Santiago different from those of my neighbor, Ana? Was the history of my great-grandmother Helena similar to that of Ana's great-grandmother? How do my memories measure up and intertwine with those of another girl separated from me only by a fence in the backyard?

The memory of those children, the neighbors, the Mellao sisters, was the memory that I longed to possess and create. My genealogy was suspended between dreams beyond all possible confirmation of the existence of those family members who slept in the forests outside Vienna or in a garden surrounded by lilies. My history was the history of those others, whom I never knew and whose voices I never heard, but that was my memory: the silent woods.

Is there then a form of memory that is spoken out loud? There is the voice that says, "Come, I invite you to my house so you can listen to me." That was the memory of the living. The memory that existed in my house was, however, the memory of the dead and their footsteps, that at night were accompanied by the smell of rain and often woke us up.

I try to establish paths to place certain memories. I would then say my priority is the safekeeping of memory, the memory of the dead, remembering the ancestral, the voices that we never heard and that have only been recreated by the mythical space of memories. That was the type of memory that framed my childhood. It was the memory of whispers, crossroads, and precipices, but it was also the collective memory of a people and its history, a people that suffered centuries of prejudice and yet survived. This only puts me closer to the memory that is linked to identity and to the fact that I am Jewish, exiled and marginal. That memory was most prevalent when the neighbors talked and exchanged religious items or first communion photos. My memory instead was that of photos hung in the smoky cities of the dead.

All experience with my relatives—whether the ones I knew through photographs or those who lived at home with us— seemed to be suspended in a time that belonged to no one, alien to contemporary life. They were the musicians of the orchestra

that only they could hear because their memories had gotten lost and existed in fragmented form.

V

In my home, memory was the memory of words, sounds interspersed with the casual Yiddish curse, some Hebrew words, the sharp-edged German words. My grandfather loved German and would read Goethe and Rilke. Years later I read Paul Celan, but only when I was living in my own exile. Exile, like a furtive breeze, brought me closer to those other histories, the ones that told me reclaiming Celan's German would imply accessing my past. I was somewhat like Celan because I wanted to feel, dream, and preserve language as part of my history that had been wounded and dislocated. My active memory, my living memory, was my language. Me and my language in exile. Now I have managed to understand that recovering my language and keeping it alive is part of my memories—it's the alphabet and dialogue of my ancestors.

VI

Is there a memory that is different and that has roots in what is experienced by each gender? We should then ask what is women's memory like? What do women remember?

My mother and her mother remembered through the old family photographs, which were the basis for another life, a return to an origin. But, what was the memory like of those women whose images are suspended in a time of horror, at the edge of an abyss? How do we remember the empty women, beheaded and condemned to the blue gas chambers and forests?

Women's memory is also a memory of the spoken, the stories transmitted by each one of them through time and through history. Aside from this, we must understand that it is also a collective memory, a selective memory that allows us to hear and not hear certain nuances and cadences. Women's memory is part of the memory of our dead ancestors and, yet, at some point the

women will reach the stage when we can disassociate ourselves from this and separate the living from the dead.

All forms of writing try to recover memory, but moreover, writing tries to memorialize and to become a memory that is part of tradition and can be a witness of what is said and told. My memories and I are here to tell a story. If those memories are used to bear witness, then they imply a condition of being and belonging, and, thus, a moral decision has been made to remember. Collective memories are the most essential element of modern society at the beginning of the twenty-first century. I dare say that the process of memory and a dialogue with history form the most essential codes for human rights. As I dare say this, I am inclined to say that not remembering is a way of violating human rights. The trials of dictators throughout the world and the challenge to their immunity are the clearest reflection of a need to remember in order to vindicate human rights abuses.

Memory in the last 50 years of the century has not been static. It does not only remember one thing among many like Armenia, Rwanda, Kosovo, Guatemala, and the Holocaust. Memory is a profoundly human thing, and it participates fully in a commemoration of history. It is not only exemplified in the observation of certain dates and holidays, but also in the creation of memorials throughout the world. We are starting to see memory take form not only in Germany but also in the United States, where Holocaust memorials have been erected. This signifies many things, but among them the fact that the memory of the Holocaust does not belong to the Jewish people alone. It belongs to the world.

What we see today is the creation of national commemorations that are intertwined with universal commemorations such as the Holocaust, which has become one of the defining events of the past century. Although there are certain groups that would deny memory and try to establish a counter-memory, we see real memory disobeying the official story and transforming itself in order to redefine itself and history.

Translated by Monica Bruno Galmozzi

Chile in My Heart

Yet again a return, another return that bespeaks absence. A return is a strange journey back to the past, a reopening of painful wounds. We return because we had to leave before Pinochet and after Allende, always that *before* and *after,* reminders that we are participants in an inopportune history. We come back to a country that is at once familiar and unknown, alien yet replete with memories, like a fresh water spring.

The emotion I feel as I approach Chilean territory always astonishes, disturbs, and pleases me. Everything in me vibrates with an intensity that is simultaneously delirium, anticipatory joy, and anguish. I love this land of mountains and small islands, this narrow strip of earth that disintegrates into archipelagos. This is the place my paternal grandparents came to from Russia, and my maternal grandparents from Vienna. I visit them on each of my returns. Some of them have died, and here amidst the willows and the acacia trees, I remember them. The light of this land is golden and always shines into my eyes as if I were a daughter returning home after the war to celebrate the propitious era of peace. I pay my respects to the dead and I am reconciled with the living.

Here I am, returning to the utopia of childhood memory. We come in from the north, across the Atacama Desert, the city of Calama where seventy-six men were shot down in the notorious Caravan of Death. The widows are stretched out on the sand, sleeping beside their dead like bird feathers marking what the sand shelters and protects. There are too many dead in this country. Sola Sierra, may she rest in peace, said that all Chile is a cemetery. And the living? Where are the living, that adolescence of light and wind, of nocturnal strolls along the turbulent and beloved Pacific? Where is that homeland we all dream of, ours and unique? Perhaps we weren't so different and this distance

made us all become more insular, crueler, more hostile. We are a country of excessive cruelties and small innocences.

The flight attendant announces that we are about to land. The desert is behind us now in its splendorous silence and its mirage of shimmying lizards. We're coming down now through the central valley of Chile: willows, light, wind, and a sun like a moon. Suddenly I see my whole childhood behind the ambiguous veil of memory. I arrive in this uneasy land that received us, the expelled Jews. I return and feel that perhaps I have never left, that my stays in other regions of the earth have been transient and invented, that they have stolen what I am and what I yearn for. I have never left; I am here, here in what I call my homeland like someone returning after a long lethargy to the luminous presence of a beloved body.

The road that leads to my grandmother's house winds back and forth. Even blindfolded I would recognize it and sense the aromas, the rocky soil, the foothills of the Andes, and the long seacoast. I think of the words of the poets. I have loved this land through Neruda's verses, Gabriela Mistral's wise counsel, and Jorge Teller's nostalgia. The geography of Chile is anomalous, a narrow strip of earth along the Pacific Ocean, ending in the South Pole. "It's a closed-in country," said Gabriela Mistral, "a country of absences." We travel through the central valley, where there are vineyards; through Curacavi, where women stand along the highways selling sweets from dawn on, waving to those who drive past. I've always thought them beautiful, as if they were wearing scarves of peace. It is noon. The sun glows deliriously. Odors begin to seep into me as they did when I was small and loved to run my hand over my sun-warmed skin. I feel even more strongly that I have arrived, that I am anchored in this earth, breathing it in and feeling alive.

So often I have been aware of this earth as a refuge, as a prison, but now I am increasingly aware that it is mine, like an adolescent re-encountering a lost love. I find a certain eloquence in this return, the paths are like hands, and the flowers remind me of my childhood pockets. I used to fill my pockets with shells and rocks and flowers. I ask the driver to stop for a moment by a tree, my tree. It is a fuchsia bougainvillea that flowered all year

long and looks like an open, bleeding heart, inventing omens and returns. I recognize it and recognize myself in its tenuous, almost invisible shadows.

I imagined that Salvador Allende, who used to say that people make their own history, came out to meet me on this sunny morning. I've come to the southern hemisphere, as I do every summer, to visit my grandmother, who is waiting for me on the balcony, waving to me with her ever more frail arms. Her gestures and her steps have diminished but her weakening heart is full of love. My visit coincides with the presidential elections. There is great anxiety about the possible victory of the right-wing candidate, Joaquin Lavin. I have great faith in the candidate of the left, Ricardo Lagos. Here at election time, I will see the country vote and thus feel that I am part of this moment in history, that I don't have to explain anything to anyone, that all of us, no matter what beliefs we hold, are deeply moved by these events.

The radiant days go by as they always have on my returns: in conversations and confidences, in friendly bonds made on the street, in cafés and in plazas. Life is on the street, in the violet seller who recognizes me and sings out "Do you have flowers, Miss?" In the organ player there since time immemorial with a parrot on his shoulder that chooses the slip of paper that bears your fortune. Why have some had to flee this land, why did some lose their sheltering sky, yet others live on condemned to perpetual indifference and above all to fear? The years of the military dictatorship filled us with a fear that chewed away at our guts, that forced us to obey and promise to forget, and to whitewash our memories.

Today I walk through the city of Viña del Mar, the city where my grandparents, cousins, aunts and uncles live. They came here, to this dreary port, solitary in the trembling radiance of full-mooned nights. They were pale when they arrived, with few belongings, speaking other languages. They gazed at the sky and vowed to remain here on these illuminated and rocky coasts. I love this city, which retains for me the sense of my history, yet is like one of those cities one visits and loves from afar. We used to come here on weekends to enjoy the magnificence of the coast, to eat fish and visit the grandparents. I spent my childhood in

Santiago, in the Nuñoa neighborhood, next door to a generous butcher who frightened us with his gleaming knives and the flies that hovered around him. The magic of that city was in the people, with their amazing, surreal visions. But Viña del Mar was a proper city with its clock made of banked flowers, its carriages ,and the joy of knowing ourselves to be so near the ocean, looking out over the sea.

It is nearly thirty years ago that Allende rose to power and fell. He is rarely mentioned anymore, as if the target of purposeful oblivion. I pause to gaze at the mountains along this Chilean coast, cliffs like fireflies that light up at dusk and suffer through fogs and rains. Is Chile a forest of smoke, impregnated with nefarious silences or is it a country with a furtive gaze? We used to feel proud of being a tolerant society where lay and religious people mixed, where the few immigrants were treated with tolerance and equality.

Allende's victory brought us world attention. His overthrow has isolated us more and more. Why do I mention Allende now? Why do I dream about him sometimes, and recall the visits to my mother's house with Hernán? I often heard the name of Salvador Allende on my grandmother's lips, when she talked about his childhood in Viña del Mar. My father used to speak of how his reforms would make medicine into a more just system for us all. Perhaps I'm thinking about Salvador Allende because today we are voting for a new future in Chile, and Ricardo Lagos is running for office, from Salvador Allende's political party, thirty years later. You can feel in the air that there are doubts, tension, and worries in this summer of acacias and bougainvilleas where our history is being debated, and the role of memory. It is almost thirty years ago that we watched the presidential palace go up in flames and we listened to the president say, "One day men will walk freely along the wide avenues." What happened to us? Are we the same as before, when Chile was a beautiful country with a view of the sea?

I've often tried to explain what it means to live under a dictatorship. The strange turns of fate have been kind to me. I lived through the dictatorship at a distance, but my friends lived through it in too great a proximity, and sometimes I could barely

recognize them or understand them. Sometimes I could not fully comprehend what they were living through, but I could sense it. This is our story: Our small seaside country lost its open and transparent face. Fear made us into a country full of strangers. We felt that we were under surveillance and we kept watch on each other. There was a great silence, like a deep, dark well. The general turned into a fearsome father. Every night we heard his voice saying, "Not a single leaf will fall in this country without my knowing."

Fear filtered into the most hidden crevices of our being. We became a country that was incapable of looking at itself out of fear and cowardice. We shrank each day, pretending on the outside to be tigers. Everything around us turned into lies and absences. "Nothing is happening in Chile." This was a sentence I heard constantly. "You don't know anything about it." General Pinochet and his rule of terror watched over our nightmares. Far away in the depths of night, time ground on amidst screams and cries. Years went past in the horror of monotony. As Sola Sierras said, the country was a cemetery and bodies disappeared in an ever more evil way. Many people went to live in the Atacama Desert, and others in Pisagua, but no one talked about that.

Later there was talk of a peaceful transition to democracy, under the Frei and Aylwin governments. Those of my generation were doubtful about this transition. These thirty years of pacts turned us into a generation that accepted whatever happened without inquiring too deeply. Thus Chile made a pact with the devil. The new democratic party wanted nothing to do with the relatives of those who had been detained and who had disappeared. They would not receive them in their halls of precarious justice. The silence continued, in the pretense that we were a peaceful and advanced society perfectly reconciled with our past. But the past remained, suspended in the lack of questions, in the absence of discussion; in the willingness to blame the victims and those who had disappeared. That meant that the victims of human rights violations were supposed to defend themselves and fight back, not for their lives because they were already dead, but to release their remains and allow closure for those who had loved them.

The years after Allende and after the dictatorship continued to be a perverse scar on our silenced skin. As we enter the twenty-

first century this much-celebrated new millennium, where is Chile? Where am I, that child who was exiled, with her parents, at the age of thirteen and who lost her history and her language ? At the very end of the twentieth century, the figurehead of Pinochet, who ruled over us for more than twenty years, was arrested and made the object of public notice—I say figurehead, because he seemed personally almost nonexistent, phantasmal. On my return, I read a recent book that provides a lucid discussion of what those years have meant. The author, Marco Antonio de la Parra, says the following about Chile:

> I had a country and it might have been yours. In truth, I had no preconceived idea about what a country should be like. I thought that all of us together made up a country. That was ingenuous, idealistic and romantic, to say the least. You decided what my country should be. I am not your direct victim. I am not dead, nor have I been tortured. I haven't been packed off to exile. (31)

The arrest of Pinochet in Europe helped us to be and to think of ourselves as less arrogant. The world looked at us and told us what we had been unable to say to ourselves. This small and fragile Chile became divided again. We were told that we should defend our national sovereignty, but we had never defended our citizens, when their throats were slashed and they were thrown into the sea. Pinochet's son defended his father saying that his father had killed only beasts, not people. The Chilean press continued to be controlled by a fundamentalist and the partisan right whose majority belonged to the terrible organization, the Opus Dei.

As I reflect, I remember the words of a fellow member of my generation, Pablo Azocar, who said:

> This is the surreal country in which we live as the millennium ends. A country that continues to practice the strategy of the ostrich that closes his eyes and buries his head in the sand. Any critical voice is usually answered by silence. Horrifying acts are confessed to as though they

were natural, as when General Contreras admitted that they did hurl bodies into the sea.... The party goes on. Everything is a show, a matter of market management. (2-3)

On election day, a splendid Sunday in the southern hemisphere, it was neither a marketing strategy nor any result of the publicity campaigns that aroused fear in the population. I don't know exactly what I felt that Sunday morning as Chile prepared to elect a president, choosing between an ultra-right-wing candidate who supported Pinochet and a candidate from Salvador Allende's party. This election was an uneasy one. Both sides were fearful. Would this mean a return to Allende's government, when the country became ungovernable due to forces beyond the control of the president? Would the country return to the authoritarian order of fear?

That morning I got up earlier than usual. I felt the morning breeze and light again against my face. I got up full of questions but decided to go out as an observer of that moment in history. At an early hour, people began to flow into the cities of Chile, coming from forests and the remote corners of Araucaria in order to vote. Women were carrying their identity cards in one hand, and bags of fresh bread in the other. I had the sensation that despite all the deaths, the clandestine or public massacres, it is a beautiful country and that the vote would bring us peace and tranquility. I also recalled a very vivid image from thirty years ago: I remembered my parents going out to vote for Salvador Allende. My sister and I stayed home, and from the balcony, we watched them go off. They looked handsome and elegant. We knew that voting was a privilege, but it was a celebration, too: a celebration of violets. It is sad to think that was the last time my parents voted in Chile, and that only a little while later a great silver bird carried us away to North America where I lost my words and a little of my soul.

That Sunday afternoon, on the 17th of January of this new century, everything went peacefully. I was in the city of Viña del Mar and I decided to walk toward the ocean, as I do when I want to fill my mind with the majestic waves and the garlands of seagulls

and birds that fly along the Chilean coast. How many promises did we all make to ourselves about this country that looks out upon the sea? How many kisses have been inscribed on these rocks and how many farewells have crossed the mountain ranges where the ghosts of the disappeared watch over us? What happened to this little country? How could it have been possible that on summer nights neighbors would have to close their windows in order not to hear the screams of the tortured? What occurred in this country where they say nothing took place? Power may have been comfortable for some, others became used to killing, practicing first with animals and then with people. Then they decided not to open old wounds and concentrated on making their way through life and through silent streets, making endless pacts and strange concessions. Forgetfulness and treachery were our allies.

I return home. The way is familiar: the curves of the pavement, the sounds of the night and day. Around four in the afternoon I am sitting in front of the television set with my mother. We listen to the results of the elections in the most sepulchral of all silences. I like listening, as if it were a redeeming caress, to the names of all the provinces. I feel that it is impossible that I should have left here, that this strange land is still not lost, that the country's landscape is part of my body and that I love Chile as one loves a tree that provides shade in one's early childhood. Chile is a star at the world's end, but it is ours.

Little by little, Ricardo Lagos' strong showing was reported. He had strong support in places like the metropolitan area of Santiago. I could tell that Lagos had won when I saw the long faces of the losers, when Joaquín Lavin was painfully polite. In a few hours, Ricardo Lagos' victory would be announced and he would be declared the new president of Chile. He said he listened to the message of the people: "We are all Chileans." That afternoon the image of the presidential palace changed: it seemed to be filled with doves and transparent spaces. Once again there was happy celebration and song in Chile. The victory was a peaceful one. Everyone seemed to have reverted to a simple gratitude. My mother and I embraced, just as we no doubt all hugged each other thirty years ago. This time it was just she and I, accustomed

to farewells and separations, to living in exile and solitude, who now felt ourselves more complete, and we went out into the street. People gave us flags, car horns blared, and we sang. I said: "Chile, I give you my heart."

That night of Lagos' victory, I felt an almost adolescent hope. I felt that emotions were intensified, that life was opening a new door for us, as though I were experiencing a perpetual invitation to participate in ceremonies of life and death. That night I felt more strongly than ever the clarity of the past and its passions, fear, and apprehension. I thought of postponed dreams, but I was also filled with the happiness of the present. History came full circle with Lagos' government. To some extent it is a government that vindicates the presence of Salvador Allende in our history, and turns around all the years of Chile's whitewashing, when Salvador Allende's name was not mentioned, when the collective spirit of socialist values was reversed by an aggressive marketing mentality that infiltrated all aspects of daily life and politics. Lagos' victory once again defines us as a country that is different from all others. The victory and promises to see justice done may be a vindication that will offset all these years of oblivion and rescue the most beautiful of our national treasures: the path of dreams.

During that happy night of victory celebration, filled with light and laughter, there was dancing in the entire country. People listened to the poems and songs of Violeta Parra and Victor Jara. I, too, gave thanks to life for this offering where history has been turned around, where the names of Salvador Allende and the disappeared are spoken, where fear is dismantled and declared obsolete. There is dancing today in the plazas of Chile, as we take possession again of our origins, our memory, and our true history.

Translated by Mary G. Berg

First appeared in *Southwest Review: Human Rights in the Americas* 85: 341-349.

Works Cited

Azocar, Pablo. *Chile en la mira* [A Look at Chile]. Editorial Planeta: 1999

de la Parra, Marco Antonio. *Carta abierta al General Pinochet* [Open Letter to General Pinochet]. Editorial Planeta, 1999.

Memory and Exile

Memory and remembering what memories are were the threads that wove my history. The lexicon of the home was filled with the objects of remembrance, from the candelabra to the samovar. The house radiated a sense of otherness, a feeling of these being alien times, secrets murmurs and passions... everything in it had been brought from another land... everything was temporary, transitory or in a state of emergency. So many times I wondered if being here, in this life and this present, meant that I had to incorporate myself into a provisory state of life.

That time was defined by being surrounded by voices, strange words, and expressions that presupposed a state of siege and the constant possibility of having to flee. As the years went by, I managed to understand that my family lived in a constant state of exile... and exile was what defined and marked us forever.

The feeling of living a borrowed life characterized our family life both in the private and public spheres. I felt that our exile was almost unearthly, that is to say, our family did not have earthly roots. As I saw it, we did not have an old family home or a land where our ancestors had lived. Although Chile was a modem and democratic country in the 1970s, surnames weighed heavily. It was always difficult to have a foreign last name and not one of the accepted ones. Hence, being a Pérez presented fewer problems than being an Agosín. Since we were more like inhabitants and not citizens of Chile, we did not occupy any land. We were landless, displaced, outside the boundaries of this country.

Exile was a phenomenon of the land, of not possessing any land, of not having a history in that land, of unconsciously feeling that we belonged elsewhere. Being Jewish is symbolic of exile. We came from so many places that we no longer remembered. When I asked about those other places from which we

had come, my grandfather had a different answer every time. For example, I knew we had come from the Austro-Hungarian Empire, but the borders were unclear. We were not sure if we were Polish or Austrian or if the family had moved to Prague. What we knew for certain was where their lives ended. I felt then that my family tree had been cut. Some of the branches never saw spring. They remained lost in the winter, turned to ash in the darkness. In order to recover them, I had to name them, to call them forth. For me, exile manifested itself as a disruption in the family tree, a deep absence of histories.

With the absence of family histories, and the feeling that my ancestors had not reached a ripe age and were part of truncated lives, exile became part of my memories. Many of our memories seemed ambiguous and uncertain.

Exile from a world to which I never had access became the essence of my writing. That is to say, it facilitated the possibility of invention, of doubt, of daydreaming. I invented the family I never had and those whose lives I assumed had ended in a forest of barbed wires, dead or feigning death. I made them come to life, gave them hair and voices.

The exile of our ancestors managed to stir my imagination to the rhythms of solitude, making it possible for me to build lives, alternating melodies and words. Exile became fundamental to a form of writing that had begun in a closely guarded fashion but was filled with a powerful desire to create life. Literature and its aesthetic expression of language were the most powerful ways to recover what had been lost, the voices and the time that has disappeared.

Thus the years spent in Chile, especially the critical time of childhood when feeling that you belong is essential, found me living in a permanent exile and developing an imagination about exile. At night, while I played inside my house, I imagined unseen fissures, faces to be born, hazy worlds that would become more solid when history recovered its rhythm, its essence and its words.

The twentieth century defined various periods not only through the exile, refuges of war and immigrants who migrated

for economic reasons, but also through the migrations spurred by those who longed for a different life. For many literary people, exile was replaced by the glamour of living outside of their homelands. Living in exile is like living a life in constant interruption.

Much has been written about being an exile and the condition has been glamorized, especially in literature. Many times I have asked myself if this condition is not a way of living literature—of imagining literature from a space within the genre—and feeling that everything that does not directly involve literature must be exile.

Some of the writers who have been most inspirational when talking about exile are Edward Said, Andre Aciman, and Edmond Jobes. When I see these names, I cannot stop thinking about the Jewish expulsion from Egypt. Maybe this has been a thread that has united the Jewish Diaspora. Both Aciman and Jobes, Egyptian Jews, postulate that the experience of exile is deeply tied to the experience of being Jewish. To this I would like to add that it is also tied to being human.

Which is the writer's space, his or her roads, his or her inclinations in the journey from place to place? How does one create the space from which a writer looks out and invokes times and histories? Where does the writer go to create distance? From what perspective does he tell his story and attempt to reinvent himself? How do the tricks of memory work and how does the writer choose what to remember? Or what to forget? Where does the thread of memory rest and unfold?

Those who write from exile write from a physical and ineffable place. Physical in the sense that they are attempting to recuperate the history of the place and the land whose presence is so often invoked by beloved objects and memories. The physicality of writing is like a gesture traversing the rhythms of history.

Along with the physical, I mentioned the ineffable. Memory is amber: ambiguous, clear and dark—beyond the light and the shadows. It possesses varying textures and lapses. Writing from exile can be placed between the coordinates of the intangible and the concrete.

Writing from exile is also motivated by anxiety over what could not be, a desire to recover the time that was truncated by having fled. Words themselves attempt to recover that moment when we had to flee. Jobes understands that literature and exile love one another, are intertwined and they dream of themselves as an eternal complement to the words that attempt to emanate into the space reserved for memories. The writer who chooses exile as a space for his travel knows there is no return. His writing will be a circular discourse, perpetually moving and questioning the departure and the potential return. He will find the time of permanence a desolate place, a blank space that can only be filled by a passion for words and a history that shapes the blank page.

I always thought that each journey begins as a blank page. The details are minimal. Then it begins to come together and form small plots within each of the histories. There is no permanent reality for the writer. The only permanence is that of exile and this is really a lack of permanence in the end because being exiled, like writing about memories, implies a fragile and ever-changing discourse.

Once we left Chile, I was stripped of everything familiar. It was as if a ferocious wind had suddenly blown through my land and my home and, after it left, all was emptied and emptiness was my only companion.

We arrived in America. The days were different and opaque. Time was measured through the insistence of the future. It seemed as if life was suspended in the midst of plans and appointments that all pointed toward the future. Little remained of my sense of permanence, only the recovery of memories and my history, which was also suspended in the fragility of remembrance, in the dangerous twists and turns of memory. I was nothing without memories and without history. My identity depended on my memories.

Once I had been stripped of permanence, words were my way of building returns. I knew how to unsay one history and configure another. Life seemed more fragile. I yearned for the permanence suggested by a return to the homeland. I remember visiting my grandparents and their memories and finding them

in their ritual baths, within the daily dimensions of their lives. However, all of that faded and was left behind. The grandparents died, the neighbors died, and other relatives died too. The dictatorship left us buried in the most nefarious silence filled with mistrust.

In order to survive, I write and remember the time when we fled. That day the wind was strong and it left marks on our surprised faces. In exile we repeated the stories we had heard from our grandparents. We knew about the grandmother who had crossed the Andes on a mule, about the aunt who sent the new immigrants a huge dresser as a gift. Surprised and familiar, we repeated the histories, but these memories were not just the history of our family or the history of the Jewish people, they were the history of the twentieth century. History is all about facing your memories and feeling their presence surrounding you. Behind me I see the Andes and the chorus of voices belonging to my classmates. I am alone, suspended in nobody's time. My hands are signaling good-bye and I know deep inside that we are alone.

In North America I was part of the generation of immigrant writers who wrote in Spanish as a form of resistance, as a way to remain the people they had been in another language and another country. Writing in Spanish was many times the sole sustenance for my soul and the only way for me to express clearly that which I had left behind. Although English was part of our history and our meditations, I longed to keep my words as the primary shelter for my memories, my history, and my being. Those were hard years during which I wrote in Spanish while living in a country that had twenty million Hispanics. It was like living in a perpetual state of colonization or not being able to be what I knew I could be. It was a struggle against a past of oppression, against forgetting the truth. I wrote regardless of myself because it was necessary to write. It was only in the realm of writing, where the blank page was the only possible sovereign, that I found the true dimensions of my history.

I return to the topic of writing to repeat that writing is a way of being and existing in exile. It is a way to retake the blank page and leave some marks, the traces and fragments of a memory

always in the making. As Edmond Jobes has said, "Writing is exile lost in the dense of whiteness where it leaves traces of its endlessly circular wanderings. The end of everybody is in reality more of a beginning than an end. It is always provisional because only through the nuances of words does the book come to know the incompleteness of its textual existence. Only through this homelessness to realize that the unrevealed and inexhaustible book must be written." I continue to write my own book now and forever from that dimension of absence in order to deny absence and to find the words that are the memories of my exile.

I must say that writing from exile is not that easy. I am not even thinking about what writing means outside of one's language, but translations have made it possible to cross the borders of literature. Writing in exile or from exile is shrouded by a feeling of loss and absence. The writer assumes an audience that becomes more and more hazy and that personifies the absence of the readers. This absence is heightened when the writer thinks about that which has been lost. For me, writing in Spanish makes exile not so much an absence but rather a search for that which is gone. Writing in Spanish has given me the certainty that I exist in Spanish. I did not choose the Diaspora as the motivation for my writing but rather I am, I exist in Spanish while living in exile and through language I can experience that which has been lost.

Here, I have tried to unite the presence of Judaism and exile and writing. Maybe the point that unites them all, the common point, is the possibility of seeing the homeland as a medium to memorialize the history of the Jewish people and the preservation of memory in the Torah as the central nucleus of a nomadic people. The only certainty that has helped maintain the history of the Jewish people is the perseverance of memory, which is a metaphor for the perseverance of the writer in exile.

My writing from exile does not attempt to find the mystical and imaginary or to glamorize exile per se. It actually attempts to recover the texture of exile that would be the ineffable, that which disappears, the presence of certain fragrances or the possibility of returning home. I would not want the past to be nothing but a lost void. I rather feel that the past and that which is lost should

be present in writing now and later. I must stress that remembering the past should not be presented as the only possibility, because always focusing on the past would create a static present, and writing in and of itself has to be ever-changing.

To write from exile does not suppose a world apart. Writing from exile must be a permanence, constantly articulating the present, the past, the memories and lack of memories, as a way of being and living in a world where the possibility of remembering and being a witness is not outside of history but a part of history. Maybe through experiencing exile in this harmonious way we will achieve the possibility of memory being a true and ineffable source of wisdom. Always in a foreign country, the poet uses poetry as an interpretation.

Translated by Monica Bruno Galmozzi

No Homecoming for a Dictator

I still remember that night, the texture of the air, the color of the sky, the sun sinking in a horizon inhabited with memories that were slowly vanishing. We had begun our trip to the United States, leaving behind a universe of great and small affections, letting go of the familiarity implicit in living in one's homeland. I was a teenager, yet I vividly sensed that the landscape was vanishing behind us like the often confused and arbitrary spheres of memory, and that all my returns would be uncertain.

Our exile from Chile in 1973 coincided with one of the great events of its history, the overthrowing of the government of Salvador Allende and the arrival of a dark dictatorship led by General Augusto Pinochet, that today still leaves sequels of hatred and betrayal in a divided nation. For me, those years of exile represent the beginning of my life as a poet and human rights activist. Although I had written poetry since I was a child and Gabriela Mistral and Pablo Neruda had occupied a very important part of my thoughts, poetry only became my vocation once I attempted to preserve the magic of the Spanish language that reminded me so warmly of my childhood. Spanish was the language that placed me forever within those spheres of tenderness and belonging. Taking refuge in it has been an anchor in my exile.

For me, political activism continues to be part of an ethical responsibility toward history, a struggle that began in the early 1970s, when we received news that my father's friends were going into exile, abandoning their country under traumatic circumstances. Other news stories told of the disappearance of university students, young idealists who gave their lives for the creation of a more just society and whose destiny even now remains unknown to their families and the rest of the world.

I remember once in 1975, when I was studying at the University of Bloomington in Indiana, a writer arrived en route to Berlin. His name was Antonio Skarmenta. Today he is widely known as the author of the novel and acclaimed film *Il Postino*. Antonio opened his briefcase and pulled out an arpillera, a small piece of decorated fabric with burlap backing. Arpilleras are made up of various elements and layers of materials superimposed one on the other, like a collage, and they narrate a powerful history through their images. I could see in this one the image of a young man being led away by armed forces as his mother looked on in fear.

The sight of that arpillera and the experience of touching it, even smelling it, were the most decisive factors in defining me as an exile committed to her nation, to human rights and to taking action. Holding it in my hands, I had a powerful feeling that I would dedicate my life to knowing more about the mothers of these desparecidos and their plight. I wanted to know these heroic women who could, through mere scraps of fabric, create such beautiful and compassionate images. I wanted to know how they could maintain faith in the face of such adversity.

For more than a decade I travelled to Chile to visit the members of my family who had stayed behind and survived under the dictatorship, to find my roots and my identity, and to begin a dialogue with the Chilean arpilleristas, the makers of the colorful fabric montages. Originally a group of fourteen women from the poorest areas of Santiago, they first met in 1974 and worked together until the beginnings of democracy, in 1992. Their first workshop, and all the ones that followed, were sponsored by the Catholic Church, which also helped distribute the arpilleras.

The first time I met these women was on a vibrant morning in 1976 at the Cathedral in Santiago. On the second floor of this imposing building was the office of the Vicaría de la Solidariedad, an organization supported by the Catholic Church and involved in protecting human rights. I arrived filled with uncertainty and anxiety. Who was I to ask them about their past and their stories? Would they think me a mere child playing with the dictatorship? All these questions disappeared as soon as I entered the office. I

found myself among a group of the original fourteen women, who ranged in age from 60 to 80. They looked very tired. Each was the mother of a political prisoner or someone who had disappeared. It was a beautiful summer day, and we left the office to find a seat near some orange trees whose scent was warm and inviting. There they showed me their arpilleras depicting scenes of detention, exile, and torture. Their hands flew and their faces came to life as they told me their stories. To this day, I can still hear their voices and feel their passion.

Created as a way to denounce the crimes committed by the state and by General Pinochet, arpilleras occupy a historical role within Chilean cultural history and possess a universal and symbolic force. The arpilleras were born in a historical context of military repression; those crimes culminated with the arrests of innocent people and the institutionalization of clandestine torture centers and disappearances. The mothers of the disappeared, living at the center of that repression, created their arpilleras with leftover materials—beautiful fabrics they used to demonstrate the terrifying truth about their lives and, collectively, the lives of all Chileans in a nation in crisis. From within those private spheres, those zones of pain, the hands of the arpilletistas recreated histories, discourses that questioned the authority of the state, the hypocrisy of the official military discourse that alluded to peace and family values, while arbitrarily destroying its children.

These passionate women armed themselves with needles and multicolored threads to denounce what happened in Chile. Their arpilleras have gained an international dimension of enormous importance. Motivated by the desire to protest their children's disappearances, the arpilleras and the women who created them, occupy an extraordinary place since they became the conscience of a society that lived in darkness and fear of the dictatorship's horrors. The arpilleras represent the possibility of preserving the light in that darkness. These humble women, transformed by their inner solitude and the arduous work of weaving a history, of telling others about their most hidden and private pain, move us all.

The arpilleras would not have become known without the international cooperation of other women who took it upon themselves, with great empathy and compassion, to reveal the strength of these Chilean women. Canada was an exemplary nation in the distribution of the arpilleras. For example, the people at CUSO and Marijke Oudegeest, a great woman of even greater courage, were among the first to understand the relevance and importance of the arpilleras and the fact that they had to be shown outside Chile.

My own contribution began as a series of talks about these women and their work. At first I did this locally, at the campus where I taught. The audience's reaction was very encouraging. The stories of the arpilleristas elicited a lot of interest and soon I began to travel extensively during the Chilean military dictatorship. I received several anonymous threats during those years, but something inside me told me that I had to continue on this path and help salvage and preserve the history and the memories of these women.

From that series of talks and my trips to Chile, which became more emotional and moving with each one, I have retained very vivid memories. Once some arpilleristas gave me their only photographs of their missing children so that I could travel with them. Those photographs became a sacred talisman and led me to write about the arpilleristas and the ways in which popular art, at a grassroots level, can exert a transforming power on society. I saw how necessary it was to restate the power of human rights and their intrinsic relationship to women's rights.

However, in those days multiculturalism was just becoming popular, and the nefarious involvement of the CIA in the conspiracy to oust Salvador Allende was still a subtle, yet ever-present, reality. After many failed attempts, I finally found a North American publisher to print these women's stories in 1987—Williams-Wallace, a small Canadian publishing house led by Ann Wallace —in a humble edition without color pictures, called *Scraps of Life, Chilean Arpilleras: Chilean Women and the Pinochet Dictatorship*. Although this book, the first written about the arpilleras, went on to gain international importance, it was some time be-

fore a publisher would publish it in the United States. This time it was a more elaborate edition with forty color photographs under the name of *Tapestries of Hope, Threads of Love: The Arpillera Movement in Chile 1974-1994* (University of New Mexico Press, 1996). To date, these are the only publications dedicated to this vital topic. My difficulty in obtaining support for these publications is in keeping with the numerous ways in which North American society chooses to look away from certain events in which its governments have been involved. Publishing a book about the arpilleras meant revealing the CIA's presence in Chile and the involvement of North American corporations in Pinochet's coup. Is it not surprising, then, that the United States has not made any statements with regard to General Pinochet's arrest in 1998?

Within the world of the arpilleristas, where the pain of others is part of their own pain, we can single out two key figures: Les Harris, producer of Canamedia Productions in Toronto, and director Andrew Johnson. In 1991, they called me to discuss the possibility of a documentary. The result was *Threads of Hope*, which won numerous prestigious awards, among them the 1992 Peabody Award. It presents, with great depth and minimal sentimentality, the lives of these women who nobly became the guardians of the Chile's memory and conscience. This compelling film allows us to meditate on the great fragility of democracies throughout the world and the struggle to keep them afloat. Chile itself, which had until 1973 an exemplary political life, fell prey to a sinister dictatorship.

Now, once again, my country has made headline news, just as it did three decades ago when a duly and democratically elected leftist president was betrayed, after a short period in power, by the same general who today is under arrest in London, awaiting extradition to Spain. Allende is no longer the central figure in this unfolding drama; instead, it is the man who led him to his death, literally and symbolically. General Pinochet's arrest is, without a doubt, one of the most important events in international politics in this decade. It is the result of the people's demand for accountability. Now there is international pressure to bring to

justice the man who ordered hundreds of arrests and deaths and forced disappearances—without previous trial and with absolute immunity. His arrest is a symbolic act of great magnitude: for the first time, history is being defined by those who were victimized.

The voices of the fascist right in Chile clamor for immunity for the General. They ask for compassion and pity because he is an old man. Does the General feel pity for the mothers, now also old, who desperately searched for their children? Did he have pity when he razed towns and his soldiers confiscated the arpilleras made by those women?

I remember the emotional day when the House of Lords gave its first verdict to allow the extradition of General Pinochet. I called my friends, the arpilleristas, my companions in my own exile and in my memories for all these years. There was no revenge, hatred or anger in their voices, only a deep gratitude at the validation of their search by an international community and the relief at not having been forgotten.

Last year in *The New Yorker*, General Pinochet defined himself and foretold his future: "I was only an 'aspirant dictator.' I've always been a very studious man, not an outstanding student, but I read a lot, especially history, and history teaches you that dictators never end up well" (Jon Lee Anderson, *The New Yorker*, October 19,1998).

Whatever the dictator's destiny may be, he has already defined his role in history as a criminal. General Pinochet, like other dictators, leaves nothing to remember, only the image of an unrecognizable cadaver. The people who support General Pinochet today are those who belong to the military, the Chilean oligarchy, and business people. Theirs are the loudest voices in trying to convey the image of General Pinochet as a benevolent old man, and they have filled the bookstores of the rich Santiago neighborhoods with tales of him as a great historian and political analyst who rebuilt Chile's history. However, the outskirts of Santiago, where the arpilleristas live, are filled with dirt and smog, and the inhabitants live in the most precarious conditions. For them, General Pinochet's arrest signifies the hope that Chile will again become a just and ethical society, a society that will analyze its

dark past and come to terms with the fact that its two previous democratic governments, led by Patricio Alwyn and Eduardo Frei, were controlled and manipulated by the military. This sad fact becomes even more apparent when Chile's government tries to defend a self-appointed dictator under the guise of national sovereignty. General Pinochet's arrest and Chile's failure to hold him responsible for his actions make it clear that the country continues to live in the dark shadow of his control, and that the arpilleristas are women of truly great heroism.

The arpilleras have made us remember the words of Salvador Allende: "People make history." To this I must add, "The arpilleristas make history." They were the faithful narrators of a history that could not stop mothers from searching for their children. Their voices might have been silenced, but their hands told the story.

Translated by Monica Bruno Galmozzi

First appeared in *Literary Review of Canada* (May 1999) : 11-13.

El Presidente

Todo vestido de blanco,
despojado de las gafas oscuras
del sable dorado,
el general, todo de blanco,
desfila par la ciudad
de los muertos y los vivos.
Nada interrumpe su paso.
Marcho diligente entre la sombra de
los muertos.
El general no escucho el quejido
de madres viudas.
El general no se detiene ante
las orejas danzarinas en los pavimentos.
Nada mancha el traje blanco.
El sol del verano temeroso,
encandila sus ojos demasiado azules,
sus párpados inmóviles.
El general desfila entre los muertos,
pretende que están vivos.
Sólo el general se posea par su patria,
un jardín de huesos,
un parque de madres buscadoras,
una patria en busca de un nombre.

El general se viste de blanco,
una perversa mancha rojiza
emana en su sable dorado.
El general se viste de blanco,
nieva en la ciudad

este verano en la patria de los muertos.

The President

All dressed in white,
without his dark glasses
and golden saber,
the general, all in white,
parades through the city
of the dead and the living.
Nothing interrupts his movement.
He diligently marches among the shadows of
the dead.
The general doesn't hear the cries
of the widowed mothers.
The general doesn't stop before
the dancing ears on the pavement.
Nothing stains his white suit.
The fearful summer sun,
blinds his too bluish eyes,
his frozen eyelashes.
The general parades among the dead,
pretending they are alive.
Only the general marches for his country,
garden of bones,
park of searching mothers,
country searching for a name.

The general dresses in white,
a perverse red stain
emanates from his golden saber.
The general dresses in white,
it snows in the city
this summer in the country of the dead.

Translated by Monica Bruno Galmozzi

Sites of Memory

At a luncheon in New York, the capital of foreigners and the site of the American Dream, a Uruguayan friend told me in the ongoing conversation about defining ourselves, "I am bicultural." I did not respond immediately. For a long time I tried to figure out if I was bicultural and I tried to renew the dialogue with what this statement implied: to be part of two cultures, to realize one's dreams in both cultures, not to doubt what space we occupy within each culture. Then I thought about language and how it fits into being bicultural and realized that language is the most revolutionary and intimate expression of who we are.

After a long meditation I decided that although I have lived more than half of my life in the United States and I can express myself in English and function in this society, I am not bicultural. My most radical and intimate experience stems from having grown up in a Latin American society. The oldest memories I have and my earliest dreams were all formed in South America: a continent still in the making. My formative years were spent in a place dominated by the intertwining of cultures and at the same time experiencing those cultures in new places.

If Carlos Fuentes in his extraordinary book *The Buried Mirror* (Mariner Books, New York, 1999) posits Latin American culture to be the intersection between Mediterranean and New World cultures, I place myself within that intersection. Latin America implies the travel to the New World as well as a journey within a continent in perpetual state of flux, a continent that has yet to name itself.

The issue of whether I am bicultural implies questions about identity and space in which we evaluate who we are and what

our memories are. My space can be found in the intersection of memory as the sum of the journeys taken by all of my ancestors, a lyrical reflection about origin and a meditation about the forms that memory acquires.

I begin writing this essay that has already transformed itself from my original intention to speculate about writing as a judgment of the self and a dialogue to understand what Chile has meant to me in the past thirty years. This essay is a great yet minute endeavor. It can be deemed great as part of a long historical process and minute in terms of the contradictions of the human experience throughout history.

CHILE

I chose Chile for a multitude of reasons. First of all because Chile is my space, my address, and the place where I fit in as a person. Chile represents a point of arrival and departure for my lineage. Relatives came to the coasts of South America searching for peace, shelter, and survival. I arrived in Valparaiso when I was three months old and remained there until the rhythms of history decided we must depart again. However, it has been impossible for me to leave Chile behind, to stop being Chilean even though my own contemporaries often tried to deny me the possibility of identifying myself with the space I inhabited in my childhood. This denial has come from the fact that I am an exile, and so my contemporaries who stayed behind in Chile felt that I no longer had a claim to my beloved land. The other possibility is that as a Jew, I also did not have a claim to that land. It is from this point of origin that I tell my story.

What is Chile? How do we imagine a nation and reflect upon it? So many times I have thought about what it means to imagine one's nation with its rivers and to recognize its cities. It is from Chile and the childhood I spent there that I experience a nation in terms of language. Spanish was my most secure identity. Exile implied symbolically leaving behind my land and my speech.

Until my early adolescence, Chile for me meant poetry. Poetry was rampant everywhere and it was part of our culture, oral

and written. The masses knew poetry and poetry sat like a sovereign on its temporal throne. The newspapers, when writing about history or politics, quoted Neruda and Mistral, who were used to define a singular national identity. Both poets were used by the dictatorship in the 1970s and the democracy of the 1980s. Neruda was seen as the poet of the communist and the dispossessed. Mistral was in reality the poet of the dispossessed, the poet who participated in various official campaigns and thus, was easily canonized by the masses.

The poetic experience in Chile occupies in many ways a place beyond daily cultural life. I would say that poetry encompassed the imaginary realm of the whole nation. If Chile defined itself through its history, we can see its beginnings in the long poem entitled "La Araucaria." As the years went by, the rapid socialist influx and the authoritarian regimes left the country suspended in a space with no language. Only the gestures or the absence of gestures could define what Chile was in the 1980s and 1990s. It was a Chile filled with fear and silence. That was the Chile that led to our exile and my need to speak out.

In one of the many conversations that exiles have about their histories, Susana Kayser, a friend from Argentina, told me that for fifteen years she could not speak freely. She felt gagged. The gag is one of the most recurrent images for the years spent in exile and it has been worked into various literary works from poetry to theatre and works of art. The streets and plazas, the places that were once filled with speech became the places of silence. The spaces usually associated with silence, like the desert, became the sites of a new lexicon of horror. Many dead were buried in the desert to hide the crimes of the dictatorship. Years later, Sierra said, "Chile is a cemetery and all of Chile is a desert." The symbolism and imaginary are transformed into other things that we no longer recognize. The dictatorship, in order to create itself, had to undo what the past one hundred and fifty years of democracy had created. While searching for the dead in the 1980s and 1990s, the mothers, the widows, the women of the desert of Atacama discovered the truth.

I return and will continue to return throughout this text to the meeting of memory and nation, the writing that will assume the histories of some with their words and their silences. Like memory, I return to what I experienced and imagine that which I did not see.

In the early 1970s we left Chile, a few months before Salvador Allende was overthrown. Almost twenty years later, I still remember the fact that it was dusk when we left. The night was coming and with it the stars and constellations I used to name. It is only recently that I can remember the last night spent with my classmates, bidding my grandfather farewell. This time, my grandfather was not receiving refugees as he did throughout most of his life. We were the refugees escaping into the night. The decision to leave Chile coincided with the political turmoil and the division of the country, as well as the fact that my father, a university professor, was no longer allowed to teach. That alone is the subject of another book. On the night we left I was fifteen years old and I understood that all that was once mine would no longer belong to me. Exile was leaving myself behind and learning to be myself again. Exile was a very individual and personal experience for each of us. Later, I understood that our exile could be part of a more collective phenomenon, the Diaspora of all Chilean people as well as all exiles. When Andre Aciman was asked why he returned to Chile, he replied: "I went back to touch and breathe the past again, to walk in shoes I had not worn in years. This, after all, is what everyone said when they returned from Alexandri." (False Papers, Farrar Strauss, 2000). When I left Chile as an adolescent, I longed for this return.

THE JOURNEY TO EXILE

The journey to exile was never a great adventure. It was an escape from the familiar geographies, the light, air, and landscape I had grown up to know and love. As Pablo Yankelevich says, to

a certain point, exile implies navigating a life experience in all imaginary frontiers and imprecise demarcations and residing where one country borders another. I believe this to be accurate since my life no longer had borders to delineate my history. Everything was unknown to me: a sea to imagine and new flavors to experience.

Eva Hoffman's *Lost in Translation* (Penguin, 1998) and Edward Said's *Out of Place* (Norton, 1999) have inspired me. Both Said and Hoffman, as well as Ruth Behar, postulate the ideas of translating the exile experience and constantly explaining what and who we are. To translate one's self implies the perpetual search for the self and the fact that we belong neither here nor there. My decision to write in Spanish and not have to constantly translate myself allowed me the privilege of anchoring myself in my history. Language was the first witness of the history we lived at home. Living in Spanish allowed me to live fully inside those spaces that recreated Chile for us. Said states that "Everyone lives life in a given language. Everyone's experiences, therefore, are absorbed and recalled in that language. The basic split in my life was between Arabic and English" (11). In Chile I spoke fluently in Hebrew and Spanish. Hebrew represented a historical aspect of who we were. Once we set foot inside Hebrew School it was like stepping into another country. This gave me the opportunity to experience a country within a country.

There is a poem written by Amir Gilboa that has had great significance in my life:

> If someone were to ask me
> Who will ask me?
> Who will ask me?
> Where were you in those days?
> Those days?
> Well then, maybe it is true
> I was not in those days
> Those days were within me.

Chile is engraved in my memory like a landscape or a lyric. I have felt passion for that country that first awakened my instincts and feelings. The fragrance and the name of the first things we touch and see have always remained alive inside me. I always mourned for the fact that I did not live out my hopes, history and adolescence in Chile.

GEORGIA

The port of entry to the United States for our small family of five was Georgia. Our imaginations were filled with information and feelings about the Civil War, most of it gleaned from *Gone with the Wind*. It was many years later that I understood that there were very few places in the United States where the history and the memory of America were one. I wondered if North Americans celebrated holidays not as a way to remember history but rather as a way to fill their busy calendars with family events organized from the artificial dictates of society. Yes, even the alleged family gatherings took on an artificial feeling. That was something I felt from the moment we arrived and it was such a powerful feeling that I felt immediately lost in this new society.

The spaces inhabited by exiles are intangible. Memory becomes sharper and more intense and then disappears. My memories of Chile were inevitably linked to the memories of my parents, whose minds were already filled with memories of other exiles and journeys. My father had arrived at the port of Marseille in a decrepit and very fragile boat. He was the son of Jewish immigrants who had escaped the pogroms in Russia and finally moved to the central valley of Chile. My father's exile became more and more silent. More than thirty years have passed since we fled Chile. These thirty years have been profoundly significant in the history of Chile since they involved the election of a Socialist government, its downfall, the dictatorship of Augusto Pinochet and his downfall, the puppet democracies of the 1990s and finally, the election of a new Socialist government. It took all of that for my father to feel comfortable speaking about Chile's politics and history again. Oddly enough, both my parents will

finally retell their stories though my writing—the daughter telling the story of her parents. Marianne Hirsh, commenting on the history of the post-Holocaust generation, states, "The post-Holocaust art of children of survivors both seeks and depends on material connections to the experience of the parents' generation" (*Acts of Memory,* Hanover, NH).

Our stay in Georgia and the constant images of an empty house remind me of how we felt: the perpetual inhabitants of a history without witnesses. Many years passed and I understood that the wound that hurt the most and still remains within me is that of having lived without a history, without inhabiting one space or the other fully, without ever becoming fully bicultural. We spent our time in Georgia reminiscing about Chile and the past. Learning English, forgetting Hebrew and our passion for Spanish, were the signposts in an already turbulent adolescence where prejudice against foreigners, blacks, and Jews defined what it was like to live in the South. In a novel published in Argentina by Perla Suez, she recounts her experience as a stranger in her own country because she was Jewish. This only reemphasized what I felt living in Georgia. "The darkness like a pitch-black night will begin a little before the girl enters the scene and will end a long time after the girl becomes a woman." (*Letargo,* p. 34)

Being an adolescent in a foreign country is complex and always troubling. Desire, passion, and the mirror that always shows us a frightening and incorrect image, alter all the beginnings that were learned in one's homeland. In Georgia my adolescence ended abruptly and I had to act like an alien intruder, perpetually a stranger to the existing customs. During that time my memories of Chile were formed and solidified.

At night I used to dream of Chile like one dreams of a lover. Chile, that long narrow strip of land, extended before my eyes. I used to imagine the desert, a horizon with no name, and the Andes like an ever-present gorge. It was 1972, and as 1973 approached all conversations at home turned around Chile. I felt that our little family nucleus of strangers in Georgia participated in the life of a country that was slowly falling apart. At night we

would watch the stars that we could not readily recognize and I felt alone in this great vastness.

We received news from Chile by mail and through friends who were constantly fleeing Chile. We also traveled in a static form of travel. We remained in Georgia in a house that received guests. Chile was accentuated. Sometimes we received visitors sent by my grandparents. They stayed with us for a long time, some times up to six months. At this time everything was scarce in Chile and everything was in perpetual chaos. I understood very little of what was happening in my beloved country beyond the Andes. I walked around in a daze, missing my Chile. I remember a poem by Rafael Alberti:

> Uninhabited cities
> Are suddenly filled with
> Derailed trains united
> They march. (30)

The memory of those years is that of an empty house filled with generic furniture and disposable plastic utensils. Little by little I began to ask questions. They say that people disappeared and that some of our friends had to cross the Andes dressed as nuns to be safe. The house was suddenly filled with the sound of my questions. Alone, I imagined what Salvador Allende's palace must have looked like engulfed in flames.

After the first few months in Georgia we returned to Chile. If we felt like visitors in Georgia, the trip back to Chile made us feel like we would be forever visitors no matter where we went. Chile was no longer filled with friends. The Jewish community had left and those who remained were too scared to talk.

1973–1978

I choose these dates because the individual days, months and years are a blur. I do not intend to summarize the political history of Chile nor repeat Ercilla's poems or sing some patriotic songs. The presence of a nefarious dictatorship marked the return and my obsession with memory. How do we remember the

time of fear? With whom do we meet? Whom do we turn in or not turn in? With the advent of democracy we are just learning to reread the imaginary signs and seek alternate routes. To live under a dictatorship means to live on opposite ends of silence and caution. There are those who speak up and those who have nothing to say.

At the age of twenty I went back to Chile and was faced with two realities: One was that a large part of my family had died during the Holocaust, and the other was that Chile's veins were filled with right-wing fanaticism. My trips to Chile during the dictatorship awakened my political conscience. I do not know how to explain how some chose courage and passion and others chose indifference. I was young and brave, like all the innocent victims. I decided to learn about Chile and I looked around me and spoke to the older women.

During the dictatorship all artistic life in Chile was censored and veiled. The writers wrote in silence and for themselves. This essay has as a focal point a meditation around art and human rights and how artistic expression is manifested under a dictatorship. Now that we are observing this from a distance of time and space, it is easier to analyze. Various things were occurring simultaneously in Chile, as if we were living in various countries at once. There was the Chile of popular art that continued to exist and generate murals, songs and popular chants. Then there was the Chile of the elite, the educated class that censured art. It is hard to enumerate each of them and to be fair to all, but I will attempt to stress the importance of art as a way to mitigate fear—from the poems written in jail to the readings that took place in the furthest corners of the country. The greatest example of this is Daimela Eltit, the writer who wrote from the dictatorship, within the dictatorship, and who refused to leave Chile.

During those years I frequented bookstores and met with dissidents, young writers. Their lives were more precarious than mine, but they were more fortunate, I thought. They were living history, and I was observing it from afar. I then assumed that history and memory were parallel and were created in conjunction with each other. I understood that the disappeared had ceased

to exist in the plenitude of their histories and lives. A nation that chose to make its youth disappear was a nation without a memory for the future.

The term *disappeared* was a significant one in the lexicon of South America. The disappeared were a disquieting part of the memories of all Chileans. To make someone disappear was to negate the presence of their bodies and their spirit. Where are they now? How did they leave? Disappearing is undoing all possible histories.

THE ANTECHAMBERS OF OBLIVION

What the disappeared left behind was a suspended memory of an unfinished life and the eternal question of where his or her life should go now. The process of making someone disappear had created an ongoing debate about memory, the ambiguity of memory and its disturbing and eerie qualities. The individual disappears. Does this mean his history and presence disappear as well and all that is left is a dialogue surrounding the search for the disappeared? Memory is born from absence, and the active and moral need to remember becomes one of the most essential elements in Chile's dialogue with memory.

The history of women in South America during the Chilean military dictatorship covers two essential aspects: women will be the key force that activates conscience and memories, and they will also judge the history of the new democracies—an active dialogue that is always aware of its relationship to memory.

The process of remembering is for those women an act of vindication and it will focus on searching for the disappeared while creating an active and tenacious bond that will inexorably link the culture of living with the culture of the dead. Memory for them becomes an affirmation of life.

The readings about the Shoah and what remembering within the Jewish experience implies could be linked to what we discussed about the Mothers of the disappeared. In the words of Eva Hoffman:

At this point, the task is to remember, but to remember strenuously, to explore, decode and deepen the terrain of memory. Moreover, what is at stake is not only the past but also the present. In Poland the lacunae in collective consciousness, the blank spots as Poles themselves call them, have had harmful and disturbing consequences. (Norton, 1999, 14)

Eva Hoffman's vision of Poland's history and the Holocaust will also be very visible in the history of Chile since the memory of some (in this case, the victims) will be the lacunae and oblivion of others. This constant tension between the tenacity of memory and the tenacity of oblivion will mark the Chilean society beginning in the 1980s, immediately following the transition from dictatorship to democracy and will culminate with General Pinochet's arrest. World opinion will give Chile a perturbing glance, filled with pain, but nonetheless it will be a glance that will increase the desire of all Chileans to share a collective vision of history. At this moment, I believe Chile is beginning to open up and participate in the memories of other nations that have a political and social conscience with regards to human rights.

Martha Minow says:

Will the twentieth century be the century most remembered for its mass atrocities, the Holocaust, World War II, the killing fields of Cambodia, Argentina's Dirty War against subversion, the Turkish massacre of the Armenians, the Rumanian terror both before and after communism, the East German system of pervasive spying and lethal enforcement around the Berlin Wall, the slaughter of Stalin, the Americans at Mai Lai, Uganda and Chile? Each of these horrific events is unique and incomparable and, yet, a century marked by human slaughter and torture sadly is not a unique century in human history. Perhaps more unusual than the facts of genocides and regimes of torture marking this era is the invention of a new and distinctive form of response.

The capacities and limitations of these legal responses illuminate the hopes and commitment of individuals and societies seeking above all some rejoinder to the unspeakable destruction and degradation of human beings. (Beacon Press, 1999)

Martha Minow's words evidence the struggle between the ways in which twentieth-century nations share a history of terror and horror. This century will mark the ways in which, through legal and ethical means, various countries participated in the destiny of what it is to create a collective memory. This will be a memory born from citizenship and the desire to negate an authoritarian regime that attempted to censor all memories in a given society. This century participates in the heroic visions of lawyers, human rights activists and artists who were all motivated to not simply close history through an amnesty but rather to open up history through truth seeking missions and the erection of public memorials.

What has Chile done to rethink its memory? What have the Chileans done both inside and outside of Chile? To answer that question I returned to Chile at the time of the coup and to the history of its women.

INTERMITTENT LETTERS

If at first I treasured the memory of living in Chile, the memory of those living in exile can accentuate the good and gloss over the bad. Our memories were a constant factor in our lives in exile. The only possible relief for our imaginations came in the form of letters: real, imaginary, faded and concealed.

We received intermittent letters, censored by the dictatorship. These letters became an unruly link that tied us to our history and the history of those who had left as well as those who had stayed behind. Trying to recreate history through these letters is not an easy task. It seems that the senders and the writers practiced a form of deaf dialogue through intermittent messages

with strange and vague sounds. Chile was a censored letter. It seemed that everything was prohibited in Chile. The prohibitions came slowly. First they prohibited the gathering of three or more people, then they prohibited demonstration and then no poems could be published without being reviewed by the censors. Little by little fear took over and mundane things like writing a letter to relatives abroad became a difficult and censored affair .

Disappearing people in Chile coincided with a key time in the history of Chile's repression. People disappeared quickly and effortlessly since there was no legal way to protest or show dissent. The country became a silent place filled with people who searched for their loved ones. Every aspect of Chilean society was affected by the search for the disappeared and finally, the voices of those who searched gained visibility.

The women, mothers, sisters, aunts, cousins, and all other women became the guardians of the younger generation and, at the same time, the guardians of the nation. Chile became a mythical country filled with those who would assassinate memory and the disappeared who in disappearing created a need for memories.

The women begin a new chapter in history through their searches. If we examine the history of these searches, we will see that first it took place in areas near the homes of the disappeared, near where the disappearances took place. Then the searches expanded to encompass the whole country and every corner of that country became a place filled with memories. This is where the disappeared played. This is where they went to school, where they rested, where they loved, or ate, or danced. The silent accomplices did not take part in the searches because they were filled with fear and indifference. Their lives had not been directly touched by these disappearances, so it was easier to remain silent and not call attention to their own families. Those who disappeared were mostly young innocent people filled with the naïve desire to change the world. How ironic that through their disappearances and deaths they were indeed able to change the world.

During the years of the military dictatorship, Chilean literature, like all other forms of artistic expression, adapted in order to coexist with the regime in the same way that political prison-

ers must coexist with their jailers. This coexistence between friends and enemies, among citizens who used to converse peacefully in the streets or shake hands acquired the form of a society of strangers who were both underhanded and perverse. Literature attempted to reproduce this history within the new aesthetics and created many novels that revealed Chile's two faces. Around this same period, we saw the birth of Nelly Richard's cultural literary criticism and the actions of various groups who took their art to the streets. Chile, the country, took on the role of perpetual backdrop to various forms of art. Many years would pass for the literature created during this period to come of age and acquire a different role: that of the essay. Chile was characterized by its many poets and not by its essayists, but a series of works appeared that attempted to articulate the experience of living under a dictatorship. These were post-dictatorship texts. One of the most important books of this genre is *Chile en la mira*. I am particularly moved by Pablo Azocar's text that says: "As a citizen, I accuse the governments and parties in favor of democracy because they mortgaged our country and tread over the dreams, hopes and expectations of millions of Chileans who fervently supported them in the 1990s" (Editorial Planeta, 1998).

All the decades of repression and post repression produced the articulation of new lexicons for and against forgetting. It is important to note what Azocar says with regard to making Chile a transparent country because this is the same image that would later be used when, at the World Expo in Seville, Chile's booth exhibited a giant iceberg. This phenomenon is significant based on the fact that Chile became known as the zone without history and without memory.

The state of transparency that engulfed the Chilean society can also be seen as an era of perpetual negation, a state of amnesia. During Pinochet's era and his false financial boom, many large buildings and malls were built to show off the Chilean society's caliber. The country that had previously lived on firm democratic principles led a new life that alternated between false economic well-being and an untrue history. Chile became trapped within its campaign to forget and ignore its memories. It was then easy

to create two nations with two different memories: the official history controlled by the government and the rich and the other history filled with gaps and the disappeared.

My first encounter with this second Chile occurred when I met the mothers of the disappeared and political prisoners. I cannot say what motivated me to begin a dialogue with them, but their plight soon became my obsession, my passion, and my way to ensure Chile's memory remained alive. Thinking back on it now, a series of events and circumstances led me to make that first contact. I lived on the margins of Chilean society having gone into exile early during Pinochet's regime. My exposure to the United States' culture and its principles made me question my own identity and my country's identity in order to understand the coup that ousted Salvador Allende. In 1977, as I watched the movie *Missing*, I had the feeling that I was indeed watching my country's history and that if I did not stop to retell it, it would disappear and my identity would disappear with it as well.

At the time I believed that memory did not exist by itself. I thought that the ritual of creating memories had to respond directly to the possibility of being told and retold. I recently watched some footage shot in South Africa and I could once again feel that memory had to be told in order to exist. I have reread the works of Pierre Vidal Naquest about memory. His works are the thread that links the history of the Jewish people and makes us understand that the world of the Holocaust began to rethink itself when the first details about the concentration camps came to life.

The Memorials

How do we recreate the memories of that which we have not experienced or even that which we have experienced but goes beyond our history? For many years Chile was subjected to silence and absences. All the histories within Chile were hushed and it seemed people whispered a lot to one another. The clandestine nature of history took on its own tone in people's voices. The disappeared were the memories of those who searched for

them. Without a trace and without a name, the disappeared occupied an uncertain destiny.

The creation of memorials and monuments in Chile was halted for many years. The military astutely did this to slow down the visible manifestations of memory. Remembering meant taking risks and being willing to relive certain experiences. Memory assumed the search for the truth. All actions that questioned the fate of the missing occupied the imaginations of the relatives of the disappeared as does the space normally inhabited by vague and ambiguous memories. More than twenty years passed before a memorial was built to commemorate the disappeared. The creation of memorials coincided with the return to democracy in Chile. It was only then that memory became a public affair again and that pain could be shared.

The memory of the disappeared in Chile is like a snapshot or a portrait that becomes one with the body of the searching mothers. The photographs of the disappeared and the bodies of the grieving mothers are frozen as one image in our memories. All days are the same for the relatives of the disappeared. They leave their houses in search of their loved ones. They march and the others look at them. The photographs that the mothers carried demand that we look at them. Wherever there are groups of mothers we will encounter their open and expectant gaze as well as the hidden gazes of those who hurriedly walk by them.

My first encounter with the memorials was through Violeta Morales, the sister of a disappeared, and I would like to travel with her through this history. The memorials are created to share the feeling of being together and remembering. For me, visiting the memorials was like being in the general cemetery. The Latin American culture celebrates death as well as life. Since my childhood, I remember seeing our nanny taking flowers to the cemetery and visiting the dead. I would go to the cemetery with them and sit and talk to the dead. Sometimes I would sing boleros to them. To me, going to the cemetery meant visiting with the dead. In the case of the disappeared there is the added dimension of terror. There is no space occupied by the dead body and the visit takes place in the imaginary recesses of one's imagination.

Visiting the general cemetery is encountering that other history, that of a Chile known better through death than through life. Violeta and I enter the cemetery walking at a slow pace. She is used to this dialogue with death. Her brother Newton disappeared and she has not stopped looking for him. I always think she has remained immobile, stuck in time. Wherever she goes, Violeta carries his clothing and his photograph. As we enter the general cemetery we feel that it is a memorial to the dead but also to those who disappeared and do not occupy any space on this earth.

The general cemetery has a long wall filled with names of the disappeared and the executed. A vast water fountain with various spouts frames the wall. The memorial ties together the visual memories and the auditory memories making us think of water and children playing in the water.

Villa Grimaldi

Visiting memorials implies behaving with prudence and silence. Walking through these memorials requires the peace of those who visit the dead. Villa Grimaldi is also knows as the Parque de la Paz (Peace Park). This was the site of one of the dictatorship's most nefarious torture centers. It is a place filled with emptiness and things left unsaid. There is a sealed door through which no one may enter. That was the hallway down which they took hooded men and women to face their torturers. The human gaze is very powerful and if the torturers and the tortured could look each other in the eye, the torturers may not have been able to carry out their orders. Hooded, the prisoners were then sent to isolated cells.

All visits to Villa Grimaldi are fueled by the desire to recover memories, to find the time of the disappeared and make it part of our present. Memory is alive in Villa Grimaldi. Unlike Europe and its vast memorials commemorating all battles and the site of the concentration camps, in Chile we have memorials to that which was crossed out of history. Yes, to cross something out is to omit it from history and that is what happened to the disap-

peared in Chile. By making then disappear, we took away their right to life and to an existence. (Pierre Nora, *The Ruins of Memory*)

In Villa Grimaldi it is possible to hide behind the shade trees. There is peace and quiet here now. We walk slowly and talk in fragments. As we walk, it is possible to feel that we are crossing into the spaces inhabited by shadows. We feel the ghosts of memories becoming the memories of the future. The memories we encounter are fragments of those who disappeared and we begin to assemble these fragments to come up with who we are and what we are and what we could have done to change history. What led our small country to commit such horrendous crimes? What makes a man turn against his fellow man?

Violeta and I walk in circles. At times we hold hands and at times we drift apart as the process of remembering leaves us feeling like wounded birds. Violeta names the disappeared that she knew and who knew her brother. We remember that we have survived this dark episode of our country's history so we can bear witness and tell and retell our history.

Memorials such as this Peace Park help us reconcile the two Chiles that have lived side by side since the ousting of Salvador Allende. They help us generate times and spaces for the dead and the disappeared to dialogue with the living. The peace that we find in this park is the peace of the dead. All is clear and all is clouded. The possibility for answers lies in asking the right questions.

CHILE REMEMBERS

Chile remembers and approaches the twenty-first century with great debates about the importance of memory and remembering as part of keeping its history alive. Chile forgets and Chile remembers. The national stadium will become a memorial park like Villa Grimaldi and it will be called the Victor Jara memorial so that the man who died may be reborn.

All acts of remembering imply a careful look inside ourselves and determine what memories and forgetting mean to us. For many years, the Chilean dictatorship demanded a general amnesia from its citizens and by making people disappear, it

played with the perverse idea of hindering memory. Villa Grimaldi is a memorial to the right to remember.

Unlike certain museums and monuments, parks such as Villa Grimaldi require the presence of movement and history. The creation of a museum for memories implies a distance between the observer and the memory, but parks are open spaces, which allow the possibility of remembering and allowing memory to flow freely. Unlike certain monuments with photos of the disappeared, these parks do not have particular photographs in them. Memory does not fixate on a particular fragment of the past or present, but rather on names. Reading the names of the disappeared demands a voice and a response.

The book *Trespassing Shadows* by Andrea Liss is dedicated to the photographs of the Holocaust. Andrea Liss, just like other writers of her time, believes that photographs are essential elements of memory. Villa Grimaldi and the other memorials in Chile allude to memory as part of life and to stress that point they fill the memorials with trees and water.

I mention this to demonstrate how the gestures of memory have changed throughout history and time. The Shoah occupies a distant place. The survivors are few and the representation of their history is done through photographs and the memories of the surviving generation that searches for what I shall call the "post" memory. In Chile's case, it is the parents who survive the children and the memory is a living one. Andrea Liss explains that the photographs of the Holocaust require a history lesson, but at Villa Grimaldi the lesson takes place outdoors, surrounded by nature and with survivors whose memories are those of living people they lost. The identity of the disappeared takes on a life of its own. The visitors do not see the face of the disappeared and what became of them, like they would at a Holocaust memorial. Rather, they see the destiny of the living that memorializes the dead.

In an interesting article about the Park of Memories in Buenos Aires, Andreas Huysen says:

> What interests me particularly is the fraught question of how to represent historical trauma.

How to find persuasive means of public remembrance and how to construct monuments that evade the fate of imminent invisibility? How to counteract any monument that intends to domesticate or even freeze memory? (Center for Latin American Studies, Harvard University, Spring, 2001)

Huysen's observations are revealing at a time when the history of the Southern Cone accentuates the public debate about memory and how best to represent historical trauma. Like many other forms of public art, Villa Grimaldi tries to reflect on the responsibilities of memory and remembering.

Violeta and I return home. We have lived the history of Chile's past before and after Allende. We have lived in exile and survived the fear-filled silence. We returned to the place where our memories were formed in order to speak of this past. We return home quietly and are convinced that the disappeared did not live and die in vain for they have altered history and the way we remember.

Translated by Monica Bruno Galmozzi

[1]"To Write the Lips of Sleepers": *The Poetry of Amir Gilboa*, Monographs of the Hebrew Union College, No. 17.
[2]"Naufragios antiguos flotan", *Poesías Completas*, Hyperion, Madrid, 30.

Epilogue

The history of lost items has been part of my family's and my people's history. Many times I asked myself, "What did the Jews take from Cordoba or Seville when they were forced to leave? Where did the last Spanish Jews expelled by the Inquisition find shelter?" All of this I ask myself frequently because I am obsessed with reconstructing history. How do we reconstruct a life, through the objects that were saved and preserved or through the ones we remember and imagine?

Within European medieval history it is possible to reconstruct certain travels and certain hidden journeys like that of the distinguished merchant Benjamin de Tudela. He was a mystical traveler who journeyed throughout the Mediterranean coasts and to Asia looking for spices, gems, and fabrics and at the same time carrying with him the sacred book of the Jewish people: the Torah.

I treasure the sacred writings that have made our people the most joyous and most beautiful of all nomadic peoples. In the Torah I find the heart of all origins and the possibility of creating and building a memory through words. As Virginia Woolf said, that which is not documented does not exist. Is it then an intrinsically human endeavor to preserve history through written language?

Since the earliest history, poetry and the spoken word have been the pulse of human civilization. How did this magical act of inscribing the word happen? At what time was it decided to record thought, emotion, and history through language? In this question lies the great miracle of culture as well as the complexity and ambiguity of language.

Writing, the gestures of inscribing words, and the use of paper and pencil requires a different pulse, an inspiration, a special attention to the recording of detail and to the interpretation

of both the past and the future. To write is also to bear witness, to resist the dehumanization of the world, and to tell and reveal. From *The Odyssey* to *El Cid*, to testimonial works, *campeador* poets and minstrels have recorded the odes of humanity, from our strengths and our sorrows. Like the markings of early man in caves, our writings not only depict our world, but allow for the possibility of symbolic thinking, as writing becomes a metaphor for the way the world should be. Perhaps all works of literature are acts of retrieval in the houses of language—acts of tracing, unveiling, and recovering what is hidden to what must never be concealed.

Poetry and the works of the literary imagination use a language that is both sacramental and colloquial. The literature of remembrance can articulate human suffering and preserve a sense of a human image that is not disfigured. From the works of Primo Levi to the recipes of imagined foods found in the concentration camps of Terezin to the brave poetry of Anna Akhmatova written during the Stalinist era, we are forced to acknowledge the power of poetry to name the unspeakable—to enter and to illuminate the secret corridor of horrors.

Writing and culture are very much related to the possibilities of the human imagination. The capacity of language allows the imagination to flow and to transform and mend the world. The gift of the imagination and its vigor allow us to create alliances with others.

Books always occupied sacred places in my house, especially the three or four books that my great-grandmother Helena brought with her from Vienna. I can still remember their smell and I can see in my mind the book covers, worn by so many journeys. The books rested upon the round table near the window that faced the Andes. Sometimes I would catch my great-grandmother kissing the books' covers and her kiss seemed to be a prayer of gratefulness for her life. My great-grandmother's love for books was further evidenced when she would sometimes walk an hour or more to reach a library in downtown Santiago in order to check out a German book.

Women have always been the guardians of memory, the safe keepers and transmitters of secrets and culture in family albums. There is great optimism in preserving life through simple words such as birth certificates, marriage licenses and death certificates as well as diaries and letters. I believe that the contribution of women writers in the twentieth and twenty-first centuries has been the preservation of memory—the minute and grand stories that constitute our history. These women have taken the extraordinary deeds from the whispered songs and voices of the powerful screams, of traumatic events, and have made out of this grief a unique artistic sensibility that mirrors human terrors as well as hope.

Yes, my family could only save a couple of books, a down comforter and the Sabbath candle-holders when they went into exile from Central Europe. From this history I realized that the element that made up the heart of a nomadic people was words. The Talmud states that an evil tongue is as dangerous as the people who commit crimes and that gossip should be considered a form of violation. From this I understood that words could hurt but they could also be used to console and alleviate pain and sorrow.

I grew up surrounded by great medical tomes in which the human anatomy was dissected, charted, and hardly recognizable. My siblings and I had very little desire to peek at these books. I created my own library one book at a time. My uncles gave me Jules Verne's books and my aunts gave me Gustavo Adolfo Becker's poems. Saint Exupery's *The Little Prince* continues to be my companion. I have a copy on my night table and I caress its pages and strange drawings and fall asleep peacefully with the knowledge that all that which is invisible can be seen with the heart.

I believe that women writers have not engaged or been allowed to participate in the discourse of official remembrance and that this is why their literature has been able to capture the frailty of the human spirit as well as its depth. Women writers who have contributed to the softness of remembrance can be traced from the early diary writings of young Anne Frank, to the visionary human rights declaration of Eleanor Roosevelt, and finally, to the powerful denouncing of apartheid by Nadine Gordimer. I do not make the claim that women are closer to the truth than men, but

women in history have not engaged in wars but rather are its victims. War, rape, domestic and political violence are expressed in the literature of women with courage, with dignity, and with the possibilities of representing pain as a way of healing, but never concealing truth.

When we left Chile my father had to burn the psychiatry books that he had struggled to buy when he was a poor student. The smoke from the pyre rose to meet the horizon and it seemed to cross the Andes. I imagined that someday we would be safe and that these books would not really die in this bonfire in Santiago. And yet, I later witnessed the poets of Sarajevo burning their books in order to have heat to survive the long hard winters.

I would like to point out that writing does not necessarily redeem the world or turn the horrific into beauty, but insists on the possibilities of remembering and representing the unspeakable through poetry, art, architecture, and music. As well, it tries to recapture the innocence of this world as we once knew it. Like secret messages in a bottle, writing and literature transcend both the individual as well as the collective experiences of this world. It creates knowledge of the world, unable to exist elsewhere but in the intimacy, as well as the collectivity of language, in a room at night with a poetry book.

Humans have a great need to express themselves through writing, singing, and painting. This is what makes us part of a community that goes beyond the self and that crosses borders and creates new geographies to unite us. Books unite people and books in translation are the thresholds of other cultures, invitations to travel and to know others.

Like a fugitive, I have searched for traces, for the words that allowed me to define who I was and who I was becoming. I became lost in a new language, lost in translations, and had to recreate a new self. Writing did save me. As I was able to invent a world of longing and nostalgia, somehow it was this longing that allowed me to recreate and dream a world. My generation was marked by the political history of Latin America, by disappearances and the absence of bodies. Actually the body was our obsession and we strove to reclaim it, to relieve it, to mend a broken

heart. I always remember the wise words of the Talmud: "Nothing is as whole as a broken heart."

As exiled writers we recovered our homes, the locus of our sorrow, the pounding emptiness of nothingness, of loss. The heaps of human bodies reduced to rubble became our history and we wrote to recover it, to make it our own, to enter into the shadowy realm of the ghost, and not speak for them but with them.

Sometimes I imagine the Torah as the great book of the world handed from person to person and generation to generation so that we may remember what unites us and to help us imagine that in all lands there is the possibility of creating a history and participating in it. Books have the strength to create a mutual complicity between writer and reader and they allow the great human family to celebrate through words the memories of other times and places. It is to that memory that I humbly and gratefully dedicate these essays.

Translated by Monica Bruno Galmozzi

List of Translators

Mary G. Berg teaches at Harvard and has writen extensively on nineteenth century Latin American women writers. She is also a translator of several poetry collections including *Starry Night: Poems* by Marjorie Agosín and a novel *River of Sorrows* by rhe Argentinian writer Libertad Demitropulos.

Monica Bruno Galmozzi holds a BA in Spanish and Physics as well as an MA in Latin American Literature from Columbia University. She works as a freelance translator and has translated *Melodious Women* by Marjorie Agosín.

Celeste Kostopulos-Cooperman is professor of Latin American Literature at Suffolk University. She has written extensively about Chilean Literature and has translated several works by Marjorie Agosín such as *A Cross and A Star: Memoirs of a Jewish Girl in Chile* and *Always from Somewhere Else: A Memoir of My Chilean Jewish Father.*

Nancy Abraham Hall is an assistant professor of Spanish at Wellesley College. She has published several articles on contemporary Mexican Literature and has edited with Marjorie Agosín *A Necklace of Words: Stories by Mexican Women* and translated *The Alphabet in My Hands: A Writing Life.*

Laura Nakazawa is a native of Montevideo, Uruguay who now lives in Wellesley, Massachusetts where she works as a Spanish translator and interpreter. She is the translator of *The Angel of Memory* by Marjorie Agosín.

ABOUT THE COVER ARTIST

Liliana Wilson Grez is a Chilean-born painter and graphic artist who lives and works in San Francisco. She has exhibited her work throughout the United States and in Italy. The cover image for *Invisible Dreamer,* an original painting in acrylics, is titled *Memorias de Chile.* She writes "As a Latin American woman who has lived through a dictatorship in Chile, I use art to give meaning to a life that is at once hard to confront and important to remember."

ABOUT THE PRESS

Sherman Asher Publishing, an independent press established in 1994, is dedicated to changing the world one book at a time. We are committed to the power of truth and the craft of language expressed by publishing fine poetry, memoirs, books on writing and other books we love. You can play a role. Bring the gift of poetry and literature into your life and the lives of others. Attend readings, teach classes, work for literacy, support your local bookstore, and buy poetry. Independent presses are supported by readers like you. You can purchase all our titles at our Web site: www.shermanasher.com